Navigators

SUNY series, The Social Context of Education
Christine E. Sleeter, Editor

Navigators

AFRICAN AMERICAN MUSICIANS, DANCERS, AND VISUAL ARTISTS IN ACADEME

Theresa Jenoure

02122 3314

STATE UNIVERSITY OF NEW YORK PRESS

Cover Photo: Maurice D. Robertson
Cover Design: Nitin Mukul

Published by
State University of New York

For information, address
State University of New York Press,
State University Plaza, Albany, NY 12246

Production by Dale Cotton and Michael Haggett
Marketing by Anne M. Valentine

Library of Congress Cataloging-in-Publication Data

Jenoure, Theresa
 Navigators : African American musicians, dancers, and visual
artists in academe / Theresa Jenoure.
 p. cm. — (SUNY series, the social context of education)
 ISBN 0-7914-4353-1 (hardcover : alk. paper). — ISBN 0-7914-4354-X
(pbk. : alk. paper)
 1. Afro-American artists as teachers. 2. Afro-American artists—
interviews. 3. Afro-American arts. I. Title. II. Series: SUNY
series, social context of education.
NX396.5.J45 1999
700'.92'396073—dc21 99-17224
 CIP

10 9 8 7 6 5 4 3 2 1

Dedicated to the loving memory of my grandmothers,
Jesusa Lanzó Lopez and Emma Dewar Spence Jenoure

Contents

Foreword

I have had the privilege of knowing Theresa Jenoure and her work over the past two decades. I have seen her perform as a violinist and vocalist and have witnessed the many beautiful and exciting programs that she has brought to the University of Massachusetts campus in her role as director of the Augusta Savage Gallery in New Africa House. I also have had the opportunity to work with her as she developed her thoughts and ideas in the work that I have been asked to introduce.

Rare are the serious studies of African American faculty in predominantly white institutions. Even rarer are studies of members of the African American artistic community who have managed to clear a space for themselves in academe. *Navigators* is that most rare of works: a study of African American artists by an accomplished artist and scholar. In an imaginative and moving blend that includes personal histories, sociopolitical analysis, and innovative pedagogy she discusses ways that twelve individual artists— that is, musicians, dancers and image-makers—negotiated paths into and through a too often unwelcoming, uncomprehending, and unsympathetic environment. Their starting points vary widely as does the degree of their successes, but the overall impact is that of individuals triumphing over difficult odds and making their institutions better places through their efforts.

If this was all that Ms. Jenoure gave us, students of African American culture and of higher education would be in her debt. However, we also get a picture of how these artists not only moved into the academy, but transformed it through the creative ways that

they drew from their deep wells of African American cultural experience to make the subjects they taught come alive in the classroom, stage, or studio, and to lead their students to change the way that they viewed themselves and the world. Of course, these are not the first or only African American artists who have had to come to some terms with life in academe. What they do represent, however, is that generation of African Americans who came into the academy in the wave of the revival of African American cultural expression during the late 1960's and managed to remain. Most have been too busy teaching and creating and surviving to take the time to reflect on what they do, why and how they do it, and how they got to where they are now. We all should thank Ms. Jenoure for seeking them out, telling their stories, and letting us share their experiences and learn from their insights.

An additional feature of this book worthy of mention is the way that Ms. Jenoure has organized it. Drawing on her sense of aesthetics and her training as a vocalist and violinist in the jazz tradition, she has built segues, riffs, and call and response into the very structure of her arguments so that one can see and feel the way that she wants students and readers to understand the material that she is presenting. For those who might happen to miss her insights into pedagogy, she has included a chapter entitled "Sailing Lessons" and a "Coda" making explicit her proposals for a "creation pedagogy."

Theresa Jenoure has not written a traditional academic study in a traditional fashion. She has improvised and created, thought deeply and wisely. Read her carefully. There is much to learn from *Navigators*.

"The artist stands at the helm of the boat pointing the way."

—Ousman Sembene, Filmmaker

Theresa Jenoure (photo by Michael O'Bannon)

Preface

The Author's Story

"Education is the key." This is a declaration I grew up hearing my parents repeat over and over again. The key to what? I was not quite sure then, but I have come to understand that the seed for this book was planted a while ago, making my own interests and biases crucial to the shape it has taken. The stories told to me by the twelve teachers I interviewed are filtered through certain aspects of my own experiences, which need to be acknowledged at this point.

Born in the Bronx in New York City, I grew up in the Bronx River Projects, a working-class neighborhood of Latinos, West Indians, and African Americans. My father is a first-generation American of Jamaican descent. A postal employee and taxi cab driver, I now realize that he worked two jobs partly to ensure that my younger brothers, Vincent and Maurice, and I could take private music lessons and that we would eventually attend college (which was never regarded as an option, but rather, an expectation on my parents' part). My mother, a first-generation American of Puerto Rican heritage, worked part-time in a factory and then as a para professional in our local elementary school. She arranged her schedule around our school day, preparing hot breakfasts and bag lunches, sending us off to school and greeting us when we returned home. They invested all that they had in our academic, emotional, and spiritual well-being.

My musical inclination was discovered by my parents when I was about six months old. I lay in the kitchen in my bassinet, under

my mother's watchful eye while she cooked. My father, leaning over me, discovered (much to my mother's objections) that his soft, melodic rendition of "Silent Night" on the harmonica could trigger my tears, even as I slept. A self-made psychologist and philosopher, his studies revealed that music had tremendous emotional power over this newborn research subject. Throughout my early childhood, with reluctant but resigned brothers as my side-kicks I created and presented performances, with songs, dances, costumes, and props for an attentive and appreciative family audience. My parents viewed these interests as inseparable signs of intelligence and creativity, and they constituted some of my early lessons in uncensored exploration.

From the first grade, when my parents opted to have me "bussed" to a district school outside our neighborhood, until the time I did my graduate work, I was always one of very few students of color in my classes. In eighteen years of school, I had one teacher of color, Miss Cunha, a Cuban American woman with a large frame, dark, reddish-brown skin, and an exuberant spirit. Interestingly, she was also my first music teacher. The first day of class in the fifth grade, Miss Cunha ushered us over to the instruments we had chosen to play. The intoxicating aroma of wood and rosin that reached out to me from my violin case as I opened it is a sensual recollection as vivid nearly forty years later as it was on that day.

I am a violinist, vocalist, and composer. I began my training in the area of European classical music, first studying in the public schools and with private teachers and then in college, for a total of twelve years. However, although I was skilled and loved performing, those music studies always seemed unnecessarily competitive and routine. As a teenager in the mid-1960s, my relationship to music began taking a noticeable shift, affected by the numerous social, political, and cultural experiences that were rapidly shaping me. The Vietnam War was raging, and I participated in antiwar rallies, performing those songs created by some of the great songwriters and social commentators of that era: Phil Ochs, Buffy Saint Marie, Richie Havens, Miriam Makeba, and Bob Dylan. Another factor that affected my perspectives on music was the host of ideological issues raised within our communities during the Black power movement. I began to realize how limited and culturally narrow my formal music schooling had been and reached out to explore new territory.

This new territory was magnificent for me, both then as I experienced it, and today, as I reflect on its impact on my thinking.

During my senior year at the High School of Music and Art, I heard about a new teacher, Yusef Lateef, who was introducing "classical music" students to music from other cultures. I was excited and curious. Also that year, I immersed myself in John Coltrane's music and completely lost myself in my imagination. At home with my new recordings, for hours on end, I tried very hard to capture on my violin even bits and pieces of the spirit of his masterful improvisations. Somewhere inside myself, though unconsciously, I knew that this music emanated from some deep, mysterious place where the divide between structure and freedom merged. I would later come to recognize those late-afternoon meetings with Coltrane as a peek into many of my current scholastic adventures.

My world of music became even larger. In my second and third years in college, I studied abroad in Beirut, Lebanon, during which time I traveled to Syria, Turkey, Egypt, and Jordan. This was followed by a trimester abroad in Nantes, France, at the Institute of European Studies. Young and impressionable, I was introduced to new worlds of music and was feeding an insatiable appetite for new ideas and experiences. I wondered if there was some way to blend all these new sounds I was hearing with my desire to improvise and experiment.

After college, I made a decision to become a professional musician. Slowly seeking out mentors and opportunities that enabled me to grow artistically, I began to carve out a career for myself, performing and recording with outstanding musicians: Archie Shepp, Leroy Jenkins, Lawrence "Butch" Morris, Henry Threadgill, Marion Brown, Reggie Workman, John Carter, and a host of other pacesetters whose work was improvisation-based. Through them and my own ensemble, the music soon carried me to France, Italy, Germany, Austria, Holland, Brazil, Canada, and throughout the United States. Composing for players with highly developed improvisational skills became my major focus, and I found that much of my writing was turning to unorthodox notation systems, which I felt gave musicians interpretational breadth. I look upon this as a rich period, where I aligned myself with others who were actively exploring the expanse of musical possibilities through diverse compositional approaches.

Also key to my growth was my association with Dr. Roland Wiggins, with whom I studied in the late seventies. He brought a novel and much-needed perspective of African American music to his teaching by proposing solid analogies between music improvisation and the structural and ideological framework of African

American linguistics. In exploring musical "kinesthetics, syntax and semantics,"[1] he opened a door to my thinking about jazz improvisation as a language. It is Roland's meticulous scholarship and artful teaching in this area that have inspired me to consider the pedagogical implications of this work, which are explored in this book.

As engrossed as I was in the world of art and ideas, I also knew that I had to make a living. Reluctantly, at first, I taught in order to supplement my income. Although many of my students expressed interest in learning to play "jazz," their notions about the music seemed static to me. More to the point, I did not consider myself an expert in this or any other style, but more of an explorer, dissecting and weaving genres, fascinated with the threads that bind musical worlds. Teaching the mechanics of style was secondary to what I believed was most essential, which was helping students unravel and tap their unique, expressive potential. My interest in teaching was growing. I was making connections and soon realized that the creativity I sought in the classroom was no different from the honesty and clarity I valued in many other areas of my life. My interest in teaching was turning to passion.

Throughout the eighties, I taught young people in New York City from elementary to high school levels as a substitute teacher, an after-school instructor, and the coordinator of an arts program at a summer camp. Since so few of my students had ever studied music formally, I needed to find exciting and affective ways of developing their interest, not only as listeners, but as participants both performing and composing. For this task, composition began taking on new meaning. Stretching and searching, I began posing questions to myself: How can I encourage my students to take adventurous leaps in their thinking? What approaches to teaching might best encourage a view of music as a wonderful language of both the mind and the spirit? How can I develop skills and nurture confidence to help them communicate musical ideas without fear of judgment and free of that elitist social indoctrination, namely, that only *some* people are musical.

Much broader questions followed: How do the various facets of my own make-up affect what, why, how, and who I desire to teach? What is the relationship between what I *know* and what I *do*? How can my creativity serve as a measurement of growth in other avenues of my life?" Many of the dancers and visual artists with whom I collaborated were also asking these kinds of questions, and I began to appreciate the ground we shared. Although both my

questions and my answers continued to shift and refocus as we exchanged ideas, it is the essence of this inquiry that remains at the core of much of my work.

I am currently the director of Augusta Savage Gallery, an art gallery and performance space at the University of Massachusetts. I also teach courses geared toward the development of creativity and pedagogy at the university and at Lesley College.

Through all of my experiences, I have only begun to understand what my parents in their wisdom already knew as they periodically tossed me that cryptic proverb about education, which is that rich, diverse, and vital learning is the key to more meaningful and productive life experiences and relationships. To a large extent, this book has evolved from my desire to hear how other artists who teach in higher education approach the challenge of communicating what they know and undoubtedly from the need to understand myself better.

Another factor that influenced this work is my identity as a person of African descent. I view my point of cultural reference as multiple and therefore complex: A Puerto Rican /Jamaican American woman, I realize that various Native Caribbean, European, and African cultures constitute my ethnicity. However, I self identify and am identified by others as "Black." I do not entertain romanticized visions of a uniform, homogeneous African American community and in fact am very conscious of being a minority within a minority group. Because I am also acutely aware of the degree to which many different communities have nurtured my own plurality, I am very attracted to the focus on the individual afforded by in-depth interviewing.

This book had its birth as a dissertation, and it continues to represent the converging of my many passions into its present form. In particular, fervently driving this work is the fact that the contributions of African descendants to American culture have been overlooked historically and henceforth discredited, both in formal education and less formal avenues that disseminate cultural knowledge. I therefore feel a strong sense of responsibility to preserve the dignity and integrity of the teachers involved in this project and welcome the opportunity to provide this format for them to speak.

Important to note is that since the interviews were first conducted in 1994, widespread use of the term *African American* has largely replaced that of *Black*, which most of the participants used throughout the telling of their stories. It is hoped that this will not distract the reader from the qualitative value and current relevancy of their experiences.

In closing, a crucial part of who I am and which affects my interests and guides my biases is my Christian beliefs. Rectifying my experience with and perception of an oppressive sociopolitical authority with that of a benevolent spiritual authority always has posed an obstacle for me. In particular, channeling my anger toward inhumanity is an ongoing challenge and signals potential pitfalls for my spirit. Where do I find solace and inspiration? I have found some of my emotional and psychological safeguard articulated in a biblical verse that is very special to me: "Be angry but do not sin." It has taken years for me to give a face to the name, but I am beginning to recognize "sin" as both a cause and an effect— that bitterness that slowly eats away my heart, that puts me at odds with God, that renders me immobile and separates me from the ability to love unconditionally and to labor in faith. Although the degree of discrimination that underlies and pervades the need for this work is monumental, I seek to contribute my ideas in the spirit of love, that is, a commitment directed toward meaningful action for the common good. Hope: a spiritually driven ethic that champions over social evil and grafts humanity to God, or in biblical parlance, the "branches" to the "vine" is what gives meaning to and drives my personal and sociopolitical commitments.

Acknowledgments

There are a few key people who have contributed in significant ways to this book, commenting on, and enriching my ideas at various stages. A special thanks to Sonia Nieto, who has been a combination of mentor, role model, cheering section, and literary agent. Doris Shallcross and Frederick Tillis encouraged this work in its early phases as a doctoral interest. For the pilot study I talked with a number of people about creativity and improvisation. These included: Dorrance Hill, Brandon Ross, Marc Puricelli, Kamal Sabir, Charles Burnham, and Deb Habib. Then, in its dissertation form Irving Seidman and E. Frances White offered solid critiques and guidance in their roles as committee members, while Linda Guthrie efficiently transcribed the interviews. John Bracey's comments were invaluable as the dissertation began its transformation into a book.

I am grateful to my husband Michael O'Bannon, whose honest responses to and support of my on-going projects fill me up. My compañeras Ellen Eisenman and Joi Gresham, who know how to work hard *and* play hard, have been so generous in their time and their devotion to collegiality. Two people are responsible for the book cover: Maurice D. Robertson contributed the wonderful photograph that he took of his wife, Patti, while Nitin Mukul digitally crafted the photo into the perfect design. Also thanks to Michael O'Bannon for his photograph of the author.

These acknowledgments are not listed in order of importance. I therefore finally thank the teachers I interviewed who took a chance on me, opened themselves up, and poured out their stories, trusting that I would handle them with care.

Introduction

In one class, I said, "Rock and roll and most of American popular music was developed originally by African Americans. In fact, 'Surfing USA,' [by] the Beach Boys, Chuck Berry wrote that." And there were many students who were stunned by that.

—*Rufus, a teacher*

African American artists have played a monumental role in the evolution of American culture. From Picasso to Martha Graham to the Rolling Stones, mainstream artists have dipped into the wellsprings and drawn inspiration from the creative expressions of African Americans throughout the nation's history. In informal but profound ways, they have been models and mentors, exerting tremendous leadership in the arts. Yet African American artists have had little influence over the formal study of their knowledge in schools.

The experience of twelve African American musicians, dancers, and visual artists who teach at traditionally White colleges and universities is the subject of this book. What is it like for them to teach the arts in higher education? What is the context of their lives that led them to their present careers? What meaning do they make of their teaching? I conducted an in-depth interview study to gain an understanding of these teachers.[1] Through narrative excerpts and profiles, twelve artists who teach at schools in the northeast region of the United States address a host of issues that may give us an appreciation for their roles in academe.

There are a number of factors that make their stories particularly significant. Comprising approximately 12 percent of the nation's

1

population, African Americans account for only about 4 percent of the faculty at traditionally White colleges and universities, of which artists are an even smaller fraction. Though there are many reasons for the proportional disparity, probably the major one is that schools defend and enforce White, Anglo-Saxon, male, upper-middle-class cultural criteria for inclusion and privilege. The fact that an inconsistent commitment to educational equity has been a major contender in the struggle of African Americans to gain entry into the academy is especially pronounced because it occurs during a period in U.S. history when the population of people of color is steadily rising. Moreover, there are growing numbers of educators concerned with how the nation's shifting demographics affect learning. For many, increased diversity in race, ethnicity, language, class, gender, age, physical and mental abilities, geographic location, and religion has now rendered it imperative that pluralism be accounted for at all levels of education.

Although centuries of segregation and discrimination are not remedied overnight, as Joyce Payne affirms, "A country that offers the luxury of 5,000 television cable systems, produces 2,800 designer fruits and vegetables, and performs delicate eye surgery with lasers can certainly find ways to advance the presence and role of minority faculty on its campuses."[2] To actualize the necessary educational reform, we need more than a concession to fulfill quotas. Numbers alone will not guarantee changes in those attitudes that perpetuate exclusion. What makes African American faculty not only valuable but indispensable to higher education is the way they enrich learning by making a wider spectrum of experiential viewpoints available to all students. Fortunately, there is a burgeoning realization among educators that all students need preparation to function effectively in a pluralistic society or to acquire what James A. Banks refers to as "multicultural literacy."[3] Toward this end, the inclusion and valuing of African American teachers is a step in the direction toward affirming our literacy as a nation, our fluency in the language of diversity, and our eloquence as agents of social change committed to a progressive democratic society.

Nestled within the sweeping range of diversity that constitutes our nation is the rich culture of artists. As both scientists and mystics, they approach their missions with passion. They search for new angles from which to view the world and invent their own languages to speak about their experience. They unveil and bring to our attention many of the ideas and feelings we take for granted by exploding myths and questioning social norms. They revive us,

sustain us, and create those places of refuge where we too might imagine the unimaginable. Yet, despite their importance, artists in this society have continually struggled for social, economic, and academic recognition. Not only has the pursuit of the arts traditionally not been viewed as a meritorious career option, but in most schools the arts arc relegated to the fringe of the curriculum.

The historical and ongoing discrimination against African Americans, positioned against the breadth and wealth of their artistic contributions, serve as compelling backdrops for the twelve teachers whose stories you will read about in this book. African American artists who teach in the academy are influenced by many circumstances that have shaped who they are. At the same time, they assume responsibility for the scholastic and creative growth of their students. Because their classrooms are comprised primarily of White students, their status as artists and "minorities" in positions of leadership suggest encounters with certain political and pedagogical challenges. Challenges notwithstanding, many of the teachers who were interviewed express immense concern for their students' intellectual and emotional nurturing. Most of them argue vehemently for the inclusion of culturally diverse art forms in education. Each one struggles with making sense of the peculiar historical contradiction of being a giant in the arts and virtually invisible and voiceless in academe. As these twelve educators help us understand their process of sharing knowledge gained from their own life lessons and fostering learning among their students, they present us with food for thought concerning the nature of oppression and power in schools.

There is a great deal that we can learn about the experience of African American musicians, dancers, and visual artists at traditionally White institutions (TWIs). These lessons will bc directed by the two main purposes of this book: the first is to tell about twelve people who have chosen to pursue their visions and callings as creative artists and to show how they function in higher education. We will look at influences on their teaching through the lens of both past personal experiences and conditions under which they presently work at their schools. This range is necessary because to a large extent their abilities to contribute freely and effectively to academe is affected by the successful marriage of knowledge they bring to their classrooms and conditions they may consider either supportive of or disruptive to their teaching.

The other purpose is to present some ideas about the development and sustenance of creativity. The arts are usually credited

with developing abilities such as the generation of spontaneous and critical responses to new information and the encouragement of ardent self-reflection. However, all learning, whether in the arts or otherwise, is dependent on these skills, which ought to play a vital role in education. Development of the imaginative faculties, as discussed by these artists, may be of particular interest to educators looking for new ways to help students cope with many of the educational and social challenges they face. Through examples provided from the teachers' classrooms, they suggest specific paths toward successful problem solving and usher us into a deeper appreciation of self-expression, risk-taking, experimentation, imagination, and affective functioning as educational requisites.

A tradition of racial discrimination has marked profoundly the psyches of most Americans regarding the capabilities of African Americans in general, but particularly in the academy. For at least this reason, a discussion about African American artistic prowess as transferable to other arenas, such as aesthetics and pedagogy, historically has been afforded less attention and will be addressed here. I will refer to these ideas as "Creation Pedagogy." As a framework, creation pedagogy has two functions. The first one, which is the most obviously displayed throughout the book, is to allow for the systematic examination of these teachers' practices as they pertain to the development of their students' artistry. Its other function is to suggest that we consider the merit of an aesthetic-based method to teaching and learning in nonarts areas of education that evolves from an African American world view. Although this second function appears considerably less overt here, it is at least as important. The story of these twelve teachers becomes a vehicle for comprehending the role of creation pedagogy in fostering more creative learning, an idea that finds its full expression in the final chapter.

Both purposes of the book are pursued concurrently. Through sharp realizations, fragile but forceful memories, and often dense political challenges, these teachers speak with authority about what they know and what they do. To acquire a solid grasp on lessons offered to us through their stories, there are three questions that will direct the scope and organization of this book:

1. How do social experiences shape values that African American artists consider useful for student learning?

2. How do teachers feel their schools support or impede them and their teaching?

3. What can traditionally White institutions of higher education learn from African American artists that might further efforts toward more equitable educational engagements?

As the twelve teachers' stories unfold, they share their hearts generously and speak their minds frankly, offering us kaleidoscopic glimpses into their biographies. They talk about the various paths that led them to become artists and teachers, honoring special people and incidents that have guided them along the way. They identify some of the ways they became aware or politicized giving names to forces that have shaped their views on social group membership. They reflect on their teaching: relationships with students, methods to which they subscribe, their views about what constitutes effective teaching and perspectives on the institutions where they work. These are stories we need to hear, and their voices resonate powerfully, presenting us with a rare opportunity to be moved and changed. As Maxine Greene reminds us, "[W]e have to remain aware of the distinctive members of the plurality, appearing before one another with their own perspectives on the common, their own stories entering the culture's story, altering it as it moves through time."[4] Listening to the twelve musicians, dancers, and visual artists featured here, we are likely to be impressed in ways that may affect our own struggles for equity and excellence in education.

Chapter 1 is a backdrop intended to establish some of the aesthetic values that have guided African American musicians, dancers, and visual artists in the development of their work. In order to better understand concerns that inform those who teach these art forms, a discussion revolving around the systemic and symbolic value of jazz improvisation is presented. Suggested as both a metaphor and a structurally viable system, the exploration of jazz improvisation visited and revisited throughout the course of this book occurs at three different levels: (1) as a form of music; (2) as an aesthetic outlook; and (3) as a pedagogy. Jazz is a musical language that embodies certain thinking patterns. Like our skin, which enables the complex, delicate human system to move about in the world, jazz is the outer layer, the sophisticated and multidimensional system of thinking we have come to know in musical terms. It is a "skin" of sorts that hosts an intelligence. This intelligence may be understood by examining the specific attitudes and behaviors that constitute it. In this chapter, I will highlight principles I believe are inherent to the music. These principles are both examined as guidelines for successful ensemble music making and explored as aesthetic codes that

have governed the development of music, dance, and visual arts in African American culture.

Chapter 2 presents brief descriptions of each of the teachers, providing a general sense of their backgrounds and current faculty status at their schools.

Chapters 3 through 6 are directed by specific themes that emerged from the interviews, highlighting similarities, contrasts, ranges, and depth in the teachers' stories. First, because their identities have a tremendous bearing on how they function in their schools, chapters 3 and 4 point out some of the means by which their knowledge has been constructed. In chapter 3, the teachers cite early experiences influencing the discovery and pursuit of their artistic nature, and in chapter 4 they speak about sociopolitical factors that have shaped them.

Chapter 5 looks at how the teachers encourage their students' development as artists. The discussion exploring jazz improvisational principles initiated in chapter 1, is further advanced here. Its function is to describe ways that these aesthetic principles are also applied by artists to their teaching.

Chapter 6 examines schools' climates which affect teaching. Some of the influential variables are identified as institutional policies and practices, while others pertain to their environments and the attitudes of those with whom these teachers work. Overall, these conditions bear on how teachers are supported or hindered in their effectiveness. They are also commentaries on the overall state of their professional well-being at their schools.

Chapter 7 offers conclusive remarks, while the Coda, which functions as an epilogue, continues the discussion about creation pedagogy begun earlier when focusing on the teachers' classrooms. Suggested in this chapter is the relevance of these aesthetic principles for educators at large.

Profiles and riffs serve as bridges between the chapters. The profiles offer a closer look at four of the teachers. Many of the issues raised throughout the course of the book come together in these narratives. They are viewed through the lens of four distinct lives, each one mapping a journey from early childhood, to present teaching, to future aspirations.

The riffs, turn inward to an ongoing conversation. This device is intended to balance the more linear quality of the chapters and profiles with a more informal, exploratory tone. In the context of jazz compositions, a riff refers to a brief musical idea or motif explored at various intervals, usually for the purposes of acknowl-

edging a junction in the music while fortifying its motion. Here, the riffs merge fact with fiction. The teachers and I speak with each other through this series of imaginary discussions that I have created. However, the conversations make use of their actual words from the interview transcripts and provide, either obviously or abstractly, connections to either immediately preceding or subsequent topics explored. It becomes clear that certain concerns were common to the teachers, and they seem to unite us despite the fact that the teachers had no connection with each other for this project.

The riffs supply yet another dimension to their stories. In my mind, we are gathered together in a room. The door is closed. These talks seem to poke through and suggest momentary pauses in the book. We go from speaking to the reader throughout the chapters and profiles with the intention of informing, to hearing and speaking quite intimately with each other, exploring shared realities. This is an exchange among us that I envisioned had we actually had an opportunity to meet in this way. Not coincidentally, the riffs are in line with and pay tribute to the creative process, which is the essence of the teachers' life's work and mine.

Pushing Off

Winston

I see myself as an entity comprised of several aspects. And part of living for however long you live is to find out how those aspects work best and how to develop them, whatever they may be: intellect, curiosity, enjoyment. To explore those and see how they fit into place. Because life, like the human body, I like to think of like a jigsaw puzzle. All the pieces do fit. It's knowing what piece goes where, and when and how hard to press.

Nduma

That's what makes life interesting though anyway. You're supposed to grow wiser. Not everybody does, but I think it's a nice thing if you can.

Interviewer

I think becoming wiser and understanding how the pieces fit are probably things many of us may want for ourselves. The question is, how do we get there? What paths do we take?

Sadik

I'm comfortable with the idea of entering the arena of ideas and advocacy toward an Afrocentric position. Because many ideas in that arena have been effected by racism, and that's where you fight those ideas, where you are. You fight them by finding out what is commonly believed and correcting it. For example, they say, "Slave trade, slave trade." They talk about

the kidnapping of Black people from Africa and the reselling of them in the new world. Nobody talks about the ninety days in the hold of the boat.

I ran into a guy who deals in the arena of ideas, and he was telling me that the ecological structure of 75 percent of the world was changed through the slave trade because for four hundred years there was a corridor of black flesh in the ocean for sharks to feed on, where there had never been flesh before. And when those fish followed those boats across the Atlantic feeding on those Black people, it moved other fish out and changed the whole ocean ecological structure of where certain plants and certain fish were. I thought that was amazing, absolutely amazing. All those lists of names lost in the ocean. There's as many there that got here from over packing or disease or piracy. There's a whole nation of people at the bottom of the Atlantic ocean. It's bigger than the Holocaust. But we say "slave trade." We say, "middle passage." It has no emotional connection. I'm looking for a better word, and I haven't found it.

Rufus

There's a certain anger that we all have to encounter. They call it sometimes "blood memory." There's four hundred years of anger.

Sadik

It can disable you. It can make you sit in one spot. It can make you inactive, but it doesn't do that to me. It's a source of energy. Energy? No. It's, it's kind of like—See I believe—(pause) What do I believe? I believe that I have this large cheering section that's made up of all the aunts and uncles that I have, all the extended family that I have. They want to see me do well. And all them people in the bottom of the ocean, they want to see me do well too. That's what I believe. It's a big cheering section. "Come on baby, get up and do something. Don't become disabled by the ignorance of the 'other.' Become charged by it. Become electrified by it!"

CHAPTER 1

Understanding the Voices
of Artists/Teachers

This chapter establishes the tone and lays some of the ground work for the voices of the twelve teachers you will hear. Much of what they do in their classrooms on a daily basis is centered around the expression, exercise, and celebration of the artistic imagination. For this reason, the following discussion is about an important body of cultural knowledge that has profoundly affected African American artists, their aesthetic values. These values, which represent particular ways of seeing the world, making sense of it, and reporting it, influence the perspectives of many of those who teach. They also mark one coordinate whereby we will later enter into thinking about the more far-reaching implications of these values for teaching and learning.

Creativity has been highly regarded in African American culture. Often, it has been the importance placed on making something new and meaningful from the remnants of what has become static, dangerous, or insignificant that has constituted this behavior, the possibility of a purposeful future upheld against the reality of enormous waste and suffering. Perhaps because the ability to satisfactorily organize reality has been socially, politically, and economically impeded to a large extent, we find a high price placed on symbolic disclosure and expression within African American culture. To this end, the arts have played a crucial role in reflecting depth and intensity of experience and documenting quantity and quality of knowledge. This issue of creativity occupies a significant

place in the stories of these twelve teachers. What does creativity look like in their lives and work, and what are some of its governing rules?

Artists arrange symbols for the purpose of communicating and sharing or for personal enjoyment. These expressions often exist in a world of commonly shared rules that determine its comprehension and value within the group, the meaning of the art having a life far beyond its physical manifestation. Just as a dream may be symbolic of a greater idea, art consists of symbols arranged consciously and unconsciously, representing realities from the simple to the complex.

However, at the same time that these symbols are pointing to an idea that the artist may have, they also refer directly back to the artist. Art not only tells us that the artist thinks but reveals a more intimate and fundamental story, which is that the artist thinks in a particular way. Because the arts play a crucial role in reflecting experience and documenting knowledge, aesthetic values that have shaped the music, dance, and visual arts of African Americans will be highlighted here so that we might also appreciate some of the thinking of arts faculty. To provide insight into these values, jazz improvisation will serve as a frame of reference as these ideas are presented.

Before proceeding with this discussion, I need to acknowledge my struggle with the use of the term *jazz*. There remains debate concerning the origins of the label as well as myths surrounding musical improvisation in the African American tradition. For many White critics and audiences, the term "jazz" has carried degrading allusions to the mythical sexual prowess of African Americans and historically has often been associated with base levels of human functioning. The naming of the music, derived from and reflective of negative stereotypes, seems inseperable from the widespread distorted perceptions and mistreatment of the music and musicians. For example, many music critics in the 1920s and 1930s insisted that jazz was noise that threatened to destroy the civilized world, an idea that to some extent remains intact today. Another common public notion is that great jazz is produced only through suffering. This belief has prevented it from being perceived as "high art," which then relieves a great deal of public responsibility for its financial support. Yusef Lateef explains how stereotypes affect use of language, which in turn affects public perceptions. He says, "[T]he use and affects of expressions appropriated for African American improvised music, such as "he/she was cooking; they were burn-

ing last night; they had the pots on; he was intensely F-U-N-K-Y; his chops were together, . . . in many instances these descriptions are vulgar, inadequate, and, in fact, unjust."[1]

Some respected musicians and scholars have suggested alternatives to the term *jazz* in efforts to more accurately and respectfully represent the music, such as *creative improvisation, American music,* and *Black classical music.* Brenda Dixon's position further substantiates these efforts. She states that "[i]f language is the exercise of power, and if the act of naming is part of the empowerment, then what is not named, or is misnamed, becomes a disempowered part of the background."[2] Yet, it is highly doubtful that simply reconsidering the use of the word will in itself alter perceptions that derive from ignorance and fear of African American creative expressions. With due respect for the complexity of this issue, although investigating more suitable terminology is appropriate I have chosen to use the term *jazz.* For our purposes, this term distinguishes the music from other musics that apply improvisation to their performance and identifies it unmistakably as that very specific, though widely diverse, tradition created and primarily advanced by African Americans.

There are two reasons for using jazz as a model in the following discussion. First, some of the structures and approaches that govern the thinking of improvisers have extramusical implications. As African American cultural knowledge, they are principles that not only guide musicians but are displayed as aesthetic precepts across other arts fields, which the examples cited in the course of this discussion will demonstrate. The other reason for drawing attention to jazz improvisation is that these principles also have pedagogical applications. These will be explored in a later chapter when discussing concerns that guide African American teachers in the development of their students' creativity.

The Nature of Creativity

One of the many ways that we make sense of our lives is by attempting to organize the volume and complexity of our experiences. By structuring and shaping what we know, we are actually trying to find ways of understanding and making meaning. Similarly, artists selectively highlight what they believe is worthy of remembering and sharing. Juggling the pieces—shapes, sounds, gestures, colors, space, time—they are involved in much more than collecting and reporting data. The materials they work with have

no meaning outside themselves. It is the unique, subjective inter-pretation of the creator that breathes life into a work of art. Audi-ences also play a highly active role in the art-making process since the work is often shaped as artists receive responses to their ideas. Playwright Julian Beck's description of this exchange is poetic and clear: "To serve the audience, to instruct, to incite sensation, to ini-tiate experience, to awaken awareness, to make the heart pound, the blood course, the tears flow, the voice shout, to circle round the alter, the muscles move in laughter, the body feel, to be released from death's way, deterioration in comfort. To provide the useful event that can help us."[3]

Part of an artist's task is to make perceptions memorable and pleasurable. In this case, "pleasure" does not posit a standard of beauty or a level of comfort. It is that quality that brings satisfaction and carries meaning on some level to the creator or observer. The arts "make special" or place activities and artifacts in a realm dif-ferent from the everyday and give us an opportunity to feel and validate feelings, which provides richness to experience.[4] The arts document who artists are and are therefore signatures of their iden-tities. Of course, this is not a process unique to artists. Making art is simply a developed extension of the creative capacity inherent in everyone, the desire for "making special" evident even in those who hold no claim to an aesthetic temperament. Our most mun-dane activities denote this behavior, apparent in the way we deco-rate our homes and offices, select our clothing, and style our hair. What distinguishes between artists and nonartists is the conscious pursuit of and devotion to this creative path through the study and mastery of particular materials, forms, and processes.

We learn a great deal about what is important to artists by examining their work. William F. Pinar notes that focusing on the individual is one way of identifying the intricate web of influences in a person's biographical situation.[5] An individual alive on a cer-tain day during a certain moment contains within him or her a complex configuration of political, economic, and cultural forces. Pinar compares this moment to a crystal with its many planes, which are all interrelated, but only meaningful as part of that single unique crystal. These forces are revealed in part through the report of the individual.

The arts are such a report and are loaded with information about their creators and the worlds in which they live, and as such, are expressions of culture. Even further, as we look at the work of African American musicians, dancers, and visual artists, we are

reminded that by virtue of the fact that individuals and groups create art within specific sociohistorical contexts, all art has social and political implications. To fully appreciate what African American artists may contribute to student learning, we need to understand the motivations and conditions, as well as some of the thinking, that guide them and give birth and maturity to their work.

Artistic Expression in African American Culture

To varying degrees, the arts have been a vital expression of culture for African Americans. The creativity displayed by these artists in some ways resembles that of West African "griots," or musical storytellers. For example, through their songs, griots express the voices of their communities, commenting eloquently on social concerns, evaluating political agendas, and articulating subconscious drives. Their art is a vehicle for both social commentary and cultural documentation. Jazz improvisation has served to communicate cultural wisdom as well. However, what it communicates may not be quite as clearly discernible as in the case of the griot, because the profundity of its message is not necessarily located in its lyrics, but in the intricacy of its process.

Webster's Dictionary offers the following definition of what it means to *improvise*: "to create music on the spur of the moment; to prepare or provide offhand or hastily." In the context of African American music, this definition falls short in that it fails to account for the tremendous preparation needed for the successful execution of ideas. Jazz improvisation is a system of spontaneous composing. It is process oriented and requires that ideas be instantly organized, which does not allow for a return to previously stated ideas in order to undo them, only for opportunities to expound upon them. Improvisers assess the past, present, and future in a relatively short span of time and choose appropriate melodic, harmonic, and rhythmic solutions. This choosing, or composing, requires that musicians have physical, mental, and emotional access to a vast reserve of musical ideas. Negotiating a fine balance between structure and freedom, they often rely on pre-established perimeters to guide the expression of spontaneous yet highly crafted ideas. It is the personality, attitude, and individual choices made by listening, analyzing, and feeling that produce the music. In this way, performers are also co-composers in that they shape the particular structure or outline into a fully realized work, which enables the process and product to unfold simultaneously.

Jazz improvisation has implications far beyond the boundaries of pure musical expression, however. *It is a way of thinking and behaving.* Cornell West's discussion of what he calls the "cultural hybrid character of black life" is an insightful example of how the jazz aesthetic is reflected in social behaviors. He states,

> To be a jazz freedom fighter is to attempt to galvanize and energize world-weary people into forms of organization with accountable leadership that promote critical exchange and broad reflection. . . . As with a soloist in a jazz quartet, quintet or band, individuality is promoted in order to sustain and increase the *creative* tension with the group—a tension that yields higher levels of performance to achieve the aim of the collective project.[7]

There are many operations involved in Jazz improvisation, and a close look at some qualities of the music may reveal important information about values it promotes. In order to give clarity and manageability to the following discussion, three dominant principles that are particularly relevant for the purpose of understanding the intelligence of African American artists and fully appreciating their unique contributions to higher education will now be reviewed. They are interaction, which refers to the process of mutual shaping; definition, which affirms the importance of proposing personalized interpretations of information, thereby giving meaning to it; and transcendence, which is the process of upliftment from the ordinary to the extraordinary. To demonstrate their aesthetic application, each principle will first be explained in the microcosmic context of an improvisational ensemble, followed by observations of their occurrance across the fields of music, dance, and visual arts. Though there are countless examples that may be considered, we will examine only a few for the simple purpose of illustrating and representing each of the three principles.

Interaction

The mutual shaping of ideas is a principle that musicians have shown great skill in applying to their creativity. A glimpse into this process as it manifests in an ensemble illustrates this point. While improvising, musical ideas are continually being shaped and re-shaped from moment to moment, often resulting in the generation of fresh, new ones. The unspoken rules of the music prescribe that every sound a musician contributes to this engagement possesses

power to change it in some way. How effectively this happens depends on how well the ensemble members respond to each other. Each must be willing to use or at least consider the proposed ideas of others and cooperate with the interactive process. Compositional structures usually serve as points of reference for the players but do not restrict the freedom of individual creative or interpretive choice, making each player personally accountable for the evolution of the music. During this process, musicians are both listening and offering ideas, establishing them as both receptors and generators simultaneously.

This principle is not confined to the ingenuity of jazz musicians, however. There is evidence of its occurrence within and between other forms of African American music, dance, and visual arts. It illustrates the dependence of artists on people and environments for shaping both their own art and that of others. In this broader context, it may be understood as means of operating that ensure the flow and exchange of ideas across and within cultures, art forms, and social conditions, a process that undoubtedly has added to the fertility, fluidity, and depth of African American arts.

First, interactive values may be observed in the way African American artists have pioneered the frontiers of American popular culture. In dance, for example, the "charleston," "tapping," and other African-derived dances done during slavery often made their way into the "mainstream" through formal lessons. A case in point is the influence of African American dancers who tutored White film and stage personalities in the 1920s and 1930s. Clarence Bradley, for one, coached and choreographed for Fred Astaire, Lucille Ball, Mae West, and Eleanor Powell.

Likewise, in the area of visual arts, European American artists Arthur G. Dove and Jackson Pollack, during the 1930s and 1940s, acknowledged and translated the influence of Black musical concepts to their work. Dove discovered that some of the principles of rhythm that make Black music "swing" also enabled his visual ideas to be propelled with greater force, stating:

> Just at present, I have come to the conclusion that one must have a flexible form or formation that is governed by some definite rhythmic sense beyond mere geometric repetition, to express and put in space an idea so that those with sensitive instruments can pick it up, and further that means an expression has to have grown long enough to establish itself as an automatic force. . . . The play or spread or swing of space can only be felt through this kind of consciousness.[8]

The development of rock 'n' roll is another example of the African American musical influence on popular culture. Emerging from the blues, rock 'n' roll simplified its harmonic structure and accelerated its tempo. The first rock 'n' roll record was *Sh-Boom*, recorded in 1954 by the Chords, a Black rhythm and blues group, and first popularized by a White group, the Crew Cuts.[9] Widely marketed "covers," or imitative recordings by White artists, immediately followed. Similarly, many of Elvis Presley's songs were composed by Black artists and performed in an imitative style, including Arthur Big Boy Crudup's "That's All Right," and Thomas A. Dorsey's "Peace in the Valley."[10] Today, much of rock music draws inspiration from the rhythm-and-blues music of the 1950s and 1960s, from funk styles of the 1970s, as well as from 1980s and 1990s rap music.

Conversely, the music, dance, and visual arts of African Americans also have been shaped by cultural interactions. Harry T. Burleigh, Will Marion Cook, James Rosamond Johnson, Clarence Cameron White, and Robert and Nathaniel Dett were all nineteenth-century composers who excelled in European concert music. However, they also drew extensively from the themes, performance styles, and compositional qualities of African American music, and as a result, many of them were criticized for restructuring the form and content of symphonic music. In 1914, a review of a performance by the Clef Club, an African American symphony orchestra conducted by James Reese Europe stated:

> If the Negro Symphony Orchestra will give its attention during the coming year to a movement or two of a Haydn symphony and play it at its next concert, and if the composers, who this year took such obvious pleasure in conducting their marches, tangos, and waltzes, will write short movements for orchestra, basing them on classic models, next year's concert will inaugurate a new era for the Negro musician in New York and will aid him in being appraised at his full value and in being taken seriously.[11]

James Reese Europe responds by explaining his reasons for his unconventional style and use of instruments:

> You see, we colored people have our own music that is part of us. It's the product of our souls. . . . [Some] would doubtless laugh heartily at the way our Negro Symphony is organized, the dis-

tribution of the pieces, and our methods of organization. . . . We have developed a kind of symphony music that, no matter what else you think, is different and distinctive, and that lends itself to the playing of the peculiar compositions of our race.[12]

We see further evidence of interactive behavior in the mutual shaping and cross-fertilization of ideas among African American artists across arts disciplines. Richard Powell documents the influence of music on visual artists during the 1920s and 1930s. His description of Archibald J. Motley's painting entitled *Blues* is an example: "Motley's multiplicity of compositional elements, their interruptions and their reintroductions are not unlike the 'riffs' and 'stop-time' of a fellow New Orleans-born Chicagoan, jazz legend Louis Armstrong."[13] He compares their similar use of syncopation and improvising against relatively structured formats. Armstrong's musical format consists of a melodic scheme and the consistency of the ensemble's rhythm section, while a system of anticipated shapes and recurring intervals serves as Motley's visual format.

African American artists also have interacted with and responded to social movements in that specific social issues often have provided the impetus for thematic and conceptual exploration and convergence among artistic communities. The early spirituals are a wonderful example. Their lyrics express not only a great faith in God, but they translate the biblical oppression of the Israelites to their own adverse conditions during slavery. Harlem Renaissance artists also responded to the sociopolitical and economic challenges that they faced, and in the early 1920s the impact of Marcus Garvey's Universal Negro Improvement Association in Harlem inspired many of these artists to explore the history and culture of Africa. Again, during the civil rights movement, lyrics from spiritual songs were adapted to express political solidarity at marches and sit-ins. In that period, many visual artists also began making definitive cultural and political protest statements through their work, with organizations such as Weusi ya Sanaa in New York and AfriCobra in Chicago and Washington D.C. encouraging the exploration of Pan-African aesthetic and political points of view. In the area of music, between the mid 1960s and early 1970s, song titles such as Marvin Gaye's "What's Going On," The Chambers Brothers' "People Get Ready," Aretha Franklin's "Respect," James Brown's "Say it Loud (I'm Black and I'm Proud)," and Archie Shepp's "Attica Blues" voiced musicians' responses to a climate of social unrest. The graffiti of the

1970s is yet another example. In its inception, as an act of resistance created by the marginalized poor, graffiti served as commentary on the deplorable living conditions of the nation's cities.

Definition

To understand this principle in the context of the jazz ensemble, we need to first appreciate that there are usually ample opportunities for musicians to "solo," thereby bringing each of their unique, definitive musical statements to the foreground. Ideas often emerge from the context of previously established ones. The ensemble provides an environment of sound against which soloists can express themselves freely, which helps propel the exploration. Because the soloist is accountable to the ensemble, there is an inherent expectation for each player to apply sound judgments to their choices. Here, defining requires that soloists offer ideas that are both appropriate to the context yet true to what they unveil individually through deep and honest introspection. This is their chance to assert their perspectives with boldness and certainty. For this to happen effectively, the soloist continually must take inventory of musical ground that has been covered, create ideas that derive from the structural limits of the composition, and propose possible routes that other players might explore when they later take their own solos. In doing this, each soloist continually reevaluates the direction and meaning of the composition.

Across the arts, the term *definition* refers to ways that artists articulate, confirm, and explore their personal locales and identities. Definitions are asserted when artists ask themselves who they are, where they are going, and how they will get there. Taking stock of their destinations, opportunities, and limitations, they dig into their personal reserves and make themselves heard against all odds.

In the visual arts, an overwhelming number of African American artists recognize the need to take responsibility for how they define themselves. For example, images projected and perpetuated through mass media and other avenues of visual representation historically have attempted to legitimize White entitlement by creating and enforcing damaging myths and stereotypes. The words of W. E. B. DuBois, who believed that Black artists and communities had to develop their own criteria for evaluating their art, have a powerful ring: "The ultimate judge has got to be you and you have got to build yourselves up into that wide judgment, that catholicity

of temper which is going to enable the artist to have his widest choice for freedom."[14] Dance scholar Brenda Dixon explains that this process of defining was a critical focus of the work of dancers such as Katherine Dunham, who in the 1930s and 1940s made extensive use of African and African Caribbean heritage and folklore in her choreography. She says:

> Redefinition, reversal, and irony practiced by Afro-Americans are survival tactics. . . . The United States resists the integration of the Black dancing body with Eurocentric body codes and, of course, we know that those body codes, which are based on a ramrod straight torso and articulation of limbs in relationship to this center, is very different than a technique which is based on isolations, asymmetry, torso articulation, and of course syncopation, polyrhythms, and polymeter. That's pretty difficult for a culture to accept which was based, in its initial premise, on a minimalist Protestant ethic.[15]

Many visual artists have struggled to define the parameters of identity by raising issues that resound not only within their own communities but throughout the mainstream art world. For example, Valerie Maynard says, "even though we had no reflections on TV, in magazines, on billboards, I knew that in school they were not telling me the truth: Dick and Jane are not the only children."[16] Questions such as those posed by E. Ethelbert Miller have become paramount in visual arts circles: "Who are our heroes? What is Black art? What criteria do we use when evaluating it? What is good Black art? Who should be permitted to judge the work of these artists?"[17] James Clifford further examines the relationship between commerce and art, focusing on the history of art collecting by asking: "What criteria validate an authentic cultural or artistic product? What are the differential values placed on old and new creations? How are 'antiques,' 'curiosities,' 'art,' 'souvenirs,' 'monuments,' and 'ethnographic artifacts' distinguished at different historical moments and in specific market conditions?"[18] Questions such as these push artists to define their aesthetic values as well as their relationships to those definitions forwarded by commercial, mainstream venues. As Carrie Mae Weems so aptly states, "We have to create a critical culture where we can discuss the issue of blackness in ways that confront not only the legacy of subjugation but also radical traditions of resistance, as well as the newly invented self, the decolonized subject."[19]

Revisiting the jazz improvisation model, we notice that a musician while soloing, also may be presented with contrasting perspectives from other musicians. As soloists explore their ground, there is room built in for other ensemble member to interject ideas that might influence the soloist's course. In this way, they establish among themselves an agreement to disagree.

In line with this idea, the following excerpt from an interview between political activist Angela Davis and rap artist Ice Cube is an example of such effective tension, their exchange focusing on the sociopolitical implications of rap music's lyrics.

AD

What do you think about all the efforts over the years to transform the language we use to refer to ourselves as black people and specifically as black women? I remember when we began to eliminate the word "Negro" from our vocabulary. . . . I didn't know then why it made me feel so uncomfortable, but later I realized that "Negro" was virtually synonymous with the word "slave." Although the word "Negro" is Spanish for the color black, its usage in English has always implied racial inferiority. . . . "Negro" was just another way of saying "nigger". . . . How do you think progressive African Americans of my generation feel when we hear all over again—especially in hip hop culture—"nigger, nigger, nigger"? How do you think black feminists like myself and younger women as well respond to the word "bitch"?

IC

The language of the streets is the only language I can use to communicate with the streets. You have to build people up. You have to get under them and then lift. You know all of this pulling from on top ain't working. So we have to take the language of the streets, tell the kids about the situation, tell them what's really going on. Because some kids are blind to what they are doing, to their own actions. . . . Nothing's going to be done overnight. But once we start waking them up, opening their eyes, then we can start putting something in there.[20]

Both positions are rooted in strong rationales. It is their agreement to meet in a public space, subject to audience critique and the weight of each other's convictions, that is such a powerful part of their defining process.

In the realm of visual representation, many African Americans have expressed disdain with ways that African American filmmakers have depicted their communities. Once again we can appreciate how the nature and dynamic of public controversy allows for the breaking of new ground as racial and cultural definitions propagated through the media are analyzed and alternative courses proposed. For example, writer and arts critic Michelle Wallace believes that images of women in the popular film *Boyz N the Hood* represent them as either "whores" or "good girls," depictions that perpetuate negative stereotypes of earlier "race films" such as *Cabin in the Sky* and *Stormy Weather*.[21] Jacquie Jones adds to this:

> We, as Black women, have been accused of being too attainable (whores), as in *Jungle Fever*, being incapable of parenting, as in *Boyz N the Hood*, causing unmendable rifts between Black men, as in *New Jack City*, and in short, of destroying the Black community. A decade ago, the word "bitch" was generally used, when voiced, to punctuate an extremely heated argument, or as a last pleading effort to muddy an opponent. Today it is the word used to define our image in popular media.[22]

Transcendence

This principle marks the crossroads where mental and physical functions merge and the artist's vision crystallizes. It demonstrates the surpassing of the confines of what seems possible into the realm of the seemingly impossible. In the case of improvisers, many often anticipate that ecstatic moment when they will be completely absorbed by the music, which then takes on a life of its own. They experience the ability to express musical ideas that seem to surpass the limits of their own technical skills. At this stage, the music acts upon its creators and changes them. For most seasoned musicians, it is the moment they await and that makes the endeavor such a great joy. It inevitably has a profound effect not only on musicians themselves, but on the audience as well. This stage requires the total immersion and resignation of the ego and personal interests for the greater purpose of aesthetic and oftentimes spiritual transformation.

We can see the principle of transcendence expressed across the arts in that artists often recognize materials they work with to be mere conduits for a greater experience than simply the functional

making of art. They welcome the necessary humility, grace, and submission to the creative process that fully envelops and renews. When this happens, there is nothing that stands between the artist and "truth." For many, to be changed, uplifted, and transported are some of the unparalleled motivations that drive them. Transcendence from a here to a there becomes the reason for creating. It is how an artist meets the calling as an agent of higher knowing and understanding.

An early source of this value derives from an understanding of the spirit/body relationship found in West African Yoruba religion. As Robert Farris Thompson states, "To become possessed by the spirit of a Yoruba deity, which is a formal goal of the religion, is to. . . . capture numinous flowing force within one's body."[24] The arts of many African Americans are steeped in this metaphysical drive to override natural restrictions and affirm their relationship to a higher law and order. We see this transcendental phenomenon translated in the church, where "catching the spirit" refers to the experience of being anointed and possessed by God's Holy Spirit. All that is required is a desire to be used. In this case, it is often the rhythmic "call and response" pattern, established between the preacher's assertions and the congregation's affirmation that helps catapult transcendence. When someone catches the spirit and voices God's message, the congregation is spiritually available to discern that the call is in fact from God, and to respond to the message.

Musician James Brown is a popular example of how "call and response" acts as preparation for the transcendental experience. As the "caller," he testifies, freely voicing his message while relying on the response, or witness, and support of his band. His musical arrangements exemplify this structure, but his overall performance style models this theme as well. One of Brown's early trademarks was that he was often attended by someone who would wipe his brow and place a cape over his shoulders after a particularly energetic, soul-rendering performance. These gestures seem to affirm that as the caller, he could venture out quite far and still expect the supportive response of his band based on the fervor and truth of his message. Using call and response as his vehicle and working his band, his audience, and himself to a fevered pitch, he would let out a piercing cry, and everyone was well aware that at any point thereon, anything might happen.

There are other tools to promote the experience of transcendence. For example, visual artists often explore metaphysical energy through their work. For sculptor Bessie Harvey, who believes

that the found wood she uses in her sculptures has a spiritual presence and that she is a mouthpiece for spiritual messages, her intimate relationship with the wood is what gives her work force, carrying her far beyond the limits of those materials. In viewing her sculptures, one is struck by how much of the wood's intrinsic qualities are maintained. There are knots that look like human joints and natural bends and curves in branches and roots that become extrahuman entities leaning and reaching out. The conventional rules of woodworking seem to be intentionally discarded and her own effective and affective techniques and reasoning established, thereby helping the viewer forget the constraints of wood and take the leap of faith with her. Harvey explains:

> I believe that the whole thing is a gift from God to me because I've always felt like that the trees and nature . . . was just of God and that the trees praised God, and that seeing the faces in the limbs and the roots and all, I know that it's a gift, a spiritual gift because I can feel the presence of something there that I could communicate with. . . . He (God) reached out at my lowest point in life and He gave me what He had put within me where that I could see it, and so I know that it's a spiritual gift and I do enjoy it and it has changed my life completely.[25]

In dance, transcendence occurs, as Sandra Richards explains, "the moment when the performer goes beyond the rehearsed to an improvised or spontaneous testing of his/her earthboundness in order to explore the previously unexplored."[26] An example of this principle is found in the "shout," a traditional religious dance. Accompanied by music, the repetitive cry begins slowly and accelerates gradually, producing an intense state. As dancers fall to the ground, others replace them.[27] It is a vehicle for worship and communication with God, with its highest level reached when the Holy Spirit enters the bodies of the shouters and takes possession of their spirits. A nineteenth-century source describes the dance:

> The true "shout" takes place on Sundays or on "praise" nights through the week, and either in the praise-house or in some cabin in which a regular religious meeting has been held. Very likely more than half the population of the plantation is gathered together. . . . The benches are pushed back to the wall when the formal meeting is over, and old and young, men and women . . . all stand up in the middle of the floor, and when the

spiritual is struck up, begin first walking and by-and-by shuf-
fling around, one after the other, in a ring. The foot is hardly
taken from the floor, and the progression is mainly due to a
jerking, hitching motion, which agitates the entire shouter, and
soon brings out streams of perspiration.[28]

In summary, African American artists have made extraordinary
contributions to American culture, the impetus for creating rooted in
a wide range of social, political, economic, cultural, and spiritual
factors. Values deemed necessary for successful musical improvisa-
tion are also principles that have operated as conscious and subcon-
scious guidelines in the expression of creativity across arts disciplines.
Some of these include the interaction of cultural styles, artistic reac-
tions to sociopolitical conditions, concerns for forging and clarifying
identities, and the importance of using art as a medium to apprehend
higher truths.

Although three distinct categories have been considered here,
most of the selected examples may find expression across these
principles. Moreover, by no stretch of the imagination is improvis-
ing limited to these functions. As saxophonist John Coltrane con-
firms, "If you ask me [what I'm trying to do], I might say this today
and tomorrow say something entirely different, because there are
many things to do in music."[29] This attempt to organize artistic
development in some ways simplifies the complex nature of cre-
ativity but may be helpful as we attempt to understand the expe-
rience of African American artists who teach at TWIs. A factor that
has helped mold them includes a vast and profound world view
that comes alive through music, dance, and visual arts. Jazz impro-
visation principles such as interaction, definition, and transcendence,
which as aesthetic philosophies are brilliantly displayed through-
out African American art forms and arts movements, are also ex-
plored in the upcoming chapters by the twelve musicians, dancers,
and visual artists who bring some of these values to their teaching.

The Climate

Alois

We live in a society that does not support the arts, does not support Black people, does not support women. So I feel that *that* is the revolution. We have to be very aware of these things. And in spite of those things, what do we need to do so we can express ourselves, be free?

Interviewer

Well, I think it might be different for each of us. What are some of the ways that you see yourself moving towards those goals?

Sadik

Most people think that we were born into a philosophical view that Black is beautiful. That's not true. "A nigger ain't shit" is the first philosophical view I ever heard. And I'm diametrically opposed to that. But most people are very familiar with that, you know. And it's a philosophical view. That's the big battle.

Rufus

The trauma of slavery is something that I think we have to all encounter directly. Because until you really deal with the fact that our ancestors were shackled and put in chains and thrown in these ships and killed—many of them were killed, and those who survived were brought over here — lived for two hundred, two hundred fifty, three hundred years in the most brutal

form of slavery that existed, as far as we know, in human history. Unless we really confront that [pause]—

See, you have this underlying thing that you don't know why you're mad all the time because—See, we came up in the time in the twentieth century where by making these rules obsolete or everyone having access to certain stores and restaurants, or whatever, then that stuff went away. But the fact is that the traumas that were institutionally inherent in all the cultural and biological and physical genocide that went on to building the slave system have a deep impact generation after generation after generation, often times without people even being aware of it.

Because when you think about three, four, five, eight, ten generations, what's that got to do with me? When a lot of people don't even know their parents let alone their grandparents or their great-grandparents or great-great-great grandparents. So, I think a lot of that is all up in there.

Mariah

I have had it in my mind that there had to have been some real reason for us being here. That is, the history of Africans taken from Africa and brought here, and what that whole struggle was like, and what my ancestors had to go through for me to be sitting here today, talking on a tape, teaching and exhibiting, and whatever those things were that I've done in my lifetime.

Alois

Yeah, what they've experienced, what they've come through. Because that's the torch that we ultimately carry. We are living the effects of it, the results of it, the failures and the success of it. And then we have to take it to another level. How do I understand who I am if I don't understand what came before me?

The Navigators: Twelve Teachers

The twelve teachers presented here are each distinctive and diverse in their own right. They are trained as artists, teach at schools in the northeast region of the country, and are U.S. nationals who self-identify as African American. Aside from these commonalities, their backgrounds, interests, views, and dispositions offer tremendous contrast. There are six women and six men, four of which are musicians, five are dancers, and three are visual artists. There are variations in the types of institutions and departments where they teach, subject areas of expertise, kinds of academic contracts, and years of teaching experience. Their ages range from thirty-five to sixty-five, and levels of education from high school diplomas to doctoral degrees. Some of the geographic and national origins of their families include the southern and midwestern United States, Barbados, Panama, Jamaica, Grenada, the Virgin Islands, and Trinidad. Although each one is either presently active or has spent considerable time in the past as an arts practitioner, the nature and degree of their artistic involvement is markedly different. They are full-time, associate, and assistant professors, artists in residence, visiting lecturers, and adjunct faculty. Some lead a nomadic existence as teachers, moving from one school to another, according to the availability of work. Some have their contracts renewed on a regular basis. Others are tenured and have spent as many as thirty years at the same institution. These contrasts enrich their stories.

During the time we spent together, they talked about their families, home environments, and neighborhoods. They told me about the schools they attended, teachers who made an impact on their

lives, and memorable classmates. They explained how they became involved in particular social groups, political movements, religious organizations, and arts activities. They recounted those unforgettable moments when they first realized they were artists. We also talked about what it is like for them to teach at their schools. Many walked me through a "typical" day, speaking at length about exchanges with students, colleagues, and the administration. They described their expectations and goals as teachers. In their offices, homes, and studios, by telephone and letters, we met with the common purpose of generating a more comprehensive public appreciation for the nature and details of their teaching and the contexts from which they have evolved. They often peeled back layers of years and ruminated on memories, sorting out emotions and sometimes uncovering still-tender wounds. We conjured up the past, clarified the present, and speculated about the future. Generous in their thinking, feeling, and sharing, the teachers now come center-stage.

Because the upcoming chapters weave fairly extensive portions of their narratives with my own commentary, it is my hope that the following "miniprofiles" not only will provide a general sense of who the teachers are as personalities, but also will be helpful as a frame of reference to which the reader can return for some basic information about them. To solicit thoughtful, honest responses and enable them to speak uninhibitedly, uncensored and with a sense of safety, each of the teachers and the names of their schools, with the exception of one who chose not to be, is referred to by a pseudonym.

Mariah

Mariah is a visual artist in her late forties. Born in New Jersey, she and her brother were raised by their father and maternal grandmother after their mother died from cancer when Mariah was two years old. Mariah became interested in drawing at an early age and moved to New York City while in her twenties to attend an art institute. Soon after arriving there, Mariah moved into an artist cooperative building, where she still lives. Surrounded by energy, there are actors, dancers, musicians, writers, and painters who all ride the elevators and walk the halls of her building. Every corner of her two-story apartment is filled with charcoal drawings, paintings, and sculptures, ranging from figurative to more expressionistic styles. They document many prolific years of work. Mariah has received public recognition for her art in the form of major gallery

exhibitions, public and private commissions, and foundation support. She has been a resident artist at various colleges but spoke about her most recent teaching at an art institute in New York City, where she states that about 80 percent of her students are White, 10 percent are Asian, and the remaining 10 percent are Hispanic and Black. Mariah has a warm manner and subtle but engaging sense of humor. Because of her busy schedule, we talked intensely over the course of one full afternoon. Moving from her living room to her kitchen, our exchange progressively opened up.

Jerry

Jerry is a fifty-year-old musician, born and raised in a small town in Florida. One of seven children, he grew up in a strict home and was involved almost exclusively in church activities during his adolescent years. His family were members of the Pentecostal denomination during the inception of the Black Pentecostal movement at the turn of the century. Most of his early performing was for church services, where he and his brother developed a music ministry and made several recordings. Raised in an economically poor community, Jerry's mother completed sixth grade and "literally lived for her children and for the church." His father, who was a preacher, had a ninth-grade education. Coming of age in a spiritually rich environment, Jerry's educational aspirations were welcomed and supported by his family. Although he no longer performs as often as he used to, he conducts a vocal ensemble at his school, and his strong performance values emanate through his teaching. A music scholar and full-time, tenured professor, his teaching load includes vocal music courses, historical surveys, and private lessons. Jerry's manner is formal, and his statements articulate and precise. Dramatic and emphatic, his diction and gestures reveal his many years of speaking and performing in public venues.

Winston

Winston, a forty-seven-year-old dancer born in Jamaica, came to the United States in his early twenties. He grew up in a strict home where he was raised by his mother, aunts, and grandmother. His interest in dance was sparked one day on his way to school, as he recalls, "I peeked through the hedge, and I saw all these people, mostly girls, dressed in all this black and walking through the gates

with these little soft shoes in their hands. . . . And I would see them dancing and hearing this piano music. . . . It was the *Fire Dance* they were dancing. And they were pretending to be the fire. And I was just absolutely blown away. I'd never seen anything like that before." Winston has a meticulous, contained posture and explains that he has worked hard to overcome certain emotional constraints placed on him at an early age. Although he has lived in the United States for nearly thirty years, he still calls Jamaica "home," the cadence in his voice is unmistakably Caribbean, and he lives in a bustling, predominantly West Indian, working-class neighborhood. His home is full of new paintings he has done, all at various stages of completion. Self-taught, Winston talks about his recent involvement in the visual arts in a warm and personal way. They seem to be the soul connection between his "work" as a dancer/teacher and his "play" as an inquisitive, vital human being. Winston has a master's degree in dance and is a part-time faculty member at a school in New York City. His statements reflect the careful thought he has given to issues regarding dance and holistic development.

Alois

A thirty-nine-year-old dancer, Alois has lived in New York City for over twenty years. She speaks openly about an estranged relationship with her parents, painful adolescent memories, the confusion of early sexual encounters, and the challenges of becoming a mother at the age of fourteen. Relying on dance as a source of refuge and healing, she says, "My life and my safety net has been through movement and music." Alois's grandfather moved from Panama to Long Island where he built cement houses and helped develop a town where African American domestic workers could buy homes and commute to their jobs. One of the streets in the town is named after him. Alois has incorporated her dance company, which she directs with great vision and just as much energy. She has an M.F.A. degree and commutes once a week to a school in New England, where she teaches dance through the African American Studies Department. Virtually all of her students are White, from middle- to upper-income backgrounds. Her teaching focuses on a wide range of African, African American, and African Caribbean dance styles, which reflects the range in her own performance interests. Over the past ten years or so, Alois and I have crossed paths as teachers and performers but never actually had an opportunity to explore in depth any of the ideas that came forward during the interviews.

Alois speaks quickly. Probably more than any other teacher I spoke with, she offered many intimate, emotionally charged stories. From time to time, I wondered if she remembered that her words would be made public. I would interject the reminder, and she continued to talk.

Rufus

Rufus, a forty-year-old musician, was born in Washington D.C. and raised in New York, where he has spent most of his adult life. His father, a minister in the African Methodist Episcopal Zion Church, was college educated and a graduate of Union Seminary, while his mother earned a master's degree and taught special education. Rufus's music studies began in the fourth grade on the alto saxophone. His home is full of different types of instruments and recordings, and he showed me a number of press reviews and publicity materials that confirmed what I suspected by the general direction of our conversations, which is that he identifies first and foremost as a musician. Rufus is married, with two young children. His teaching focuses on African American music in the context of other world musics. He places many of his stories in social contexts, and his words and tone of voice grope to make sense of the stresses and challenges of being an active, committed jazz musician in the academy. True to his station as an improviser, he will take a thought and present me with almost unlimited variations on the theme. Rufus fluctuates between guarded responses about his personal life and pointed, emphatic assertions about the richness of African American culture.

Petra

Petra is thirty-seven years old and was born in Alabama. She is a third-generation teacher on her mother's side of the family and was trained as a dancer from an early age. After moving to New York, her mother received a doctoral degree while Petra was still very young. Many of her teachers, whom Petra describes as "bohemian, avant garde kinds of people" came out of the progressive era of modern dance. During her early public school education, she was one of the only African American students in a predominantly upper-middle-class Jewish school. She speaks of her education as having afforded her the benefit of "a sensibility that comes through privilege to experiment and to open your mind." Petra identifies her teaching as a "calling" and expresses a strong commitment to guid-

ing her students' creativity. She began her current teaching at a small teacher training college four years ago, but prior to this she served for ten years as a faculty member in the African American Studies Department at a larger school. Petra speaks confidently and carefully. She is a philosopher and rarely answers a question without first understanding why I have asked it. Her lengthy and centered responses are packed with wisdom, and her deliberate choice of words suggests her strength as a self-reflective and critical thinker.

Cindy

A forty-one-year-old composer and flutist, Cindy is from Tennessee. An only child, she was encouraged to pursue her education and her desire to play music. She and her parents lived in the back of a grocery store that they owned and operated. Starting flute lessons in the fourth grade, she played in the school orchestra. Cindy later received a scholarship to an independent boarding school in Vermont and continued her music studies there. During college, she traveled throughout Africa as an exchange student, performing with a band comprised of African and African American musicians. She later married the saxophone player. Cindy has a doctorate in music and teaches at a small, young, progressive college. Through her teaching, she stresses the need for students to experience many types of music and to develop skills and approaches that will help them in their ability to improvise. Cindy is a lean, conservatively dressed woman with a soft-spoken, polite, and almost shy demeanor. Her ideas are often stated hesitantly, her thoughts restructured midsentence, as though perhaps she does not like the sound of her answer. Modest, careful, and delicate, Cindy's emotions seem contained and are parceled out sparingly.

Paige

A sculptor in his early sixties, Paige is from a small town in Georgia and a family of eleven children. His parents encouraged his desire to be an artist. Paige was as an architectural designer early in his career and then established his own advertising agency. Strong-willed and highly motivated, he refers to his role at the college where he works in the following way: "We have three major Blacks, and one of them is assistant to the president of the college. The other one is the director of visual and performing arts. And the other one is an artist in residence. And all three of those are me."

Many of his sculpture projects are on-cite installations that give voice to his concerns about both human suffering and dignity. Paige has a large presence and an assertive and passionate disposition. He is generous with his stories. He occasionally prefaces his accounts by saying that he is not sure where his remarks are leading. But these humble admissions have a confident ring to them. He trusts himself, follows his hunches, and inevitably comes to rest at insightful and poetic points.

Clarissa

A fifty-three-year-old dancer, Clarissa was born in Harlem and raised in the Bronx in New York City. Her father, a restaurant owner, had an eighth-grade education, and her mother, who graduated from a college in Georgia, played the piano. Clarissa's early interest in music was supported by her family, who stressed that "education is the tool for upward mobility." She attended a junior high preparatory school, with the aid of a scholarship, where most of her classmates were White. Clarissa married a doctor after her first year at a historically Black college and has raised four children. As an older student, she pursued an earlier interest in African Caribbean dance, an area that has received her full scholastic attention. Clarissa has a Ph.D. and is a tenure-track professor at a small liberal arts college. Her classes are always full and in demand, and her teaching style is sensitive but firm. She has a very youthful, poised presence, and she dresses in vibrant colors and flowing garments. She spoke at great length about her social isolation as an African American faculty member.

Sadik

In his mid fifties, Sadik is a painter who teaches art at a school in Massachusetts. Born and raised in New York City, he remembers being interested in art from as early as the first grade, when he and a friend would draw on the street and then "go in the building and go on the dumb waiter system and look down" to see what they had drawn. Sadik's grandmother, who spoke with equal reverence about "Marcus Garvey, Joe Louis, and Jesus Christ," was from the Virgin Islands. She encouraged his talents by saying, "If you don't use it, it'll evaporate on you. And if you use it incorrectly the same thing will happen too." Sadik credits his membership in an arts collective that flourished during the Black power era of the sixties

with having shaped his aesthetic and political values about his social responsibilities as an African American artist. His painting style is distinctive, colorful, and often portrays images of prominent African American figures. He has been teaching at the same school for over twenty years and speaks about the importance of making students aware of the history of African American visual arts. Sadik owns a home in an African American neighborhood that is a fairly good distance from his school. He dresses with a flair. His manner is casual but intense, and the rhythmic inflection of his voice delivers responses in a curt, matter-of-fact way reminiscent of the progressive poets of the sixties.

Nduma

Saxophonist and composer Nduma is in his midsixties and was born and raised in a small, tightly knit African American community in Texas. His family and the teachers from his schools all attended the same church, which enabled parents to stay informed about their children's education. Nduma's early passion for music was supported at home and in the classroom, and he quickly moved through grade school and high school, graduating from college and taking his first college teaching position at the age of nineteen. He is a tenured professor of music and the director of a major arts center at his school. A high-profile, high-level administrator with a great deal of political clout, he explains that no matter how busy his administrative duties have kept him, he has intentionally carved out time to teach. His values in the classroom are rooted in the care and nurturing he acknowledges as necessary for student growth. Nduma has a formal but inviting manner that welcomes discourse. He expresses high ethical standards and speaks gently but self-assuredly about philosophical and pragmatic issues of race and culture affecting this society and this generation.

Patti

Patti, age forty-four at the time of the interview, was born and raised in New York City. An only child, both of Patti's parents supported her desire to dance and were both, at earlier points in their lives, involved in the arts. Patti received formal dance training in the Martha Graham technique and integrated modern movement with thematic material that draws on African American sociopolitical issues. She received a MFA degree from an Ivy League school in

New England, and her most recent teaching was at a college that offered her a two-year visiting lecturer position. Battling breast cancer, she took a leave of absence after a year and a half and underwent surgery but quickly returned to complete her half-year of teaching. A dedicated and caring teacher, her words and emotions reflect complex self perceptions of her role in the classroom. She viewed herself as a source of creative nurturing for her students, who were almost all White, but also articulated an intense, uncompromised commitment to the struggles of African American communities. Unshakable, courageous, and outspoken, Patti died during the writing of this book. For her, it was inconceivable that I could write about her and not disclose her identity, connecting her to the people, places, and things she shared with me. Patti O'Neal Robertson insisted that her real name be used.

CHAPTER 3

To Be Free and to Fly: Artistic Influences

There are many experiences that have marked teachers' lives, helping to form their knowledge and influence those values they assume in their teaching. This chapter examines the roles that families, teachers, role models, and arts organizations have played in the formative stages of these particular teachers' growth as artists. Their creative development resulted from lessons stressing values such as the social and personal significance of the arts; the importance of envisioning the world from uncommon perspectives; the usefulness of certain creative attributes, the sense of personal gratification that results from creating art; and the fact that the art world is directly affected by racial discrimination. It shows cross-fertilization of ideas generating from elders, siblings, mentors, and colleagues and illustrates the range and depth of knowledge made available to the teachers in their formative, impressionable years. In varying and composite ways, these experiences have molded, guided, and fueled their desires to become artists, providing them with technical and emotional ammunition to pursue their visions.

Families

The teachers' families represent a wide range of structures, ethnicities, and economic classes. For most of them, artistic interests were supported in some way by their families, though the nature of that support varied greatly. Some experienced direct nurturing by

39

parents and family members. Others were raised by parents who were creative in their outlooks or simply had family members who valued aesthetic development.

Paige, who is from a large family, was given a violin at the age of six by his mother. She used to tell him stories about great artists and overseas voyages, which as a young child intrigued him. Her vision and memory seemed to crystallize through tales of grand people and places Paige then knew nothing about. He recalled how his parents met, and talked about his mother's stories:

> My father told me. He said, "You know when I met your mother I met her on a ship. I was working on an oceanliner and your mother, just this cute little black thing was working there too, traveling around. And from the time she was twelve years old until the time I married her she was a traveling mate for rich White folks. She lived in London, in France, in New York." He says, "When she came to visit me I said, 'What do you want to do?' She said, 'I want to go to the Met.'. . . She says, 'I used to go to the Met and I used to go to the theater and I used to go—' She started naming all of these people."
>
> That's where the violin came from. That's where all the newspaper clippings out of magazines came from. . . . [Stories about] all the artists that went to Europe because they couldn't do something here came from her. It was like subliminal seduction my whole life, and I never knew that it happened. . . . She planted it in my food. She planted it in my thought, in my sleep. She told me the same kind of stories when I went to bed. She made me believe that a Black person could be an artist.

Like Paige, Mariah lived in a low-income section of her town. Her Aunt Cecelia, "an avid reader," would get books from the library, read to Mariah and her brother, and encouraged them to dream. Also similar to Paige, Mariah developed an interest in the world outside her town from the stories her aunt read to her. Her earliest exposure to the arts came from her father, who had a sixth-grade education and loved to read biographies. "He was always talking about either Billie Holiday or he was playing opera, so we grew up hearing all kinds of music." However, it was Mariah's brother who sparked her desire to create visual art when she was seven years old:

> My brother used to always draw this man's head, the same thing all the time. The same man's head. I loved it. Everything

to me that he did was wonderful. . . . I used to go to him and say, "Michael, draw that man's head." And he would say, "Okay, okay." He'd always act like "Maybe. All right, all right." He would draw this same head. I just wanted to watch him. It was so great! And you know what? One day I went and asked him to do that, and he said, "No." He said he would not draw that head, and if I wanted to see it I'd have to draw it myself. And I said, "I can't!" I said, "*You* draw it." He refused to do it.

So I had to do it myself, and I did. I made this drawing. And it did not look like his, but it was an incredible thing. It was the moment that I realized [pause], I realized what a joy it was to create. Just to make it. Whatever it looked like, I just loved the act of creating. It was just absolutely wonderful. And I realized then that I could feel really good making things, drawing, and just sort of become a part of it. . . . It was sort of like losing track of time. That was the thing. It was realizing that this had happened and that I wasn't totally conscious. . . . [I]t was a feeling like I could do no wrong. Just moving things, changing things, moving things, following it, and lo and behold, there was something on this paper. Nothing had affected me in that way before. And so I didn't say I was an artist. I didn't even say I loved doing it. I just kept doing it. I did it as much as I could. And my family loved it. Everything I drew they thought was wonderful. It was absolutely wonderful.

Like Mariah, Winston's introduction to creating art was an exhilarating experience. He was able to finally connect parts of himself that had previously felt very disconnected, which gave him a feeling of tremendous freedom. However, that experience held high contrast to what he explained was an emotionally trying home environment, where he was "continually under some kind of lash." Winston believes that "when you grow up under certain rigid conditions, and when you find an avenue that allows you to be free and to fly, you're going to gravitate towards it."

Alois's relationship with her parents was also strained. Placed in dance classes at an early age, she learned that there was a correlation between her motivation level and her parents' support of her dancing:

We always had to work for anything we got. We were always encouraged to go into the arts. It was like after they pay for your first two classes, if you wanted to go on that meant you

had to work to pay for it. . . . You had to take responsibility for it. I wanted to drive. They weren't keen on it, and they saw I was going to do it anyway. [My father] handed me a book on the engine: "You learn this book. You learn what to do with a car; then you can drive a car."

Her family showed their support by emphasizing the importance of a strong work ethic. Others encouraged creativity in other ways. Patti's parents, for example, were attentive audience members at her backyard performances, where she would imaginatively transform a garden rake and other immediately available objects into stage props, creating impromptu songs and dances. Sadik's grandmother opened his eyes to the wonder of subtle color gradations as they watched the sunset from her window. He says, "I learned that it wasn't just purple. It was lavender." Petra explained about the importance "naming stories" have had in her family and the value she places on certain accounts relayed to her by her mother:

> I was raised with stories of how I presented myself as a dancer when I was a toddler, a small child. My mother tells a story about this . . . movie strip of me when I was eighteen months old at this May Day celebration in Tuskegee where we lived. There was a group of people doing this circle dance, and the movie strip has me . . . going into the center of the circle and dancing for all these adults. That's my mother's naming story for how it was clear to her from that moment on [laughs] who I was to be.

Her mother's account acquires fuller value in the context of another fascinating and humorous story:

> In my mother's family, there were ten children. My mother's family's name is Sanders. And my mother's oldest brother's name was Christopher Columbus Sanders, and he was a mathematician and scientist. And my mother's older sister's name was Florence Nightingale Sanders, and she was a nurse. And my mother's next oldest brother's name was Ralph Mendelssohn Sanders, and he was a composer and a musician. And then my mother had a brother, a younger brother, who's name is Albert Einstein Sanders. He's a humanist [laughs] and kind of a philosopher. And then the rest of them had names, but they were regular names, but they were big names too. They were named

after someone, or they were made up names that were outrageous, you know. And I remember always being conscious of these big names when I was little, and not just the big names, but Ralph Mendelssohn Sanders, how did he become a musician?

There's this relationship between your name and your becoming that. . . . That was a very real thing in my mother's family that you really become that character, you take it on. . . . To me it's very much the same as my mother's story about my dancing and how she kind of named me as a dancer from that little May dance in Tuskegee [laughs]. I relate to it the same way. And it's just an incredible mystery to me. I feel bathed and loved by it. That whole thing of name-sake is a very powerful form of discipline. It's kind of self-navigated [laughs]. You had something to live up to, something to measure up to. . . . Something that you really [pause] internalized most of the time.

Arts Teachers

School teachers were influential in a number of ways. They provided some of the first connections between the early attraction these artists had to their respective art forms and public validation of their dreams. When Paige was sixteen, his teacher helped him come to some realizations:

Miss Rangewood would take magazines and show me and say, "Everything you touch, everything you see, an artist plays a part in making it real." And I went, "How?" [She said], "Well, this radio, an artist designed the case that it went in. That car, an artist designed the outside of it. Clothes you wear, an artist designed that. Artists can make a lot of money. Artists make the world go." And then she talked to me about Roosevelt and the WPA. Nobody ever talked about that kind of stuff before.

Alois's dance teachers' roles differed at various stages of her life. One whom she recalled with great admiration exemplified strength and courage. She taught throughout the duration of a terminal illness and gave Alois, who soon became her student teacher at the age of twelve, the opportunity to develop leadership skills:

She chose to die of cancer as opposed to doing radiation. . . . [T]he radiation was going to get her so weak that she would

not be able to have the patience with kids to teach. As she got weaker physically and couldn't demonstrate, I was a demonstrator. . . . And so I would be up on the box, and I remember she would be in this lawn chair. . . . [S]he would just talk the class, and I would do everything. She got sicker and sicker, and I learned more and more about being that leader. In essence, it was leadership training. . . . I don't even remember what year it was when she did her last concert. And she basically did it from that lawn chair back stage. She died three weeks later, and I went to the funeral. She made a decision, and she lived it through.

However, Patti felt that she often did not receive the care and encouragement she should have from teachers. The tremendous stress on discipline and "old school" techniques dominated her early dance training: "I used to go to this ballet class, and there was this Russian teacher with a stick, hitting you and hitting the floor, yelling and screaming and carrying on. I never liked that way of teaching, but that's all the teachers I ever had. And I said to myself, 'If I ever become a teacher, I will never ever treat a student the way that I've been treated by these people.' "

Many of the artists spoke about overt and subtle forms of prejudice communicated through the curriculum and attitudes of their early teachers. As young students, they were, for the most part, not prepared and certainly not supported by their schools to dispute the authority of those experiences. Mariah told a story about a teacher at the art institute she attended after high school:

I can remember incidents where it was [pause] mindlessness I guess, in terms of the teacher being unconscious of some of the things she was saying. For instance, once she said, "You can tell how cultivated a people are by the colors that they wear. People who are highly developed wear tans and browns and black and subtle colors. And people who are uncivilized [laughs] wear bright colors. And I'm sitting in the room, I think in something bright. And everybody looks. In fact I'm the only Black person in this history class. And everybody looks around.

Although this teacher is accountable for her remarks, Mariah seems to attribute these remarks to ignorance and neglect rather than a malicious intent. However, this reasoning makes it no less of a potent memory for her. She described other incidents:

We often had Black models, and there was one Black man who modeled for us. And the only way they could see him was as a sort of native-in-the-jungle kind of costume. Actually, he was a dancer, and he was getting up in years. But he had this very wiry body, very sinewy physique from being a dancer. He was still in good shape even though he was an older man. And the teacher really liked that, so I guess in her mind she was showing off his physique by having him always pose as if he was throwing a spear. And then what we had to do was build a story around whatever this pose was. This is part of an illustration class.

Another incident in my painting class. . . . This woman was a Cuban woman. . . . So she's looking at me, and she's looking at my painting. And she said, "Oh, you could have such a future in the art world. But you know, they're not going to pay any attention to you. I don't know, maybe you should put a bone in your nose and put on a leopard costume and, and then see what would happen. I bet they would pay some attention."

Now, it was so strange to me that she would say this. These are the years when I was really very shy and quiet. . . . And I think in her mind she thought she was giving me some advice that was being helpful. First of all it was saying that she was conscious of how racist the art world was. And also she was conscious of the fact that it would take some kind of gimmick. But I just found it bizarre [pause] and it sounded racist to me, too.

Sadik remembers an art class he took during college and a tough but pivotal conversation with his professor who introduced the class to the works of eighteenth-century African American artist Joshua Johnson. Sadik recalls:

The professor was showing the slides, and I raised my hand and said, "You know, this guy's a Black man." And the professor said, "So?" I said, "Well, I think it's important that he's a Black person because he—" He said, "No, this is not important that he's a Black person. What is important is that the work is good." I said, "Yeah, the work is good. I wouldn't disagree with that."

But the fact is that I found out that [Joshua Johnson] worked for this White man in Baltimore. Had a pass to go out on weekends and had to be back every night with the money that he

earned going around taking these paintings. He'd take paint-
ings in a push cart and he had the bodies all [painted]. And
he'd go up to this middle-class house, and he'd try to find out
if they wanted their portrait. And if they wanted their portrait
and there was a mother and two daughters, he'd get the [paint-
ing] that had the frame, the clothing in the background of a
mother and two daughters, and he'd paint the faces in for the
mother and two daughters. And that was the traditional way of
doing it back then. And then [he would] turn over 90 percent
of the money to this White man who had four other slaves.

[I said], "I think that's very important that this Black man
did that." He said, "No, that's not important at all." I said, "Well,
I'm trying to show that there's Black art, and you're saying that
that's not important." He said, "No, that's not important. What
are you trying to show, (sarcastically) that there's a particular
brush stroke that a Black person—?" I said, "No, that's not what
I'm trying to show at all. But it *is* important out of what circum-
stances a person is doing what kinds of [art]." He said, "That's
Marxism!" Well, I said, "Okay, call me a Marxist."

Role Models

Added to arts teachers and family members were other role models
who contributed to these artists' creative growth. Some of them had
achieved stature in their fields. Some had overcome limitations and
proved that pursuing personal dreams and goals was well worth
the effort. There were also some people who affected the teachers'
creativity in more general ways, expressing and modeling prin-
ciples that later would be valuable to their own art making and
teaching.

With reverence, Nduma remembers his grandfather who per-
sonified wisdom and demonstrated that formal education was not
a criterion for intelligence:

My grandfather [inspired me] actually, in the sense that he was
an illiterate man. . . . Couldn't write or read. . . . He's one of the
smartest people I think I can remember in my life, because he
knew how to do everything. Here was a man who hadn't learned
to read. But you're talking about not too far from slavery. Sla-
very supposedly ended in 1863, but there's a lingering thing.
So, how did he know to do all these things? And [he had] a
remarkable intelligence. He could make bricks; he could lay

concrete. When we needed shoes repaired, . . . in those days you couldn't buy a lot of shoes so we'd get to the five and dime. They sold a kit to fix your shoes. He could do that, repair shoes. He could do anything. [pause] . . . I guess I've become animated in talking about him because if you even picked up a broom and started sweeping, he would tell you that you should sweep this way, but then turn it around because he noticed that a broom wore at a certain edge. When you keep going the same way, it wouldn't wear evenly. Who thinks of things like that? Who wants to be bothered with it? . . . He cut my hair. He could do anything! . . .

I remember things that he said and things that he did. The guy's wisdom. I don't understand it really. He didn't get it from reading. It's a question of the powers of observation, I believe. . . . I remember things that he said. . . . [C]onsumer advice. He would never use such a word as I think about it now, but he would say, "You realize that you're usually better off buying a new automobile than a used one because you don't know who used it." I mean, it wasn't a question of how much money it was [laughs]. And he was right. People were getting these lemons and everything. And he said, "You'll end up probably spending more money on repairs." Things like that. His words of wisdom. And I remember my cousin who was about twelve years old then didn't pay him any attention and ended up with one of the lemons [laughs].

So, I mean just full of wisdom. Full of wisdom. Very imaginative. One of the most imaginative, creative —I'll just say simply intelligent, because that's the best word I can think of for him because he could do so many things. And it seems to me paradoxical, I guess, to talk about one of the most intelligent people I ever knew couldn't read or write. But it's the truth.

Nduma's equating imagination, wisdom, and intelligence is particularly profound in that the qualities demonstrated by his grandfather were the same values Nduma would later hold dear to him as a music teacher. Some of his early teachers were role models also. The ones he remembered most vividly were ones with eccentric characters, exemplifying the individuality he insists is at the core of artistic vision, as did one particular elementary school teacher:

He had ideas that were seemingly nontraditional. He would get up and although his subject was geography, I think, or civics

or something like that, he would get up in front of the class and talk about, "Well, you realize people do exactly the wrong thing in terms of showering. In the winter they get up and take a warm shower." He said we should take a cold shower and go out, and our pores won't be open. He sort of radicalized ideas. Nobody thought that way. Things like that sort of stuck with me though. And I think it's that kind of thing that the unusual just stayed with me. Ordinary teachers did not last. I don't have the impression, the lingering impression that I do of these who had something, seemingly, which was contrary to convention.

Nduma recalled another unusual teacher:

[His] name was Melvin B. Tolson. A very eccentric man [laughs]. Tolson had an impish quality about him. He was an English professor there at the college. And [at] one time he had only a bachelor's degree. . . . He made an impression on me because he was one of those brilliant, brilliant orators. That's an art in itself, a great art. . . . [H]e was in great demand to make speeches, all sorts of assemblages all over the place because [of] his power of the word. He would make us feel that we were the greatest thing in the world. You go to one of his assemblies, and he'd go on. He was a poet laureate to Liberia for instance. So I was fascinated by him.

Now, he was an English teacher, and he taught *Beowulf*, which I wasn't particularly fascinated with at all. And in his classes he'd talk a little bit about *Beowulf*, but most of the time, as I can recall, was spent on spelling and grammar [laughs]. . . . And *Beowulf*, . . . he really didn't dwell on *Beowulf* [laughs]. I didn't find *Beowulf* particularly interesting, and I don't know that he did. . . . And his vocabulary we all wanted. He said, "Well, I memorized the dictionary." He knew what the root stems meant, so any word that would come up he'd go back to the Latin and get its root or the Greek and so forth. . . . And he had these big unabridged dictionaries on his desk. . . . A very deep man, very profound. It's fascinating when you think about the inspiration that I was privileged to. And so I was in awe of him, not as a teacher but as a character.

During college, Cindy's flute teacher made an impression on her. In her eyes, this teacher seemed able to strike a balance between professional aspirations as a musician and her self-perception

as a woman. The simplicity of the event but force of its impact rendered it an invaluable lesson for Cindy who sought to identify with women pursuing their artistic dreams:

> She . . . wore very red lipstick and she never took it off to play the flute. And I thought, "Wow, she's not afraid to wear her red lipstick and get it all over the flute" [laughs]. And she was a very good player. I like that. Yeah, that struck me at a very young age. . . . She was really a fantastic player and she played with her lipstick on [laughs]. . . . [I]t was encouraging to have that kind of a role model. Women were doing things, and they were doing it the way they wanted to do it.

Not only did role models offer the wisdom of their ethical standards, behavior, and advice, but as in Cindy's case, something as seemingly insignificant as her teacher's physical appearance was to become a marked, symbolic memory for her. This was also the case for Alois, who as a teenager during the 1960s, would find a relatively small number of highly public African American women with whom she could identify. One such event tangentially relates to an emotionally charged topic during that period, which was the issue of standards of beauty and henceforth social acceptance within and from outside the Black community. In Alois' recollection, she was first drawn to this role model and bonded by a common symbol of pride, which was natural, chemically untreated hair. From then on, Alois was ready to receive her instructions, as she recalls:

> [F]or me as a kid, Odetta was one of the most beautiful ladies in the world because she had this "natural." I used to look at her picture. And I prayed for the day so I could have my hair natural. Because pressing hair, and the permanents—at that time they didn't have different strengths, [they] would burn my head. I hated that stuff on my hair.
> Odetta was working at the Cookery. I just knew there'd be crowds of people in her dressing room. And I went there, and she was there. And I went downstairs to go to the bathroom, and her dressing room was open and she was just sitting in there by herself. And I just wandered in like [laughs] a stray cat. And she just knew. She just knew. And what she sent me off with was, "There's no formulas, young blood. There are no formulas. You make your way." . . . That's what people would

do sometimes, just say little things like that. . . . So, that's how I started living my life. There's no formula. I just make my way.

Coming of age as a dancer, the influence of veteran musicians continued for Alois in more intimate and artistically instructive ways. During the 1970s, there existed a great deal of interest among African American artists in interdisciplinary projects that sought to merge the arts in new ways. In particular, there was a tremendous focus on creating collaborative works that were improvisational in nature and that explored untraditional structures. Through the constructive criticism and advice of musicians with whom Alois worked, she began to shape her conceptual approach to dance improvisation:

> I learn about dance movement in a studio, but the philosophy of art . . . I've learned from musicians. Like being on the stage with Max [Roach] and doing a step and him stopping a fifty-piece chorus, his band, everybody, and saying to me, "Why did you do this movement?" And me turning around saying, "I don't know." And he saying, "If you don't know why you're doing the movement, don't do nothing!" And once again it's one of them life long lessons you take back and you lay with. Very few dancers have had that kind of guidance. . . . Somebody to talk about how to construct a solo.

Another prominent musician became a role model for Rufus. His teenage memory of a personal encounter with Duke Ellington looms larger than life. Meeting this musical giant inspired Rufus to pursue his interests in jazz and in performing in the church, which when he was growing up, were viewed as incompatible aspirations:

> The first time I really got into jazz was when my father was involved in putting on the . . . premier of [Duke Ellington's] second sacred concert at church. . . . That was 1967. . . . I had heard about Duke Ellington, but I didn't really know what he was really about. . . . It was really this unbelievable experience because I mean I'm sitting there in church, and here's Duke Ellington and his band playing his music. . . .
> So, then my father took me back on the break and said, "Duke, I want you to meet my son." And he had on this purple paisley kind of set. You know, Duke, when he would wear those tuxedo smoking jacket type things, that shiny stuff. He

had one of them on, and he was switching from the purple one to the red one for the second set. And, I mean, to me this guy was literally about twelve feet tall. . . . And he just said, "Hello, son." He was so nice and friendly. I don't remember what he said, but I remember he said, "Hello" and "How are you?" and "Do you like music?" or something like that. It was an unbelievable experience. And it took several years for me to start really being able to focus to know I wanted to get into music because it was viable as a life then.

. . . I got something directly from Duke Ellington that affected my whole life. . . . [A]nd it's funny because, for instance, since September I've played several gigs in churches. . . . I played "Come Sunday" and a couple of other Duke tunes. . . . I think it really made me learn how it translates into teaching. You never know how one little thing that you're doing that's maybe totally insignificant but at that second that might have absolute impact on a person's life, and especially a young person. I've had situations where people will come up to me, and I'm tired and I'm stressed out or whatever. I just don't have the energy to talk. But I always try and pull back to that, especially if it's a young person. Hey, I may be shaping or having some positive effect on the next major figure in the music.

Arts Groups

Formal arts organizations have nurtured the talents of many artists. For example, in the 1960s there was a flourishing of collectives, established to support African American aesthetic explorations. During this period of social and political regeneration, these organizations met the need for artistic self-realization and self-sufficiency. They served as "think tanks" as well as places of refuge where many artists received the emotional safety necessary for the evolution of their work. The search to articulate a Black aesthetic as a step toward greater autonomy became a common theme for many of these organizations. Sadik described his involvement in one such group as having shaped values that would later also inform his teaching, recognizing it as a turning point in his overall growth. They met every other Sunday for about eight hours. Members brought their art, but what is more important, they struggled with thematic and sociopolitical issues that were central to the discussion of the work itself:

For example, we decided we were going to work on the Black family: What was the Black family about? What was the value of the land to Black people? What kind of paintings did we produce that dealt with that?

. . . [W]e would bring our work to the meeting. If somebody didn't do a piece of work, they couldn't participate in the critique. And the critique was basically: How do you make what you're doing more successful? It was the first time I'd ever had the input of peers telling me what it was that I was doing and how it was that this piece was coming on. And the rules of the game were that you could talk about the piece, but you couldn't talk about the person. . . . You can't mention me. [You could say,] "The large left-hand section with all of this red doesn't seem to fuse with the bottom part where all these green[s] and blues are. And there could be a better modulation of color through here to there." So, when you got out of the meeting you had four or five different solutions.

The other thing we did was invite other people who were in the areas of culture to the critiques . . . so we would get some kind of cross-fertilization of the arts—Somebody was coming from the music area telling us what was happening in music. . . . Don L. Lee came a couple of times. He was writing poetry. He's a trained poet, but what he was doing during the days was going up in the projects and recording people's voices, people's stories and then coming back and writing in those kinds of rhythms. And then he'd come to a meeting, and he'd give us poems that were out of that kind of rhyme that was happening then. I thought that was fascinating.

But we were doing the same things. . . . We had an exhibit at the Studio Museum in 1970. We gave people ballots when they came in, and we asked if they could afford the images there, which one did they prefer most? So, when we got out we knew the most popular image of each person in the group through ballots, and we went back and made silk-screen prints that sold for ten dollars, . . . which is revolutionary for art because in art you're not supposed to care what other people think. Well you *are* supposed to care what other people think. Because you're an artist it doesn't mean you can produce anything you want to. Well, you *can*. It does mean that if you don't care about it being received. If you care about moving people along on some level, then it becomes crucially important that you're not producing an art that only addresses your own aes-

thetic needs, your ego. . . . We'd have exhibits in barber shops, beauty parlors. The prints that we made, we'd exhibit them everywhere. But it wasn't about the museum. It wasn't about the fine art. It was about an art that you'd get brothers and sisters to respond to.

It was [pause] *stimulating* is too small a word. [pause] See, as a visual artist, I'm trying to make a picture that the community is going to respond to. Now, I've got to know as much about that community as possible in order to have them to respond to my work and to meet them on the level that I want them to receive it.

. . . So, you start to get through these things, and you start reading. Particularly during that time, . . . Karenga was talking about art, DuBois' thing was on art, Ellison's thing was on art. Bring them all to meetings and just try to immerse yourself. So, you become teacher and student, and you're learning, and you're teaching and becoming more aware of a lot of things at the same time.

This particular collective challenged many of the definitions and parameters that occupied much of the thinking of the art world during that period. They crossed artistic boundaries, seeking out new formats and ideological points of collaboration and exploration by questioning social and economic issues regarding the role of artists in their communities, the function of critical response among colleagues, and the use of other art forms and scholarship to invigorate their work.

Mariah speaks with similar enthusiasm about a group to which she belonged. Soon after her arrival in New York City, she became a member of a small collective of African American visual artists, actors, and writers established in her apartment building during the early 1970s. This was a new experience in that her previous contacts had been primarily with White artists and had been more formal associations through school:

[I]t was a very political cultural organization, which was good, and I was really committed to it. . . . [T]he direction was a really positive one. We felt that we could use our art to help make the whole world for Blacks a whole lot better. . . . It [pause], it gave me hope, really. It strengthened me, and it put me in touch with a lot of people who had like visions. . . . [T]hey had plans. They were working at their art. They were coming up

with ideas that were different. They were writing scripts and
directing and producing, or starting record companies and things
like that. . . . I was exhibiting my work, and we were always
pushing each other along by confirming that it was positive
and it was good. And that was good. It was a very close situ-
ation, like brothers and sisters, like family in a way. . . . So, here
again it was reaffirming, just like my family was. I mean, here
I was in New York, and I had met up with a group of people
who were still saying, "Oh, this is wonderful"—appreciating
my work. . . . And it was very focused and directed at Black
people. But that did make some people in the [apartment] build-
ing uncomfortable.

A Pathway to the Garden
Alois's Story

An energetic, enterprising dancer, Alois talks about growing up
too quickly, her close associations with history makers in the
field of African American dance, and her current teaching. Her story
demonstrates the influence of particular values and life circumstances
on an artist's self-image and professional ventures. Her lessons have
come through a range of conflicting but powerful messages, and
her ongoing attempts to make meaning of her experience attest to
her strength of mind and spirit.

*I grew up for the first fifteen years of my life on Long Island. I was
somewhat of a tomboy. I had a boy cousin who is less than a year
younger than me, and we were raised as equals. We played together,
we climbed trees together, we played in the factory yard together. And
one day I was called in the house and given a bra, and then I was told
what I couldn't do. It was like announcing to me that I'm a female
[laughs]. And I think part of my life now is still rebelling against all
of a sudden being told, "You can't do what your cousin does."*

*I started dancing at seven, once again influenced by my cousin
who had been enrolled in this dance school, and I wanted to do it. At
this dance school you ended up taking everything. You had your ballet,
tap, acrobatics, jazz, and once a month my teacher put music on and
you had to improvise. You had to get up and dance whatever you felt.
I hated it, but she made you get up and just express yourself. It was
frightening. But after a while you got used to it, and then it became*

very natural for me. During that time, I was beginning to get wild in the street. One day my teacher was taking me home, and she said, "You're going to have to decide. Do you want to dance, or do you just need to take some time off? If you want to dance, you're going to have to get to see it more serious." She saw I was not concentrating to my fullest because I was beginning to look at little boys.

When my teacher wanted to take me into the city for classes, my father made a suggestion that I not make waves, that I shouldn't get that personal with the dance teacher. Because she wanted to take me to her mother-in-law's house and go swimming. My father said, "I'll take you into the city and take a dance class, and then we'll go out to my mother's." I remember he said, "Don't make waves." And I said, "I was born to make waves!" I always had a fast mouth. As time went on, I ended up going by myself. I wasn't going to wait any longer for people to tell me they were going to take me somewhere. I did it. My mother didn't know where I was. We'd sneak out after I learned how to skip school and go to the city and take classes.

What busted the reality of the teachers at that school liking me and really being interested was that there was a group called the "Regional Rockettes." It was like a summer group portion of the Rockettes. You didn't have to be as tall, and they worked up in the Catskills. My teacher and the owners of the studio said I could do this because my kicks were high enough and my tapping was strong. They said, "We'll give you the number of the audition." I remember going to the city. I couldn't find that place for nothing. The phone number was wrong. So I just thought a mistake had been made. That year at the end of the recital, they announced that these other girls made it. And when I went to them, they said, "We didn't want you to be hurt, but they don't hire Black people." Then I said, "Well then, why did you tell me that I could do this?" I worked all year to get my kicks, my taps, and everything in order for this audition. I felt I should have been the one to decide if I wanted to go in there and be ridiculed for being Black. And at that point, I was through!

At that point, I was drinking a little bit. I think it was the latter part of seventh grade. I had a teacher then who was putting the whammy prediction. This teacher said, "You're all going to be pregnant by eighth grade." I had very little interest in school. And people didn't necessarily like me because—I mean I didn't really run with any one particular crowd. Like I said, I was interested in boys. I remember I was drinking. I could have been an alcoholic very young, and that was because there was nothing happening at home. By the

time I was born, my father and mother did not have a harmonious relationship, so the house was not a harmonious place, and I didn't particularly like to be there.

My grandfather migrated from Guyana, and he worked on the Panama Canal. He had gotten enough money to come out to Long Island—there were hardly any Black people—and set up a cement business. So it was a family that was a very proud family in a sense. But it was also a closed family. My grandfather's goal was that he did not want any of his sons to have to work for White men. And our thing was: you do business, but you never get personal. And that's why my father's thing, when I started getting personal with this dance teacher, was that you're not supposed to do that. You work, you're friendly, you go to the weddings, you send flowers for the funerals to different people that you've done business with, but you don't get personal. All my holidays, my friends were my cousins. Holidays, you spend it with the family and maybe a few other Black families that were in the area. Otherwise, you're just with family.

I danced, but it couldn't make the overall impact and keep me from fornicating because I had already stepped into that world. And so that by the end of ninth grade, I was pregnant. I packed my stuff up and moved to Washington, D.C. I saved [money] because I always had a job. My father had different things like when you couldn't obey his rules in the house, that was the time for you to leave. I was not obeying his rules, so I made plans to leave. I moved, and I went down to D.C. because I'm thinking D.C. being the capital, Black people would be together. And I'm finding the average D.C. person is straight up the Mississippi River, and I learned that every "brother" ain't a brother. And I learned how ignorant White folk could be.

Somebody recommended me to the YMCA. I checked in there, met these two girls who said People Drugs are hiring counter people. By the time I finished lying, I had a register job. I worked the main register, so I would steal the stuff from inventory and sell it back to the employees and just pocket the change. That's how I was making extra money to have my baby. So my little bank account was growing. And I think I had to have at least a thousand dollars to have a baby because I wanted to go to a good doctor and good hospital. And this guy, he tried to get me to sleep with him. One night he said, "Let's go over to this discotheque near my house." So, I went out there with him. It started to rain, so I went inside the house with him, and I never got back out. And that was my first time being raped and brutalized.

Over these years, I've been doing fasting and trying to cleanse a lot. Because I've been like this for a part of my life, especially after these rapes and having my son. I remember I had the dream: I was in my parents' room with my brother. And I remember he said, "Let's play a game. I'll be the dog, and you be the fire hydrant." It didn't feel good, and I remember slipping away from him and slipping out of the room. And I don't know what all else could have happened during that point in my life. I really begin to see that there might be other things in there that need to come up: Why I was like this, and why I was always "ready to go." Like that man who saw me [pause]. There was a man, at twenty-one, who turned me on to cocaine. And he made it clear that he had watched me from the time I was eleven years old. I used to play with his niece. He waited for the day I was old enough. He used to talk to me, and he taught me a lot of things. And he taught me a lot of things because he waited for the day I was legally old enough for him to take. I do remember always having to get away from people. Those kinds of things have always been a thing with me, and that's what I'm trying to, in a sense, flush so that I can eventually have this healthy relationship with people.

I [eventually] finished school, and I went into the master's program. I was their first African American fellow in that department. I tried to commit suicide up there. [pause] And in order for them to release me from the hospital, I had to agree to see the psychologist. I mean, that's the intensity in which I was living and just trying to hold this together. The mental strain had its toll, and eventually I couldn't figure out all this. I was losing sense of what was real. I would sit in this antique rocking chair I bought, and I would just rock for hours. I used to drink at least one bottle of wine a night in order to get to sleep. I realized I was losing it. People would call me from New York, and I couldn't remember who called me. I was losing it. And I just couldn't hold on. I didn't know what's real, what wasn't real, what I was doing, who to trust, who not to trust. And one night I got up at three o'clock in the morning and got in my car and left. I got up, and I left, and I drove back to New York. I ended up finishing the program. And it took me much longer working, but I got it done. So I do have an M.F.A. in dance education.

I teach at Patterson University in Connecticut. I teach jazz dance from a historical perspective. It's a course that I've been developing these seven years that I've been there. It's a studio course with what

I call "mini lectures." I have full benefits. I teach twice a week. I teach two courses a semester. I'm a visiting lecturer. The kind of contract I have is I don't have administrative responsibilities. I only have to be accessible to students, and that's what I want. That's my purpose for being there.

I find the people that consider themselves scholars, they deal with theory, they deal with books, but a lot of the material that they theorize is not functional out here in the real world. It's just that: It's theory. They can give lectures, but so little of that is taken and put maybe in a satellite community and worked to say, "This can help people be better people," or "This is how we can break certain negative cycles within our society." They talk about the reasons but don't come up with the answers. And very few of them leave that environment. Once you have tenure, you're there. You don't have to go out. You're not answerable to a bigger population. That distresses me because what I see by doing workshops in public school systems is that the continuity of learning and the circular breathing in terms of what you learn in grade school and high school—when you go to college it doesn't flow back. That's where I find the whole educational system not being an even flow where you can progress and come out with something that can then be regenerated and expanded upon.

It's a liberal arts college. The kids are intelligent, but none of them really are specializing. My dance students are okay, but none of them are at a technical level for me as a choreographer to really be able to put the meat into it and be able to use these students as a choreographic resource. I'd always have to make compromises for their physical limitations because they're not studying intensively enough in the art of dance. That, I don't so much have a problem with as much as I do with a sense of commitment to whatever a project is. I expect that level of self-commitment if you're going to choose to walk into a studio. That's one of the things that I say the first day of class: "Don't walk in here because I'm in here teaching and you've heard about me. You better walk in here for yourself. I'm not going to baby-sit you."

The whole sense of history and the exploration of dance history has been in my life since eighty-two, eighty-three, in terms of really consciously studying the progression, the physical manifestation. It's important to learn and respect that there is a cultural evolution within African American culture, just as there is in European culture, that jazz dance can be considered a classic dance just as ballet. Now, what's different is that jazz dance reflects the whole art of survival with improvisation. We as a people had to be very flexible and knew how

to improvise with our lives in order to survive. You improvise, you make up something new in order to stay unique, to show your individuality—that each individual has a voice. It's very valid for me. Improvisation is not just moving your body till the music stops. It is the development of a theme, the exploration of a phrase. And within that, you express self, and you expose self. You share self with your audience. It's not that you project above your audience. You're sharing with, you're communicating. You're learning as well as teaching, so that becomes a circular exchange.

I was out on tour with Sun Ra. And I was doing these steps, and he had names for them. I found those steps, but I didn't know what I was doing. And he said, "Oh, you're doing the Suzy Q." And then I realized: Are we reinventing the wheel? I had heard that there were these older people that got together and danced. But, you know, we were "intellectual modern dancers." We didn't go out of our way to find them, you know. We heard it was kind of a closed group. But when my spirit was ready, I found them. I found Norman Miller and Frankie Manning, and they were doing the same steps that I was doing with Sun Ra, but they had names for them. It came from someplace. I said to myself, "You're reinventing the wheel." So, I approached them about learning and being part of them, and one of the dancers said, "Let me see you swing out!" And I danced. She said, "You can't swing. You want to come and look? Watch?" And for three to six months I went to their rehearsals every Sunday morning, and I sat on the side, and I watched. I was the gofer. Because one thing I did hear was that they did not like trained professional dancers because they didn't swing. They had no feeling. They were too Eurocentric. So, I didn't let anybody know that I was a professional dancer. I just went, and I watched, and it was swinging! They were dancing to the big band music. And I watched some of the videos up at Lincoln Center library. Them, as teenagers, Day at the Races, and Hell's a Poppin' that they did with the Marx Brothers. One day one of the dancers didn't show up. She said, "All right, you've been sitting there long enough. Get up and dance." And I got up. But because I'd been practicing on the outside, I could swing by then. She said, "Yeah!" And what it was—you talk about humility—I had to go into the situation and say for myself, "You can't dance" so that I could be totally open to what it was that they had. I had to humble myself. I had to approach it naked, like I was a newborn baby.

I don't think I have ever been the same because this kind of dance, like African dance, you don't separate it from your life. It then incorporates certain life values in terms of being in rhythm, being flexible.

That's why when students start breaking something down to the minute point where it's not even the dance phrase anymore, I find when they get to those points of that level of intellectualism, I freak out. You will not tear me apart to become nothing. It happens in a whole. This step is in reference to that total phrase. So when you're dealing with a four-bar phrase, you don't just practice that one bar because that one bar came from somewhere and it goes somewhere. You don't just start this step here, isolated. They happen in groups. You sing a song in groups. It's like somebody tearing me to nothing—like piecing me apart. I remember the first time I felt that. That's when I realized: I am it. I am the concept, so you cannot tear it down like this. And that's how I live.

How to learn, in my class, is just as important as learning dance. So what I give students are my dance values. I then have to trust what they do with it. But the biggest thing is they leave my class with respect of it, that it's not just a light recreational thing, but it's something that comes from somewhere, and it's going somewhere, and that they as individuals can have a voice because that's what makes jazz a universal art form. But as I tell them, I say, "Each movement that I give you, you have to find your total being. Don't try to just look like me. I don't want you to look like me because you didn't live the way I lived. Find how you live and yet do the choreography." And so, through dance, I teach life, a reflection and expression of life, a process and a vehicle to help people explore and decide about their own life. I want them to feel good about what they did with themselves because then no matter what it is they choose to do in life, they know that they've got the power to do it for themselves.

I'm respected at the school mainly because I'm the most actively working professional artist. That creates enough intimidation to supersede any kind of racist attitudes that might prevail, which, the teacher before me was always screaming about how racist they were. I don't like to use up energy with that. I'm a doer. So that helps insulate me from what insecurities there are. I mean, they're just who they are. I don't try to be their friend. Going back to my childhood, you do business with them, but you don't go and lay up in the hot tub with them [laughs]. You just be colleagues. You have something in common. You work with that. And after that I go home. That also keeps them secure. The other part is that I'm not trying to get tenure and trying to deal with any of their jobs. So, in essence, I have no problem at that level of isolation. I go to one or two faculty meetings. I don't want to submit myself to people that I don't truly respect in terms of them being qualified to judge me. I go to the elders. I go to

people that I respect who are beyond me. Usually, whenever I do a production, or before I do a lecture, there are people that I go to to make sure what I'm projecting is correct. Once they say it's cool, I don't care what a critic, I don't care what a White person, I don't care what any of those people say. Because in the tradition, the elders of a community, they decide. And there are elders here within this Black community, the dance community, like Thelma Hill, Olive John, Max Roach, Cecil Taylor, Frankie Norman. I don't speak on the Lindy Hop. If I'm going to do something, I call them up. "Is this correct? Am I saying it correctly?"—I take it to the people who lived it and who I am representing. And if they say it's correct, can't nobody who just read a book—because I know now, them books interviewed by them people could be lies. I don't want to be judged by that. I won't put myself up for their scrutiny because I don't feel them qualified. A goal of mine, which I've seen happen, is for me to get to where they just say, "We will give you tenure." If they want to give it to me because of who I am and what I'm doing, just based on that, I'll take it. But I'm not going to ask them for it.

In the African American program, as far as they're concerned, I'm too simplistic. I mean, they're in their whole struggle of being accepted. They're going to do everything the White folks want them to do. And they saw that they still can get denied. My thing is I'm not here to please nobody. I'm here to do my job. They figured if they got their Ph.D.s and they wrote all the books that they would then be brought into the fold as equals. Then, they found that they were denied or paid off to leave. Most of the people in the African American Studies Department are either White, married to White people, or come out of very upper-middle-class bourgeois things. So, a nappy-head woman looking like me, coming in fast and hot from New York is not very appealing. But the results of my work speak for [themselves] and gives me a place there. So, they just leave me alone, and once again, I don't go and sit down and eat lunch with them. I walk into the little club, and I say hi to everybody, how is everybody doing, and I go to my office, do my stuff, and go to the studio. I've found my survival in those kind of institutions is not investing my whole self into it so that if it gets stupid you can always walk away. That university knows I don't need their money. I enjoy it because it's steady, but I never let my standard of living get to the point where I need their money. And I think for me that gives me freedom. It gives me freedom to make mistakes. It gives me freedom to step out and to take chances.

That's how I've been able to get along. And that's why I don't want to buy into that kind of environment, to any bureaucratic envi-

ronment, because I want to teach. I want to share the information. I find with the expansion of information is the ability to change situations. I feel racism and violence [are] based on ignorance. So, if I want to sit there and say it, then I've got to do something to make it different, at least as much as I can do as an individual. That's why even if I'm performing all around I always find it's necessary to be teaching. And my performance is a teaching vehicle for breaking down ignorance. That's my contribution to change the world. If I can make any one of those students a better teacher when they go out to help and understand some child so they don't just put a label on them and throw them out to pasture, then I have helped the evolution of this society and the world. That's why I do it. I once said, having been around people like Thelma Hill, Olive John, Eleo Pomare, that my goal is to one day be a master teacher. The art of teaching is absolute giving. So that when I hear teachers say to the student, "You're not giving me anything back"—a teacher's not supposed to need anything back. You're supposed to give and empower. You might see glimpses within the process of a student going, "Ahh! I got this." You might not ever see the effect of what your work is, but you have to trust that you're doing it so that you are potentially laying the groundwork for growth, helping people create values and expectations for themselves. Then they will have expectations for the society out there, and they won't take just anything.

I woke up one day in Austria in a cold sweat wondering, What am I dancing for? I am not the best dancer. I'm not doing these phenomenal things. I do average, mediocre choreography. I make no profound choreographic statements, ethereal, heavy duty. So what [am I] doing here? And I realize what it is is that I have lived an experience as a dancer with musicians that very few dancers have ever had the privilege of doing. I learn about the body, and I learn about dance movements in a studio, but the philosophy of creating art and of dancing I've learned all from musicians.

I try to keep myself diversified, and that's why I work so much, not having all your eggs in one basket. No one source is my major income. I cannot do it all the time in terms of just teaching and not having other stimulus in my life. The performing nurtures the teaching. The choreography nurtures the teaching. It gives me new things to bring. It gives me new ideas to explore. One feeds into the other. Yet with each step I take, I get incredibly, incredibly frightened because [pause] I don't know if it's wanted. I don't know if it's the right

thing to do or the wrong thing to do, if it's needed, if it's wanted. I constantly have to try to tell myself, Go do it. Go do it.

At the bottom line, I don't have this Hercules courage and self-confidence. I am insecure because people have told me, "You're not good enough to do this," or "You don't have the right kind of body." And yet I still do it. And it's not that I do it because I so strongly believe in myself. I believe that either you sink or swim. I usually swim because my instincts for survival are that strong. So I'm beginning to say just the fact that I have survived to speak on it—I have raised a child that can take care of himself and has not been in jail, I have not missed a meal, and I've never been on the street. And I now own property, and I have been able to make a livelihood as a dancer and teacher. That's how I say I must be somebody. And that's how I just keep my courage. I'm a fighter. Now I'm in the process of trying to explore being a woman, being vulnerable, being a leader without being too hard. I'm just trying to keep my vessel open, so I can hear what it is I am supposed to be doing. And I do feel confident that this dance, the teaching of it, the sharing of it, the expression of it is the vehicle for now. And we'll see where it goes.

I do dream sometimes, when I stop this, of having a garden, waking up and having no plans for what I have to do before the sun goes down. Just waking up and just being. I feel like those are things I want to experience while I'm here on this planet.

The Course

Mariah

There is a bigger picture. I'm just interested in what that is. It certainly wasn't for no reason at all that we survived all this and are working the way we're working, and still in spite of everything we are still changing this world. When I say "we," I mean *our* people. It seems that the things that we do seem to affect a lot of people around the world. When Rosa Parks decided not to get up, I think that protest has never been the same since then, in that it ignited something, and it opened and paved the way for people all over the world and ever since then to speak up. And so all the movements owe her a lot.

Sadik

Well, those are the people that make space for the rest of us. Like Malcolm made a lot of space for us. King made a lot of space. Stevie Wonder, when he got the mike, made a lot— because most people say, "I thank my mommy and my daddy." Well, Stevie don't do that. Mohammed Ali didn't do that. Tell you what was going on when he got the mike. Most people—, "I want to thank this—" No. Tell them what's happening. When you get the mike tell them what's happening. It's the only time you're going to get the mike. It's the only time.

When Stevie got the mike, he said, "We're going to make Martin Luther King's birthday a national holiday." When you get the mike, you tell them what's happening. Don't talk about your mommy and your daddy. Your mommy and daddy are

proud of you when you're up there. That's fine. That's all good. "And I'd like to thank my producer and—" Really? Uh-uh. Even Marlon Brando sent an Indian woman up to get his award to talk about the plight of the American Indian. Yeah, that's right. Everybody remembers. They don't ask him to take the mike no more, but it's all right. We know where he is.

This Far by Faith: Sociopolitical Influences

There have been experiences and moments of social and political awakening that have profoundly affected each of these teachers. Their biographies are situated in rich yet complex circumstances that to varying degrees affect how they function and make meaning in their worlds. Through private and public avenues, issues of race, economic class, and the challenges of coming to terms with social and personal expectations related to gender have made their way into the teachers' psyches. At the same time, the safety net of family, political organizations, religious institutions, and significant allies has often enabled them to feel secure, gain clarity, and renew their strength. They spoke about some of the obstacles and subsequent lessons learned about asserting opportunities for self-determination and negotiating terms for social inclusion. All of the events and realizations have directly and indirectly, as well as consciously and subconsciously, shaped the individual and collective perspectives, identities, and convictions of the teachers. This chapter looks at some shared topics among them.

Personal Lives

All of the women disclosed details pertaining to how their private lives have affected their professional decisions and values. Each referred, at various points and to varying degrees, to spouses, children, and significant partners, offering perspectives filtered through

their multiple roles as women. The same disclosures did not happen among the men. Four of the six men are fathers, yet, with the exception of Rufus, who once mentioned that he is married with two children, the men provided virtually no information of this nature. Although I remain uncertain as to why, perhaps the differences reside somewhere between varying perceptions regarding what actually constitutes the "personal," as well as the nature of same-gender and cross-gender discussions between us.

All of the women are mothers and have alternated between raising children alone and with the help of partners or other family members. Patti and Alois spoke specifically and at length about the challenges of early childbearing. As single, teenage mothers they had to confront social stigmas, the difficulties of progressing in their schooling, and an onslaught of pressure to make career decisions.

Pregnant at the age of fourteen, Alois needed to prove that she could be a mother and head of a household because no one expected her to succeed. She talked about her family's attitude projected on her:

> My mother one day called me up at college and said, "You got to take care of yourself, because women who live like you age early." My grandmother wouldn't allow me in her house with my "bastard child" to upset her husband. My father didn't think I was going to live, so he took this money that my grandfather had put away for us for college and turned it into a life insurance policy because he thought I was going to be dead by twenty-one. So, that's . . . what people expected of me.

Clarissa's husband was a doctor. Married while in college, she trained as a medical and dental technician with the intention of assisting her husband when he went into practice. During that time, most of her creative energy was channeled into her home. Although this focus was necessary to support her choices, she found that the social demands of being a doctor's wife and eventually the mother of four prevented her from pursuing her career goals. In spite of that, it marked a significant phase in her identity:

> I guess the quickest way to say that [is] those twelve years of working in the office and all that was really about building my family. And I did assume the goals of my husband. And it was our dream for him to be in practice, and our dream for him to

establish the kind of practice he wanted and then to get a house and to have a space for my kids and to get them situated in schools and do all that kind of stuff. . . . Now I figure, until after my last child was born, that was my really "becoming a woman" phase.

She reflected on what that period meant in terms of her posing crucial questions and prioritizing goals:

Most of us have learned as women that you have to juggle some stuff. I think in years of children, that is the paramount thing. I had to take care of the children, and I had a job. So, in between there you can take a class, work on a degree, maybe give a concert, maybe choreograph. In those years I think it didn't feel like a dilemma. It didn't feel like a choice. There *was* no choice. Later, there were more choices. I chose to go back to school. I wanted to finish, and I couldn't. And when I hit those difficulties of graduate work it was like, Why am I here? What am I doing? Why am I being truly demeaned in so many ways? Why would I subject myself to that kind of stuff? And it would be because I wanted to learn. I wanted to do this thing. I *wanted* to do it.

As a wife, mother, daughter, teacher, and composer, Cindy finds it difficult to structure her time and balance her personal and professional lives. She is at a point where she wants to spend more energy composing, which is difficult, given the demands of teaching and raising a family:

I'm not a composer who can compose with little snatches of time. I need longer chunks of time to write. It's been hard to get that because my mother's been living with me now for quite a while. She's elderly and has required a lot of medical attention. . . . I'm the only child. I'm the primary one who is responsible for taking care of her. And there are my children as well. And there's been the divorce that I've gone through. . . . [T]here were various problems in my marriage before it broke up. . . . Home wasn't the place to work because it wasn't a stable environment. . . . I was just mentally in turmoil from things that were going on. I just couldn't still my mind to it.

It's always a balancing act for me. Balancing out the personal responsibility with the creative impulse. And if you need

a lot of time to write, that's a luxury in having three or four hours at a time to work on composition. It's just tough to do that. And with teaching responsibilities to boot. . . . It's hard to separate my work from my personal life.

Aside from the more obvious issues of how personal and professional roles have been negotiated, both Mariah and Petra referred to the impact relationships with their families have had on their art and teaching, specifically as they attempted to create healthy and nurturing environments for raising their children. Mariah's son has been the subject of some of her drawings and a recent installation, and her changing perception of him as well as that of others around him concerns her. In one of her portraits she expresses feelings about being the mother of a child who experiences daily racial hostility: "[I]t was a very graphic image of him and a close-up of him, a very serious kind of look. . . . It was me speaking from a mother's perspective. What does it mean to be male, black, and twelve in New York City?. . . [T]hey're unwanted. Nobody wants them around. Where is there a safe place for our children?"

Petra's concerns as a teacher overlap some of her motives and goals as a mother:

I would like to see my children supported in the way I was supported so that their talent and their love and passion can unfold in the way it unfolded for me. If I could do anything to assist that, to support that, I would love to do that. . . . I always knew in my family it had to do with character building. . . . That is the guiding focus to me as a parent: How can I help my children to hook up with whatever builds their character?. . . . [T]hat's very important for me as a person, as a mother. As a teacher I try to do the same thing for my students.

All six women explained how raising children and the difficulties and successes of personal relationships have affected the development of their identities, ability to pursue careers, advocacy for certain social values, and concerns for the education of youth. As Cindy says: "The whole life fits into the work. . . . It's not always at one starting point and finish a goal. Things are interrupted. And life actually goes on through all of this, your personal work and professional work."

Skin Tone

Some of the teachers deliberated about the way social categorization and color casting within African American communities have affected their self-perceptions, relationships, and to a large extent career pursuits. Paige told a story about how he came to understand social definitions of "Black." His mother had a dark complexion, and his father was half White and very light-skinned. His baby sister had blond hair and blue eyes, and he recalls the first time the difference in social attitudes became apparent to him:

> [M]y baby sister was about two years old, and we were walking downtown at the new park in the court square. They had just installed a great water fountain, and I was carrying my baby sister on my shoulders. But instead of putting her piggy back on my back, I had her straddle across the front so I could look up to her and talk to her. And the sheriff or the policeman stopped me and said, "You know, boy, you're not supposed to carry little White girls that way." He says, "I'm going to tell you how you carry little White girls. On your back." I said, "That's not a little White girl. That's my sister." And then he said, "Who's your folks?" and I said, "My father's name is Ed" and then he kind of did a double take, back-tracked and said, "I'm sorry.". . .
>
> I felt that something was definitely wrong with him because my family was so close that my father and my mother really tried to every day let us know that we were really worth something, and that we were really very important people. And even though we were called "coloreds," that we had to figure out how to handle that, and that we had to find somewhere else to put our anger. . . . I think I went inside of me and withdrew to being part of the artist that I learned to be early on. But it affected me throughout most of my life in one way or the other, and sometimes I tried to deny that it did, but it did. . . . And I think how I overcame that was to just go on and try to excel to the next level.

Clarissa's family members in Florida exhibit similar conflicts in regard to color, class, and privilege. They have given her insight into many of the limitations of those values, but also a respect for her family's reasons for adhering to certain social standards:

My father was mulatto. . . . [He] looked White and would never allow people to think of him as White. Just growing up in the South at that time and being subjected to the notion that you were always Black no matter what color you were. . . . My father just had so much baggage, I just presume that he was so color conscious and so deeply filled with Black pride, what we would call now Black pride, that I mean he just gave us . . . this, I don't know, I call it "cultural groundedness" now.

My mother's people didn't have that kind of stuff. My mother's people were these mixtures, these "Creole" types they would be called. . . . They never called themselves "Creole." They were Minorcans. Now I gather that they really were from Minorca in Spain but mixed with the British that came and the Indians that were there. It's just like Black people that were mixed that were trying very hard to strategize for the best advantage possible. And it was not advantageous to be Black.

My mother's people kind of came in conflict in real profound ways with my father. . . . My father came from this uneducated "on the other side of the track" kind of family. . . . [M]y mother's people came from a "Who are you and what's your blood line, and how light-skinned are you?" and "Are you doing something? Where do you come from? You have to have a name." [It] comes from a kind of elitist sense when we would think about it. If you were to hear the conversation, the actual words now you would analyze that as an elitist and/or Negro and/or Blacks without a consciousness. But I don't think of those people like that. I think of those people as being fully aware of what was going on at the moment in history that they were living and strategizing in the best way possible to get ahead. . . . She comes from that . . . period, the nineteenth century and the early twentieth century. It is understandable. . . . [W]hen you know that there are overwhelming odds against you, the best way to manage certain situations is not to die. You strategize to kind of get ahead and make sure that the next generation have more, or have more access, or have better advantages.

A lot of my mother's people could be viewed as elitist, ungrounded, pseudo-Blacks. But I don't know. Maybe it's my rationale because I loved my great-grandparents. I loved going to Florida. I loved the life that they had. I loved the fact that everybody, every single one of my great-grandmother's children, came to her house every single day after work and checked

in or had dinner. Every man that married in and every woman that married in knew that no matter what, you go to Grandma Landon's house every day. There's a sense of family and connectedness . . . and everybody was supposed to be about *doing* something.

. . . . I can understand some of the history of my mother's people a little bit from the period that they came and the sense of property. They probably were scoundrels too some of them. . . . But also, land was taken from the family because then the Blackness of the family became more and more apparent, and legally it was apparent. Then land was taken away. So that in the absence of a real wealth or their real power, the sense of pride in family and name was left. The accouterments of prestige kind of lingered. So, that's part of my background too.

Nduma explained how he came to understand that for some light-skinned people, identifying with White role models codified their aspirations toward a higher social status. In the eighth grade, as a young musician, his goal was "to be a trumpet player as great as Louis Armstrong." Members of the school band often had debates, one of which occurred between Nduma and another trumpet player:

[A]t the same time that Louis Armstrong was such a great and famous person, Harry James came along. Harry James is a White trumpet player. And it's an interesting situation. All throughout our history we've had African Americans pioneering in innovative statements in the arts, particularly in music. And the culture finds a White counterpart, which is not the same, but it's somebody who is given that same kind of status. . . . Well, I was influenced by Harry James some too. . . . He played things like "Flight of the Bumble Bee." And I learned to play the "Flight of the Bumble Bee" on the trumpet. All that did though was to give me great technique. But my impetus was rhythmically and melodically more naturally akin to Louis Armstrong because there was something about his statements and his phrasing.

So I had a discussion with a fellow in the band who was older than I. . . . And he was saying that he thought Harry James was the greatest trumpet player. It was interesting to me because he was a big, light complexioned Black fellow. And that's been this thing racially too between light-complexioned and dark complexioned and all that stuff. Never bothered us too

much because we all were segregated, so it wasn't an intense thing. . . . So I said, "Okay, you like Harry James better than you do Armstrong. That's just fine, but I don't." And I just went on my way. . . . [I]t wasn't an antagonistic thing. I guess it was a sense of naturally allying myself [with] what was natural to me. What Louis Armstrong said on the trumpet was more profound, and I'm sure I didn't have the word in my vocabulary then, but that's the way I felt. . . . I think that sometimes it's easier for us to think that there's a certain strength and a certain aspiration towards imitating power in your culture. It's a dangerous thing in a way.

Economic Class

Petra, Rufus, Clarissa, Patti, and Alois are from middle-income families and were primarily raised in integrated communities and schools. Four of the five teachers' mothers were teachers, and each of the five is from a family where at least one parent was college educated. For Mariah, Sadik, Paige, Winston, Jerry, Nduma, and Cindy, who explained that they were from low-income families, education was viewed by their parents as means by which one generation is able to have more social opportunities and economic advantages than the previous one had.

Some of the teachers discussed how their perspectives about economic class evolved. Petra and her mother moved to an integrated, middle-class neighborhood after her mother earned a doctoral degree. She spoke about a dance teacher with whom she spent a great deal of time during that period and who influenced her awareness of class differences:

She and her family were Jewish, and they were the first Jewish family that I remember knowing. And they were the first White family that I really remember having any kind of relationship to and had all this access to her and her world. I remember feeling very, very comfortable in that home. . . . I was lucky enough that through . . . these communities where I'd been raised, I had certain opportunities. . . .

We were living in . . . Long Island, and there was a new suburban sense of opportunity and privilege that existed there that we just kind of accidentally fell into [laughs]. We didn't own a piece of it, but . . . my mother was given a teaching po-

sition after she got her degree, which allowed her to work on Long Island. And she got an inexpensive house . . . which allowed her to commute a short distance to work. And I was about the only Black child. . . . I had all kinds of opportunities just because I went to the public school. People through privilege were able to afford or provide opportunities for their kids that I probably wouldn't have gotten had I stayed in the city. Having stayed in the city, I would have gotten different kinds of opportunities.

"I always wanted to be part of the middle class," Jerry says. In his hometown, the positions of honor were awarded to the town's two highest professions: school teachers and preachers. During his attendance at a historically Black college, Jerry remembers how impressed he was upon meeting social activist and leader Mary McLeod Bethune, and what it meant to him:

Mrs. Bethune was highly respected. When they decided to have that colored cabinet, I guess it was Roosevelt first sought out Black people to ask them, "What is it we can do for you directly?" Mrs. Bethune was one of the persons that they asked, and she used to go to the White House regularly. Well, that was big stuff. People would come on the campus, and I got to see a world where people had fine manners and spoke well and were positioned, who traveled. And I thought, "Hum, I'd like to be like that."

Economically middle class, Patti's parents settled in Harlem at the turn of the century. As a child in the early fifties, one of the avenues by which young people from similar class backgrounds were encouraged to socialize was through clubs such as Jack and Jill. Patti's mother enrolled her when she was thirteen:

[The] underlying thing of this [group] was to match people up that were in a certain class. . . . We went to different activities. We went to the museum one month and then we'd go to a concert together one month. But . . . the children of these parents were very, very materialistic. I wasn't raised like that. . . . We never talked about what we had or what we didn't have or what other people had and what they didn't have. So when I got into this group, and people were making judgments about other people—"Oh, well they have two boats. Oh, well they

have no boat," or, "They have furs and so and so's parents have—." . . . I said, "I don't like that. I don't understand that. I'm not into that. And it doesn't make any sense to me."

Segregation

An important factor in the shaping of Paige's identity was the means by which racial segregation was enforced in his town through public facilities:

> I bent over and drank out of the water fountain that says, "White." There was this white porcelain [fountain]. [A]nd six feet away was a little dark brown one that says "Colored." And I just bent over and drank out of the white water fountain, and the owner of the store or the manager of the store kicked me in my rear, and I cracked my teeth on the spigot of the water fountain. I didn't tell my father about it until years after I had left Georgia because I knew that he would do something about it. . . . I grew up and went back to Georgia years later and confronted the man. But those kind of things let you know where you are.

The taboos and expectations of legally and socially enforced segregation were a part of his early life. Paige told another story that shows how he developed a sense of the inner workings of the system:

> [M]y father had a friend named Dr. Jackson. He was a White doctor. And we went to this building. [My father] used to clean up there. He had so many jobs. And I used to go there with my father at night when he was cleaning up. Well, if you got off the front of the elevator and turn right you went into the White waiting room. And if you got off the elevator and turned left you went down the hallway and behind the elevator and went into the back door into the storage room. And you could go through the storage room to the Black office because there was no dentist down there.
>
> They had [a] dark tan chair and stuff for the Black folks and [a] white chair for the White folks. And I used to laugh because the same nurse [who] did the Black folks did the White folks. And the same tools that they boiled that do the White folks did

the Black folks. The White folks didn't even know it. I just thought that was funny.

Patti attended grade school in the years immediately following the 1954 *Brown v. the Board of Education* ruling to integrate public schools. Although her classes were technically integrated, African American students were often reminded of their "place" by some of the White teachers:

> I remember [a teacher] saying to us one day, "Okay, I want all the White students to stand up." And all the White students stood up. She said, "Okay, I want you to sit down. I want all the colored students to stand up." We stood up and sat down. She said, "Now I hope you know where you stand." That was the end of that, and I wasn't quite sure what that meant except that they were first. You know, she asked them to stand up first, which made me feel [that] whatever was going on, we're probably second.

At seven or eight years old in the late forties, Mariah realized there were others who viewed her in a different way than she viewed herself. She lived in a town that was racially divided. African Americans lived on the north side, and Whites on the south, although many African Americans also worked on the south side as domestics. There were Jewish-owned businesses in her neighborhood, some of which sold goods to women from the trunks of their cars, but overall, interracial contact was limited, except on certain occasions:

> When it was possible, especially like Thanksgiving or something, we would go to the supermarkets. That was always interesting because that meant we went on the south side. And people were always looking and watching and staring at us. Not that they didn't see a lot of Black people. I'm saying that because my brother and I made up a language. Here's what happened. We'd go to the supermarket, and I remember, I can almost see it now, how this sort of came about. I'm with my father, and he's getting groceries. And we kind of feel strange without even saying anything. My brother and I are very close. I can remember a White woman staring at us, and we sort of feeling a little uncomfortable. And my brother said a few words like "Ungawawa," something like that [laughs], and I answered

back. Just these sounds that to us sounded African. And we kept this dialogue going, and people were amazed [laughs].

We just did that, and it set us apart in a way that we chose to be set apart. We knew that what we were doing was something that they had no idea what it was. We were communicating, and it was fun. So, we used to do that. In fact, once somebody asked me, "What was the moment in your life that you felt you were politicized?" That would be the moment.

Church Affiliations

Rufus, Clarissa, Jerry, and Nduma each spoke about how their churches grounded them in some clearly outlined social and moral values. All four were members of churches that were central sites for progressive educational activities. Both Rufus and Nduma attended African Methodist Episcopal churches, Clarissa belonged to an Episcopalian church, and Jerry, to a Pentecostal one. The Black church has a rich history, which gives its significance in the teachers' lives ample dimension. Having served as a source of religious, social, economic, educational, and political organization and strength, it has encouraged a positive sense of ethnic identity and been a tremendous source of leadership.

Jerry's stories are especially rich. Looking at them, we can appreciate the influence of his church on his community and his own life. A spirited worship style and strict conduct codes made it somewhat of a curiosity to people in the surrounding neighborhoods. At the same time, it provided him with a feeling of belonging and helped him realize the importance of living up to certain ethical standards:

> We were members of this budding sanctified church. In the late forties when I was a small boy, and in the fifties when I came into my teenage years, you can't imagine what that meant. It was still considered rather hedonistic and undignified African sort of worship. It was against the upwardly mobile pattern of behavior that was established by the community fathers. There was this loud singing and this clapping of hands and beating tambourines and falling out and fainting, and the ministers sort of chanting their sermons. These were the things about which we had been criticized by the majority culture. As I remember, people kept saying, "You act like the Africans. You want to take us back to Africa. Here we are trying to move forward and

move into the majority behavior." . . . Actually, people would say things like, "Here come them sanctified boys." They would shout and carry on, making light of the situation. . . .

Now there's another element which is important in all of this. Pentecostal churches at that time believed in abstinence. You didn't go to the movies. You didn't drink. You didn't smoke. You didn't play cards. You didn't dance. It was a church of "don'ts" rather than "dos." They said, however, that everything you need is in Christ so that there were a series of activities which were associated with the church, which kept you busy so that you wouldn't have time to do these other things. They had these sewing circles where the girls and women, they would sew things. The boys had the Sunshine band and the Bible drills and memorizing.

It was really quite radical for that time. . . . [I]t would be for that time the allegiance that the Muslims required in [the] sixties and seventies, where you dressed alike and where your very presence was supposed to signify your association with the membership. . . . I had some of the nicest times there because small congregations tend to band together wherever they are. So that five or six towns would gather very often for meetings, and you got to know people from throughout the state. It's almost like being a clan member in that you live among yourselves, but you know everybody else who has the same approach that you do.

Jerry's reference to the Black Muslims or the Nation of Islam makes for an interesting comparison. Although their theological and political positions differ, they have both drawn ideologically from religious sources that directly affect their social actions. The Nation combines Islamic theology with nationalist thought, providing discipline for its members through a strict code of morality; prayer; temple; attendance; cleanliness; codes; dietary and dress guidelines; drug, alcohol, and tobacco prohibitions. As a result, membership provides economic and psychological anchoring for many who have been written off by society.

Through similar means, the Pentecostal church provides its members with a sense of self-esteem. Jerry talked about his mother, an active, well respected member of their congregation and a woman who lived what she espoused. Guided by strong spiritual convictions and her relationship to the church, her lifestyle set a standard for others within the community:

Sometimes we would have to go to the grocery store. We didn't have a car, and we would walk through a section of town which was called "the Square." This was where the pool hall was. This was where the liquor store was. This is where the all-night restaurant was. It catered obviously to a certain type of person, the good-timing people who liked dancing and clubs and drinking and playing cards, etcetera.

And my mother could walk through the place, and [people would] say, "Shh, here come Mrs. Brooks. Here come Mrs. Brooks. Hide that stuff." They would hide their liquor. They would hide their cigarettes. And they would say, "How are you Mrs. Brooks?" [She'd say] "Fine. How are you?" And there would be other women who could come through they wouldn't recognize that way. . . .

Now, she hadn't done anything to deserve this other than to live. I mean, she wasn't the principal of the high school, or she wasn't a minister, or she wasn't the police, and yet she commanded rather than demanded. . . . She was *sanctified*. She lived a certain kind of life. They never saw her doing things which were unbecoming, not only to women but to Christianity. In other words, she lived the kind of life that was represented by the church that she attended. . . . For example, my mother died at seventy-five and she never wore a pair of pants in her life. I mean, this sort of literal translation of the Bible.

Her very presence among these people said, "Here is someone who is good and kind and upstanding, so I really want to show her that I'm a nice person too." . . . I think it's because deep down within, we all . . . want to be the best that we really can. . . . And if I see it in someone else I can say that one of these days that's what I'm going to be. It's almost like a model. It's almost like having a goal. And I think that that's incredible because that's what was needed for that kind of church at that point.

Not only did the church serve to support individual behavioral choices, but, as Jerry notes, it provided a tremendous corporate community knowledge. That is, regardless of the difficulties that resulted from lack of money and education, they shared a desire to provide their children with the necessary moral resources and wisdom that might help them improve their lives:

Remember now, we didn't have any school teachers in this group. We didn't have any post office workers. We didn't have

Black people working on the trash truck then because that was a high salary job. We didn't have any plumbers' helpers. We had people who picked oranges, which was domestic work. We had people who cleaned up the train station. We had people who cooked in this person's house. We had people who mowed this person's lawn. We had people who chauffeured this kind of person. I don't even know if there was a high school graduate among that congregation. But they had children. And while they didn't organize the church themselves, they saw their responsibility of getting their children up, so that mother always said, "I don't want to see you have to get up at five o'clock in the morning to work in the field like I did as a child."

Race Consciousness

The teachers spoke about their racial identities and perceptions of their evolution and meaning in different ways. Sadik identifies strongly with an Afrocentric position. From an early age, he differentiated between identifying with "Blackness" as a racial descriptive and claiming positive identification as a member of a historically oppressed group:

> I grew up in a Black neighborhood, and all my friends are Black. When I was about ten we'd go see Jackie Robinson. And then there was Roy Campanella, and Roy Campanella was a great catcher. But Roy Campanella's thing was that he *happened* to be Black. And Jackie's thing was that he was Black, and he was going to do this for Black people. And everybody understood the difference in attitude about that. And it was crystal clear to me and all my boys. [We'd say] "Yeah, I'm down with Jackie." So, I'm still down with Jackie!

By contrast, Cindy expresses some skepticism about the cultural nationalist position assumed by many African Americans in the seventies. As a college student, while traveling with her boyfriend through Africa, she became aware and somewhat discouraged by what she considered idealistic perceptions about Africa as "the motherland." She absorbed the culture around her, but under the pressure of having to acquiesce with what she felt was a "politically correct" stance, Cindy found it difficult to question her boyfriend's opinions. She felt that his nationalist leanings left "no room for objectivity." She says:

Being African American is not quite the same as being African. You can sense a deep connection, and I did feel that, especially in the musical context. But just everyday living and cultural things. . . . [T]here are differences.

It seems like there was a tendency for people to overlook all the differences and say, "Oh, we're home. We're right back home." . . . I try to be open and yet objective in viewing anything . . . so that I can have the freedom to say what it is that maybe is a little different—some things that I don't like as well as things that I like. So I felt, I guess from my colleagues, that it felt a little bit strained on saying things, as if you couldn't criticize anything that was African. You had to eat up everything [laughs]. . . .

It was that time. . . . It was necessary to have the pride and to have that instilled in us and to see ourselves and to see our history and to accept it. Certainly. The danger is, I guess, with the majority race putting it down, to do that for ourselves. But at the same time you know there's a constraint too. . . . We're people from these two worlds, and that's very special as well, seeing yourself in both settings.

Twenty-seven years old, married, and the mother of three children, Clarissa was politically active during the height of the Black power movement in the late sixties. Her church's support of Black Panther party members is not unlike the involvement in community politics demonstrated by many African American churches throughout U.S. history. In this tradition, it positioned itself in favor of liberation struggles, although the consequences of doing so caused friction among church members:

[M]y church was the church in Oakland that was the meeting place for the Black Panthers. My church was an Episcopal church, sort of an elitist little center but always a socially committed space. . . . So, I was hearing Bobby Seale and Huey [Newton]. [T]here was fighting among the congregation about letting them use the space. They were in the newspaper. People were being killed and houses ransacked. So that I was identifying with people I actively knew as church members, and mothers, family members of these people, these young men that were being harassed in the news.

Prior to the activities of the Panther party, the major thrust of social and political efforts of the civil rights movement had been

toward integration. However, the growing Black nationalist movement addressed what it viewed as the conservatism and ineffectiveness of integration efforts, resulting in a national call for Black power. The emergent nationalism of that period played a role in Clarissa's decision to become involved in some of the more active social programs:

> I become tremendously radicalized by the whole liberation struggle, of the fight between Malcolm and Martin. . . . So I made a decision at one point. I needed to be doing something about that actively. My third child was being born, and I was saying, "Here we are, we're in Oakland and all this is happening. . . . Yeah, we're participating, but what have we done as part of the struggle? People are losing their lives, and they're marching, and they're doing things, and we're talking about it here." Somehow I made a decision that I wanted to go and do something. The way I articulated it then was, "I have to say something to my children when they're growing and they ask me, 'What did you do? You were alive then. You were here. What part did you play?'"

Clarissa demonstrated her support by participating in a work project in rural Mississippi, where many people had "lost their jobs and their lives and their livelihood" by registering to vote. She typed, drove people on errands during the day, and pitched in wherever she was needed. Her stay in Mississippi opened her eyes to the diversity within African American communities, the complexities of group membership, and the importance of developing a sensitivity to those issues:

> I was an outsider. . . . I was watching my friends conduct a meeting with these local young people, talking about a demonstration they were going to have. . . . I got active and started talking in the meetings and then got quietly but severely reprimanded. [They said], "You shut your mouth because you don't know what it is. And they're putting their lives on the line. You're going back to Oakland, California, in whatever your time period is. You just keep your mouth shut and do what you're supposed to do. You make your contribution where you're asked. You don't get in there and incite people . . . when you're not from this community." It was a wonderful lesson of belonging and participating [in] the struggle of Black people but knowing that there is a time to lead, there's a time to follow. [pause] Wonderful lessons.

During the same period, in the mid sixties as a young teacher in an elementary school in Ohio, Sadik was involved in the political organizing of teachers from various schools. He reflected on some factors he believes led to the broadening of his awareness:

> Maybe [it was] my Garveyite grandmother. . . . I don't know, but I've always been race sensitive, let's put it that way, and [pause] an advocate for Blacks. I don't know whether it had something to do with John Coltrane in the midfifties or following Miles Davis around. I don't know. I know that in college I spoke a couple of times because down in Nashville the sit-ins had started. I know that I had been on the King defense fund committee to try to get him out of jail because he got locked up a couple of times in the South. I know that my mother carried a sign at Chock Full O' Nuts in the forties to get jobs there for Black people. I know that my father used to take me . . . along to see Adam Clayton Powell when Powell was speaking someplace. I know that it was because I grew up in Brooklyn and Jackie Robinson started playing in baseball when I was nine years old. And at nine years old I knew the stats of everybody who ever played. And we used to go and climb the fence to see Jackie Robinson and Roy Campanella and Don Newcomb, the Black players. . . . I know that even before that, my father and my uncle used to take me to see the ballgames at the Polo Grounds where the Black teams played in the early forties. The Cuban teams and the Puerto Rican teams, you know, Black teams. Kansas City Monarchs were playing. I saw Satchel Page and all those people. Being Black maybe. But I know I've always been advocating that kind of "Up you mighty race" position.

After the assassination of Martin Luther King Jr. and the numerous uprisings in major cities in the late sixties, the push in colleges and universities for Black studies programs sought to rectify educational deficits. Proponents of the movement recognized that one of the ways racism had been perpetuated was through textbooks, teacher bias, and course content. The Black studies department at the university Patti attended was on the forefront of establishing such a program, spearheading an alternative elementary school with a culturally diverse, socialist-oriented mission. She enrolled her daughter in the school, and her participation with its programs proved to be educational for Patti as well:

Being involved with that school exposed me to people that were involved in some different ways of looking at the society that we live in as people of color. . . . [The school] offered me a group of people [who] I felt really opened me up and helped me grow. . . . I think that they gave me an instrument in which to not just look at myself in a small box as a person: Patti, operating out of this small box. They had people look at what's going on at an international level, particularly with people of color. And like most children, you are self-involved and you think the world revolves around you. . . . I did think that my little world was the whole world, and my little world was *my* little world, a legitimate part of the world, but only an aspect of the world. . . . Some people never go out of their block, and their whole world is around the one block they live on. I learned a lot that I didn't know about. That there are other people thinking and feeling, suffering and celebrating the same way *we* do in other places like Nicaragua, in Mozambique. And I had never thought of that idea. I was young.

With a Map and a Compass
Paige's Story

A sculptor, administrator, teacher, and gallery curator, Paige tells his story with exuberance and warmth. Now in his midsixties, he takes hold of vivid, detailed memories of growing up in the South with its many personal and public rites of passage and applies those lessons to a visionary art and leadership style.

I was born in Georgia. That's a long way back. My town that I grew up in was very, very small. Everyone knew everyone. I'm the second oldest of eleven kids. I came from a family that has very, very strong family ties. Even though they were poor, we were okay. I thought we were poor, but we were rich. We grew all our own food. We lived on Wellington Street. The street in front of us was called Grandfull Street. Grandfull Street was all White people. The street behind us was Cravat Street. It was all Blacks. And the next side street was all Black. The pavement stopped in front of our house. The people down the hill with pavement were White. We had the first toilet because my father put it in. He embarrassed my mother by letting it sit in front on the lawn for a while and then finally built a room to put it in. Before that we had an outhouse.

My mother did something called "taking in washing." In other words, she washed clothes for White people. And at first, my father didn't know about it. We'd go on the next street over and pick up the washing. We'd come back, and she would boil it in this big, black cast iron pot that we had in the back yard, the same pot that we boiled the

vegetables in to can vegetables, the same pot that we put the fat in where I made soap and sold it as my first entrepreneurial exercise when I was a kid. But one day my father came home early. There was no such thing as coming home early from work, you know, but he came home early. And my mother was boiling clothes. And he pulled them out of there, and he said, "Who's clothes?" And she says, "Well Ed, I'm taking in washing." And he says, "Well you take them out and take them back. I don't want you to wash any clothes for any White man." She said, "I wash yours." He said, "I ain't a White man" or something like that. Then he said, "You can find a job doing anything you want to, but I don't want you washing any more clothes for the White folks." And I never was able to put a handle on what that meant for them.

My father worked at a bank. He was a cabinetmaker. And then he worked at night stoking the furnaces of three major buildings. From the time I was six years old until I left there, after school I used to go to work with him and clean the offices and stoke the furnaces. He would talk to me all the way. Took us maybe an hour to walk from my house downtown. And we'd talk all the way, and we would talk all the way back.

When I got downtown with my father at night, he would take me over to the library downtown, the White library, and talk to the lady and say, "This is my son, and he wants to read some books on art." And she let me sit down there and read books. Then every now and then a White kid would come in and say something, and she'd say, "Leave him alone," make some kind of excuse for the reason I was there. And then she would let me take a book out, and my father would drop it off the next day. And I didn't know anything about the kind of art that I wanted to do, but that's where I read a little about it.

I entered this art contest when I was thirteen. I carved a piece of Georgia red mud that was dry, and I carved a picture of Edgar Allen Poe, this bust of him, with sharpened knives and spoons that my father made for me. And at the end of it I didn't know what to do with it. This White friend that lived on the street in front of me, well, him and I were close till he grew up and deserted me because I played with his sister all the time until he went to another school, a White high school, and they found out that him and I and his sister and my sisters and brothers all played together. And somebody said to him, "Don't let a nigger play with your sister." And he left. And his sister cried, and I never seen him no more in my whole life. He just left our group. He learned he was playing with "niggers" and he was better. But anyway, he helped me take this piece of art down to this depart-

ment store, Manley's. And he took it in, and on the back of it I scratched into the clay my real name. He covered it up. And then on the front with the entrance form we put "M. Paige." If we had put Paige everybody would have known.

I did this piece of art and didn't think a lot about it. Then one day my friend came home, and he rode his bicycle down the hill. He came down there and dropped the bicycle in the street and come running, and he says, "Your thing's in the window, and it's got a blue ribbon on it." I says, "Nah." He says, "It is!" I got on my bicycle, and we headed downtown. And finally I said to my father, "Sunday there's this thing downtown after church where they're giving prizes for art." He says, "You still messing around with that stuff, boy?" I said, "Yeah." My mother was encouraging me, and my father wasn't. He was saying, "It's a heartache. You can't be an artist. The world won't let you. Not now. You need to go to college and be something else. Doctor, engineer, scientist." So, in any case, I went downtown and [stood] in the store, and all these White people were there. And the store owner says, "Hi little Ed (his father's name)." I said, "Hi." They wouldn't dare run me out of the store. So anyway, all these people are there, and everybody is sitting around. And they had some kind of punch, and they're announcing the winners. They just built a new part on a cotton mill, Lance Mill, and some people from out of town had moved in, and that was kind of shocking to our neighborhood that outsiders moved in to work. These are White folks. And they were saying, "The winner is Mr. Paige, and we don't know the family. It's probably one of those newcomers. Is their family here? Would he come up?"

Anyway, so I'm sitting there and don't know what to do. And I said, "It's mine." Everybody turned around and laughed a little bit, and they said "Little Ed, be quiet. Little Ed wants to be an artist." I said, "It's really mine." And I got up brave as I could, walked over there, and picked it up. They said, "Don't touch that!" And I peeled off the little thing I had on the back, and I said, "See, there's my name." Everybody looked at it, removed their glasses to look at it and then got in there. And it got quiet. Quiet. And I'm just sitting there, and everybody's walking off in the corner whispering and all kinds of things. And then the next thing I know this one Black guy that worked in the store, he's dead now, tall guy, his hands were this big (gestures), they were talking to him. He came over and put his hands on my shoulder and said, "Little Ed, go home. Don't cause no trouble. Just go home." They talked him into it. And Mr. Manley said, "I'm sorry Little Ed." And I said, "Leave me alone."

We had a chicken yard and a chicken house and an apple tree. And behind the chicken house near the apple tree was where I went to take my lessons from my father. Get talked to, get scolded. I learned how to grow up. I never remember my father whipping me. I remember him threatening to a lot. I went on out back there, and my father came back home and said, "Your momma told me you're out here." I'm in trouble in two ways because you just don't lie. That's the worst thing you can do is lie. And I had lied to everybody about the art show. I didn't lie, but not telling the truth is lying to him. So anyway, we talked, and he said, "Tell you what I'll do. Everybody's gone home now from the store, but tomorrow after school you go on downtown, and we're going to go down to the store. I'll tell you what. We'll make them give it to you. How's that?"

Next day, I thought about it, and thought about it, and thought about it, and thought about it, and I talked to my friend across the way. He said his father said it was scandalous that a nigger could win a prize over White folks. I said, "That's what he said?" We talked, and then my father came home early and said, "Let's go." So we started walking, and he said, "Look, I could make them do this, but you don't want to be where people don't want you. It ain't gonna be comfortable for you." And he says, "The rest of your life that's what you're going to have to do. Right now you don't have to do that." He says, "I'll tell you what. You want to be an artist? I'll help you. But you got to listen to me. It's going to be the hardest thing you've ever done in your whole life." In 1983 [long pause] they named a street in the town after me. They opened up a museum in an old prison. People waited in line to get to my show. More folks than I'd ever seen in my life came. The son of the mayor who told me that it wasn't my prize gave me the key to the city, and I did a show of my work [long pause].

In the sixties, Alex Haley was one of my best friends. He turned me on to discovering the Black in me. He was poor, writing for the Saturday Review *and* Playboy *magazine. He was living in upstate New York. And we were probably the one or two Blacks up there that weren't in the military. And he found me when he got in town because everyone said, "There's another one of you guys," and he said, "Everybody's talking about come see you because you're the other Black up here." After that, we talked a lot. He's very, very talented and a very creative person who made me look at a lot of things. And he says, "Who are you?" I said, "I'm Paige Morrison." He said, "After that who are you?" I says, "I'm an artist." And he says, "After*

that. Strip that away. Then what are you?" "I'm a man." And then we sit there and looked at each other, and he says, "After that what are you?" "I don't know." "Is that the end of you?" "No, that's not the end of me." "What is it that you want to do? What do you want to leave behind? Or do you want to leave something behind? Where is it that you go in the middle of the night when you lay your head on your pillow and nobody else is around? Where is it that you go when you really face yourself? You don't face yourself when you look in the mirror. That's a stranger. That's a left-hand image of you. You face yourself somewhere else when you face your thoughts and your feelings when you're alone!"

When I teach, I think to make a good artist or to make a good student I try to find a way to make them face what they are and what they're really about. And I think the only way to do it is just keep breaking down layers of this superficial stuff about drawing straight lines and imitating art to really get them to find themselves. I know this is a difficult process in art, but I think it works. I think out of that comes better and truer artists. And there's no blueprint for that, see? There's no blueprint for that because every person that you meet is unique within that person's self. So there's no schedule saying that if you find somebody with green eyes and brown hair and one-third this and two-thirds that and can bend their fingers back and touch the back of their hand, this is the way to approach that person. It's like going through the forest. You've never been through it before. A map won't tell you to go to the big oak tree and turn left until you see a fallen leaf that's a maple and that is brown. Then you come back again, and that leaf is a different color. So how do you get through it? You just do it. That's the same thing when you face people. Each day uncovers something different and new about them.

I spent five weeks at an art school in Chicago. It's supposed to be one of the finest teaching institutes in the world. I just went back there to do an installation, and I was turned over a lot of students to work with me on my installation. Most of them went home at five o'clock. Most of them dressed the part. They looked as if they had went with their parents to Goodwill and got all the right clothes torn in the right direction with the right coordinated colors that showed under the rips in the jeans. And their art reflected the same kind of funny images. I shouldn't be saying this as an academic and also as a college administrator—we need the money for every student that come across the board—but I found that the school now has almost open enrollment, so that if you can pay or come up with the money or get the right kind of financial aid, regardless of how weak your portfolio is,

you can study art there. And you're not channeled into photography or commercial art, or printmaking, or anything. There is no way to push this person in the area of printmaking or something else that would be more suitable for that person. You just study art. Out of it comes a lot of bad artists. A lot of people spend a lot of money studying art.

I guess I got to the point in my life that I can talk about this because my job's not in jeopardy. My art's not in jeopardy. I come to work every day ready to quit or be fired, whatever happens. That probably goes way back a long time. Being a college administrator and an artist, I guess I'm not willing to be an Uncle Tom. That's one of the things that comes from way back. I'm not willing to be a token Black. I'm not willing to compromise my values to keep my job. I'm not willing to do anything that doesn't fit my personal and moral code of how I should live. I do enough crap to my own self without having somebody else ask me to do it. I just think that this is probably in-grown for years, that there is so much stuff that I had to do all my life to get to where I am that there comes a time when you just won't do it any more. And it's not bad things. I just won't do it any more. I always thought that everyone could make it on their own all my life. And I probably did. I remember the time when I—I've always owned businesses, and being a Black person in places where other Black people couldn't own one. I never went up there and asked, "Can I do this?" I went to a movie once in San Antonio, Texas, and it's the most prejudiced kind of city I've ever seen, years and years ago. I was eighteen years old. And they had a great big neon sign up there that says "Colored Balcony in Rear." Now, I get a ticket and go up these winding stairs and sit way up there in the balcony. Then I just walked back out front and said, "I need a ticket." And they said, "What?" I said, "I need a ticket. Give me a ticket. Hurry up. The movie is starting." And they said, "Well, we need to—" "Excuse me. I need a ticket." And I just got it. I just kind of made it on my own. But somehow you compromise something when you do that. Today, I wouldn't do that. I'd just raise hell because I could get in and every-body else couldn't go in. They didn't know how to do what I did. I owned a business, and I owned an art studio in Amarillo, Texas, when no Blacks were allowed on the street at night. And I wouldn't do that again. If no other Blacks could be there, or if I couldn't help other people do it, I wouldn't want to be there either.

I don't run a normal teaching experience. Sometimes I've been told, "You've got to keep the kids in the classroom." Sometimes I've

been told, "You can't take everybody and put them on the bus and take them somewhere. It just doesn't work. You just can't do that. You can't have everybody sitting on the floor in the middle of the night talking half the night." Those kind of the things are an abutment to some colleges' ways of teaching. It's got to be from 9:00 to 10:45.

To describe a normal class, I'll have to start somewhere in the middle of it. They've already got books and things of this sort, and they've already done some research, and they've already become familiar with part of the subject matter that I'm teaching. And we're studying Colombian art as it relates to sculpture, and why that experience is important. At the same time, we're doing a correlation of African art that is somewhere a half a decade ago that you don't find a lot of information about here at our libraries or at any other associated libraries at colleges here. We have to deal with Yale, Harvard, or sometimes Brown University or maybe Rhode Island School of Design. So we enter a classroom situation where all of the students in the classroom, their idea of bronze sculpture and creating pieces of art from bronze is [the same]. They all know that it's going somewhere to relate them to what we're doing when we get to the foundry. Make one out of a piece of plaster, and they're going to work on it for a week. Now, when they finish this piece, they're going to take and treat it and make a mold in four different parts. And the next day we get a hammer, and we chip away all the ceramic. And then we got a bronze cup that's got a little straw coming up this way and this way. And then we take a saw and we saw all of those off. Now we've got a cup, and then we file it, and then we sand blast it. Then we do what we call a "patina" on it by heating it again and brushing acid on it, a sulfur solution or something else until we get it brown or red or bronze. Then we polish it. Now we've got a piece of art. And we take that same mold and make another wax and make another one if you're going to make an edition of two or three pieces. They all know that's the way to get two pieces of bronze sculpture. We're told from our books that this is the way you do it.

But what they didn't know is that five hundred years ago there were Africans out in the middle of the sand in West Africa creating bronze sculptures. They didn't have a foundry and they didn't have all this wax. They didn't have the equipment to go through all of that. But they created something just as nice. And how did they do that? So, we study how they did it. They did it probably the same way we did it, but they just made a furnace out of trees, out of clay and out of bricks and out of rocks. And instead of gas to fire it with, they made it out of charcoal that they made out of a tree and put it in there and

blew on it until it got hot enough to melt all of this stuff. And that was their furnace. And what did they use for a mold? They took a certain kind of sand and mixed animal fat and waxes, and water to get it to hold together to do all this. They went through probably the same steps in a different kind of way.

Now, these students have their round little beady eyes, and all of a sudden they're excited now and their eyes are big. They can create this thing without any obstacles and [know] that even if you don't have this or that, you can do it. They can be a bit more spontaneous in the way they do it. They can create a cup that has feeling to it now. They're not just making a duplicate of what they saw there because they know how it's done. They know that the people in South America and in Africa did it a different way. They did it out of feeling. They did it out of emotion. They created a way to do it. It was not just duplicating an image. It was part of their culture, their life. They lived it as they produced it. How did I get them to get that information? We just stopped the class. We get on the bus, and we go to Harvard, and we go attack that library for a while until we find as much stuff as we can find. Then we come back here a couple of days later, and we get excited about it. How did the Africans do it? How did the people in South America do it? Now these artists are really excited about how this happened and what within this can help them produce a piece of art that has no limitations.

As a teacher, I think I would like to take all of my various collective experiences that I've had. And I'll say, even though there were times when times were really very bad and very trying and things were terrible, they were all good experiences for me because they all made me whatever it is that I am. They made the heart. They made the part that is soft. They made the part that is compassionate. They made the part that made me not greedy, and even though I need money for everything I do, not make that the most important thing in my life. I'd like to try to draw on all of that in teaching young students so that they can find themselves and be better at it than they could have been if I'd just gone into a classroom, took a book, and taught theory and some skills and perspective and all of that. I think I'd like to teach them hurt, hunger, pain, hardship, desire, dreams and give them the skill to put it all together. I know I can't physically go on forever. My art I hope will. But I don't want to create a miniature Paige Morrison. I want to help to mold some other artists that can go on and be themselves but somehow carry on some of the spirit of what I taught them. I think that as a teacher that's what I'm looking for.

As a teacher coming from so many varied and different back-grounds and different experiences, I think that I'm better equipped than a lot of my colleagues in helping young art students. They come to them with blinders on and channeled in one direction and just purely teaching art, and art isn't just learning how to blend colors and patterns and shapes and forms and perspective and all of that. Art is what you feel and see and hear. Sometimes artists or master painters, somewhere after they turn eighty, and there are a number of them out there, become legally blind. They can't see too well. They see just blurs. And they go on to paint some of their best works because the sharpness of a lot of technical stuff disappears because it has to. And the blending of feelings and emotions become more important to what they do than just what they see.

I think what's down the road for me is to spend more time pro-ducing larger pieces of art that I feel good about, environmental pieces of art, do a lot of lectures about it. Maybe [I'll] teach a part of the semester each year and take on maybe just very special students. And this way would allow me more flexibility. Financially, I'm pretty se-cure. Emotionally, I think I'm very secure. Physically, I'm in good shape. And I think I just need the next thirty years or more to expe-rience life and create what's really by nature, or God, I need to do. If I do that, well, that's probably all I can do. I'm not looking for the Academy Award. I've had it over and over and over again. If you don't look for it, you just try to be the best you can be, all of a sudden it comes along.

I think if I had one way to sum it up, my life is about my art and about my contribution to mankind, peace to the world. Early on in my life, someone said to me, "Well, you could be an artist on the week-ends and can continue owning a business. You've got something going for you." And I said, "This is what I'm supposed to do." And I didn't know how to explain this to him. I said, "What do you think about Martin Luther King?" "Well, he was put on this earth to do what he did." "What do you think about Christ?" And [he] said, "God put him here to do what he did." I accept that, and I agree with that. Same thing about Martin Luther King. He knew that he was going to die. That was his destiny, to stir the consciousness of people, to be sure that people embrace peace. Why wasn't I just put here to do my art and do what [I'm] supposed to do? I'm not as great as those other people, but that's what I'm supposed to do. I didn't choose to be what I am. I didn't make myself the way I am. I think that something willed

me to do what I do in the strange way that I do it. And that's what I have to do. I just don't know any other way, and I don't know where that leads me because each day it leads me down a different little road.

My art deals with reality. It doesn't always deal with beautiful images or well-balanced images as far as the art world is concerned. It deals with images and patterns and spirits about what is and what ought to be and what was. I try to provoke in people some kind of way to make them reexamine their own conscience. And if they just look at it and understand it and walk out of there either feeling anger or love, or go and take some action because of it then I think that what I do is very successful.

I had a show here three years ago, and I helped to bring it to this country, and I helped to put it together. It was from Northern Ireland. And it had two Protestants, two Catholics, and one person that kind of sat on the fence between the two. These are artists. And this is one of the most powerful art shows that I've seen. We invited the head of every art agency in Massachusetts to come. And two of the artists came, one from each side, to help me put the show together and to hang it on the wall and talk to me about it after we got it here.

The night before, my son had received a notice to register for the draft, and he was helping to hang the show here. And we stayed up all night working on the show. This is one of the most important shows that I've done here because the people from the college said that you shouldn't be bringing a show from Northern Ireland. You shouldn't be dealing with those Protestants and Catholics, and everybody was saying that we've just got to stay out of this, and it's wrong. We brought a congressman here for the opening of the show and the head of the British Consulate General. And [the congressman] is Irish. They both came to give a speech to open the show up. And I was tired. I worked all night. I was worried about my son having to register for the draft and deal with putting this art show together and all of that.

So, I walked in here and laid my head down on the desk from about nine o'clock that morning until about ten. And my son came in and woke me up, and I thought I had been sleeping for 150,000 hours. And I'd been dreaming. You know how sometimes you dream, and you don't remember what you dream, but you know you just did a little bit of it? And I'm standing downstairs at the podium and get- ting ready to introduce the two artists from Ireland, standing up there with my black suit and bow tie, because it was a formal opening. We had crowds of people, and all of a sudden the dream came back to me. And I was just stupid enough to get up there at the mike and tell everybody what I dreamed. And I knew what had happened. I knew

that all the stuff, worrying about my son, worrying about the art show, worrying about the criticism I got from both sides of it, I went to sleep with all this worrying in my head, and it got mixed up and became a dream. I dreamed so vividly, and I didn't even remember until I got up to the podium.

I remember it, and it just came, and I just got to say it. My eyes just glassed open and I said, "I dreamed that it was the beginning of a war, and [there were] all of these people. There was a line of people on one side, a line of people on the other side maybe fifty feet away, so they could actually look at each other. And the first row was laying down with guns, but the guns weren't muskets, they were M-16s. And the next group was kneeling, and they had M-16s. And there was one general, and he stands up with a saber in the middle there and he was saying to them, 'Get prepared to start the war. Ready, aim—' and just about the time he was getting ready to bring his sword down to say 'fire,' this guy came riding in on a white horse. And he was a corporal, and he rode in the middle of it with this flag waving. And he says, 'Hold it, hold it, hold it. You can't start the war right now. We need to take both of the generals and we need to go off to the opening of an art show.' [laughs] So he rode off with them two following him to this art show. And so standing there, here's these troops from both sides getting ready to kill each other. They waited an hour. Finally, they put the guns down. And then somebody had to go behind this tree to piss, and he did. And then somebody from the other side did, and they got less suspicious of each other. After about a couple of hours one guy walked over to the other guy and said, 'I wish we'd get on with this.' And pretty soon this guy reached in his wallet and took his wallet out and showed the guy from the other side a picture of his son and his daughter. Then somebody else showed a picture of his parakeet and his dog. Then another guy started talking about how his kids got sick. Another guy talked about how he couldn't afford the orthodontist. And so pretty soon they were all there exchanging talks about their wives, their family, and their kids and talking and just going on. And the hours passed, and all of a sudden down the road you see these two riders coming, just riding. They're coming fast because the generals were coming back. Everybody got back in order. They both got over and got their sabers in the air and they said, 'Prepare to start the war!' Everybody aimed, got their eyes fixed on each other. And they both said in unison: 'Ready. Aim. Fire!' No one fired. They looked at each other, and they got angry, and they yelled out loud again: 'Ready. Aim. Fire!' And nobody fired. They couldn't kill their friends. There wasn't an enemy. The people on the

other side had sons and daughters and mothers and dogs and orth-odontist bills just like they did."

And I said that I didn't think that art could stop a war, but it's the most powerful tool I know to help people become in touch with their real self and to show them life as it is on the other side, and how we live and love and hate. And if this show that I did could bring artists that would otherwise be killing each other together to talk, then maybe it's the most important and the most powerful thing I know. That's the way I feel about it. That's what I'm about.

Stations

Interviewer

It seems to me that there are so many ways to make a contribution.

Rufus

I feel I'm an African American "jalee." You know, the whole tradition of what jalees do in terms of their role as spiritual and mundane interpreters and historical and cultural bearers of the tradition through music. That's what I feel I am, and that's what I feel my job is.

Interviewer

That's a very large and honorable station that I think some of us share with you. But would you say that, overall, we need better ways to communicate what we know?

Alois

Why do we have to constantly reinvent the wheel? Other cultures pass on generation to generations. There's always movement up. We as African Americans have this tendency to constantly go around in the same circles.

Cindy

The way we label things, I find, is reflective of not being aware of what's gone before and what's come after.

Alois

There's no communication. We don't really understand what has come before us so that we understand and we don't have to do that no more. Now, how do we empower ourselves to not *react* to what happens to us, but to *create* what we will do?

Winston

I think on a personal level each one has to be aware if rage is there and know how to deal with it. I don't have to necessarily inflict my rage on the rest of society. Because we all have rage for one reason or the other, whether it's against what you think society did to you, or whether you think it's what your parents did to you, or whether you think it's what a sibling did to you, or whether you think it's what a neighbor did to you, or whether you think it's what your boss did to you. We're all going to have some kind of rage. But that doesn't necessarily mean that I have got to inflict it on everybody else. I should find some way of dealing with it that allows me to go on to be a person, a much more realized person, a much fuller person, a better person. Some people think that society owes them. Society doesn't owe you anything. Life doesn't owe you anything.

See, I find a lot of problems with some of the things I hear coming out of some Black people's mouths now in terms of being oppressed. I'm saying regardless, we have so much more freedom now to do what we will and to make of ourselves. There aren't laws on the books anymore that say to us as Black people: You cannot learn how to read. There was a time when that was dangerous to a Black person's life, learning to read. But people did it. Black folks did it, and they taught other Black folks to read. Maybe sometimes we take too much for granted. Life doesn't owe you anything. You're going to get something from life, and what you make of that something is up to you.

Mariah

I think a lot of times things have to be discussed and brought out in the open. I think people walk past things every day, and they don't notice it, or they're not conscious of it, or they decide to ignore it. Whatever the reason, it's not a part of their consciousness. Sometimes things have to be revealed or spoken

about or pointed out or something in order for people to actually acknowledge that it is occurring.

Winston

As human beings, I think we all need encouragement. As old as I am, I need that encouragement. And I know that I didn't get it at a certain time. And I know what it has done to me [pause]. There is—there is something that—[pause] I don't want this to sound pejorative, but there is something I have noticed that White folks do to their kids that I don't see many Black folks do. White folks have a way of telling their children that they are the most beautiful and wonderful things in the world, and they can do whatever they want and be whatever they want. And they tell them that hour after hour. It builds in that child a certain kind of confidence. And it's what a lot of Black folks reacted to back in the sixties when they talked about White people's arrogance. That they think they own the world. But they were told this, yes, in a sense.

Whereas with a lot of Black children, what I find within my earshot on the bus, in the streets, in the supermarket, [loudly] "Shut the blank-blank-blank and sit down! Shut up, and sit down!" That White child says, "Mommy, what is that thing on that box?" And that mother will give that child a whole lot of explanation. And a Black child says, "Mommy what—" "Shut the blank blank blank up!" It does this to that child [shrinks in his seat]. [pause] It did it to me.

Mariah

I'm not excusing all of this behavior, but often, we are so hard on our kids, and saying, "Sit there!" You see them in places where there are other children, and the parents will just about do anything to make sure that the kid stays in line. Often, I think it's coming from a sense of control, having control of a situation also, but making sure that he's going to be all right. If he gets out of line—if he does, something is going to happen to him.

And a lot of it is that they've been left alone. They've been left to whatever. And we've in many ways handed our children over to television and handed our children over to somebody else,

you know? [We've] handed them over to people other than us, or instruments or vehicles and such so that we, we just don't even—They used to say, "It's nine o'clock. Do you know where your children are?" But now it's like, do you know where their heads are or their minds are? Do you know who's teaching them and what they're learning and what their values are?

CHAPTER 5

Toward Creation Pedagogy

In the beginning God created the heavens and the earth. Now the earth was formless and empty, darkness was over the surface of the deep, and the Spirit of God was hovering over the waters. And God said, 'Let there be light,' and there was light. God saw that the light was good, and he separated the light from the darkness. God called the light 'day,' and the darkness he called 'night.' And there was evening and there was morning—the first day.

—Genesis 1:1–5, N.I.V. Bible

In this quintessential act of creativity, we see at least three principles at work. First, the free intermingling and merging of vast, fluid environmental elements. This is followed by the willful establishment of boundaries through the naming of the creation. Finally, there is a rising above the arduous details and technicalities of the work, whereby we behold the jewel—the first day. The principles are old, familiar, but magnificent nevertheless: Interaction, Definition, and Transcendence.

These principles, revealed maturely and ingeniously in the context of jazz improvisation and described as a guiding cultural aesthetic across the arts, as introduced in chapter 1, now will be explored further as what I will call "creation pedagogy." This is a term used to describe what I view as the combined effect of the twelve artists' values as it manifests in the creative thrust of their teaching. What is creation pedagogy? It is an approach to teaching and learning aimed at fully accessing student creativity, whereby students, in order to mature, are guided through specific developmental processes. In the

context of this chapter, it refers to how these teachers have gone about the task of developing their students' abilities as musicians, dancers, and visual artists. These processes coincide with qualities attributed to the three jazz improvisation principles discussed earlier, namely interaction, definition, and transcendence. The teachers offer descriptions of curriculum activities and methods, lesson objectives, values about learning, their attitudes toward students, and standards to which they adhere. In essence, these principles serve as a container for a variety of ideas about artistic development.

In representing their accounts systematically as creation pedagogy, I do not mean to infer that any one teacher fully subscribes or adheres to all the precepts that characterize this approach but that the sum of their experiences and accounts seem to support its logic. It amounts to a proposal on my part that we seriously examine insights these teachers extend and strategies they apply in their classrooms and their implications for student learning. To accomplish this, their accounts need to be understood not merely as isolated, individual experiences but in a comprehensive context rich with pedagogical significance.

This discussion is in three parts, with the three outlined jazz improvisation principles now examined from the standpoint of how they pertain to teaching practices. Because the three principles often intertwine with and imbricate each other, it is important to note that these are not necessarily to be viewed as developmental stages, although in some cases learning may occur according to this particular pattern, with one area of learning leading to the next sequentially. Most important is the fact that they are ways of referring to three highly important operations.

Finally, as part of this discussion, the teachers reflect on their roles as facilitators of student learning. By modeling the values they advocate, expressing sensitivity to student needs so that uninhibited discourse may take place in the classroom, nurturing and guiding experimentation, and exhibiting flexibility in their methods, they demonstrate an understanding of their roles in the classroom as being intrinsically linked to their pedagogies and explore the nature of their responsibility to their students.

Interaction

Interaction refers to the ability to be open and responsive to various sources of information in order to broaden one's perspectives. It invites exchanges between and within a multiplicity of disciplinary, cultural, and ideological locales. This value plays itself out in many

different ways among these teachers. For some, it is expressed in their attempts to avoid an "art-for-arts-sake" approach to music, dance, and visual arts and foster more socially relevant approaches. Others encourage more cohesive associations between the arts and other academic disciplines. It is also displayed in their concern for infusing the curriculum with African American and other under represented cultural expressions. Mainly, it pertains to the diversification of the arts curriculum, advocating the inclusion of many elements, some of which may not readily be associated with the arts, but which inevitably affect art making and appreciation.

This principle translates into teaching in a number of ways, making it a multifaceted theme. First, some of the teachers acknowledge tremendous breadth in the overall nature of art, advocating stronger bonds between it and other facets of curriculum. Some applaud the ability for the arts to stimulate critical discussions about pressing social issues related to the making, selling, and consumption of the arts. Most feel that the politics of culture should not be omitted from the study of the arts. In general, teachers encourage cross-fertilization, seeking to eliminate or at least draw conscious attention to unnecessary ideological divisions affecting the arts.

Petra addresses the principle of interaction as she speaks about how the arts are studied apart from other subjects. For her, the traditional stance of dance as a pure form, practiced and taught for its own sake, is philosophically quite far from her own teaching interests:

> To me, as a discipline, dance is one of the most adisciplinary fields that I can think of. It's such an impostor as a discipline because I see it as being what connects so many different things. I've always reacted to the way dance departments position themselves as being legitimate, self-contained programs that are separate from music, separate from drama, and separate from other arts as well as other academic disciplines, separate from history and separate from anthropology. It's always been very self-conscious as a discipline. . . .
>
> I think you have to come out of the separateness of things and come back into a language which draws things together. I'm trying to find that language now, and I don't know, I think in part it'll be a language that I create. . . . [F]or example, I'm attracted to cultural studies because I think it has that kind of cross-disciplinary language. I think it's inquiring into how you bring things together, instead of . . . managing to hold onto all these different paradigms, which are separated for political

reasons. That's the only reason they're separate. If you're going to uphold those pieces and their relationship to one another, you have to understand the political framework which necessitates that they be separate. But if you push that aside and you look for a different kind of order, then you see that they by nature gravitate together. They want to be together.

I'm attracted to that kind of rationale, that kind of function. And I'm trying to find it in the way I teach. Not so much in the content or subject of what I teach but in the nature of the dialogue and interaction of what I'm teaching and in the language itself. And that's been an interest of mine all along. But now I'm becoming more articulate about it. I'm becoming more conscious of it. And what it enables me to do internally is . . . to let go of "dance" on some level.

The result of separating disciplines affects the thinking of teachers and students alike. It enforces the false notion that there may be qualitative differences between the various subject areas. Myths about art prevail at Sadik's school, as he observes:

If you're going to close down somebody, you don't close down the science department. You close down the art department, the music department, the phys. ed. department. That's the way it goes on that. . . . What's in people's minds that those things are more important? . . . [I]t's the whole idea that culture is less important than the sciences. I feel it in my own department. . . . [There are] hierarchies in people's minds as to what's important.

Interaction, whether to minimize boundaries between art forms or promote more equity among arts and nonarts disciplines is a response to separation, as Petra and Sadik contend. However, boundaries exist not only among learning disciplines but also within them. For example, another manifestation of separatist thinking is apparent in the way artists are perceived by the public, and even among practitioners themselves. In these cases, fission among artistic styles within an arts discipline often disables dialogue across styles. Petra views this as a way that commercial control is maintained, which puts unnecessary stress on choreographers:

The dance world is really rigid. When you're in a "scene" you're in a "scene." Like in the African dance thing, you're in "the African dance" thing. If you're in the Ailey thing, you're

in "the Ailey" thing. It's completely separate. There's no conceptualization that you bring pieces together or that you can as an individual float in between the communities.

. . . And commercially what's happened now in the dance world is that African American . . . choreographers . . . have been put into the superstar syndrome. So . . . there's only one Bill T. [Jones], and there's only one Jawole Zollar and Urban Bushwomen, and there's only one Beebee Miller. There's a whole politic which is ultra commercial in its agenda. . . . [I] think that keeps that separate too. I'm not at all attracted to that trap. It's very, very narrow to me.

One of Patti's ways of discouraging her students from labeling others and seeing themselves as separate or better than others was to address distinctions traditionally made between "experts" and "lay people" as it pertained to her choreography. Most choreographers tend to use trained dancers to execute their ideas because of the obvious benefits of having their choreographic visions more fully realized. These visions are often technique driven and greatly dependent on the kinesthetic skill of the dancers. Although technique was important to Patti, she seemed to be constantly striving to redefine its function in her work. She had a strong desire to have more egalitarian relationships evolve in her ensemble, where there might be more of a merging between trained and untrained dancers. She also did this in an attempt to bring a more realistic feel to her work. Just as Sadik challenged the status of the artist at the bottom of the hierarchical ladder, in yet another context, Patti spoke about the distorted perspective of the artist at the top:

That's an elitist kind of thinking, the idea that people in the arts are special people. We're not special people. We just happen to be attracted to and took the time to get involved in that area, which just *happens* to be the arts. But we're not special people. *That* I don't like. You'll hear that kind of thing: "You're just different. You're just special." No, we're all special. We are like the street cleaner or whatever. It's just that we chose dance or theater or visual arts or music. That's all.

Patti also encouraged communication between her dance students and the general public by maintaining an ongoing relationship with community centers and other service institutions in the town surrounding the college. She taught a course she designed

and in which she was highly invested, entitled *Dance as a Vehicle for Social Commentary*. In it, students studied about dancers who had committed their lives to creating work with strong social and political messages. In the process of developing an understanding of the issues that motivated these choreographers, her students identified topics that would serve as inspiration for their own dances. As a result, many of her students expressed concerns about the problem of the growing homeless population in their community. Therefore, Patti initiated a relationship with one particular center that administered a literacy program, daily meals for the homeless, a daycare center, and welfare services for young mothers. On Martin Luther King's birthday, her students performed a full program of works they had choreographed, based on their growing commitments to issues affecting those populations.

Similarly, one of Mariah's art courses integrates social issues into the curriculum, with students examining the relationship between the lives of contemporary artists committed to social change and the art they create. Her lessons fold in discussions about discrimination, making discourse on gender, class, and race equity integral components to their learning. Also included are films and videos that expound on some of these issues. Mariah described her students' reactions after showing a particularly powerful video about the way mass media perpetuates racial stereotypes through children's cartoon imagery:

> The class was stunned because they did not know just how much racism was a part of day-to-day things in this country. When the video ended, they were just sitting there.... At first they were laughing at the cartoons. And as it went on and they started hearing, then they started feeling like they had been a part of something that they didn't realize. Then they were saying that they were surprised. They didn't know about the cartoons. Why would anyone want to do that? And on and on about some of the images. This is basically the White students. The Black students know this already. They know when they see racist stuff a lot quicker than the White students.

While examining racial stereotypes, one of Mariah's students shared an account of how she had been affected personally by denigrating media representations. Born in Korea, the young woman had been adopted as a baby by a wealthy Swedish family and was raised in Sweden. The video triggered buried emotions, as Mariah explained:

[S]he told us the story [about] how she grew up and that she never ever saw any images of herself. Except she went to see *Breakfast at Tiffany's*, and seeing that movie brought it back to her. That there's a scene in the movie where Mickey Rooney plays Mr. Yamaguchi who's in this building that Audrey Hepburn lives in. And Audrey Hepburn rings the bell and . . . this guy, Mickey Rooney, comes down and he has fake teeth jutting out of his mouth. And they've pulled his eyes back, and he keeps talking like his mouth is open and his teeth look like they're going to jump out of there. He's in this fake Asian accent which is totally demeaning. He's yelling down, and he's acting so bizarre and so weird. The only time you see this man, this is how he's behaving, screaming at her. And it's a joke. She was so hurt by that because she knew he was supposed to be her people.

Interaction between various social and political issues and the arts curriculum takes other forms as well. It is sometimes advocated from the angle that students be provided with a broader representation of cultural contributions through the arts than the teachers themselves have been offered through their education. Cindy has observed an increasing number of students requesting ethnomusicology courses as a result of exposure to other cultures through the media. Though the media may not provide information that is comprehensive in scope, it nevertheless has peaked student interest in more "global" perspectives. For her, an important curriculum goal is for students to make cross-cultural musical references as well as to make comparisons across epochs:

If I could play an example of traditional Japanese music, making use of voice . . . or something from the Kabuki theater for instance, very old. And then have them look at a particular example of singing from Ghanaian music. And say, . . . listen to Axel Rose in Guns 'n Roses. If students can listen to those very different vocal techniques, vocal styles, and see and understand somewhat of a tradition of each, and can make some kind of discussion for similarities and differences, and understand that those four types can be talked about in the context of a single class say on vocal techniques spanning centuries, then I would say that's something that a music program should aim for.

Most of the teachers agree that infusing the curriculum with diverse cultural representations and establishing a strong ideological foundation for this is paramount to their teaching. Nduma speaks about his tremendous desire to see his students grow culturally. However, as learning occurs, he discovers a great deal about the nature of their inhibitions:

> People are accustomed to hearing what they grew up with. Now, how do you broaden your pallet? You have to try other foods. And then you [say], "Ah, I like this." Then after a while you find life with a lot of variety for enjoyment. I think the arts can be done the same way. It's only natural that you're going to respond to what you grew up with. How do you then go beyond that? You have to try other things, and you have to want to badly enough to do it. . . .
>
> The key is that . . . [my students] hear music that they didn't know, and that some new light is shed upon it. Most of them don't know where most of the popular music they listen to comes from. They don't know that it comes from the African American tradition. They think it's original probably. It really isn't, not a lot of it. . . .
>
> I play Odetta. I play folks who can do these things and move you. That's what I'm teaching, culture, music, but culture through music so they can learn to appreciate. They, I hope, might be more sensitive to racial issues because there's something great coming from these people, which they might otherwise think, "Well, they haven't won any Nobel prizes for science." . . . I don't expect them to be critics, but in a sense [I teach] criticism because I want them to cultivate taste . . . [and] develop critical value systems.

Integral to the critical skills Nduma hopes his students will acquire is the ability to exchange new ideas with other members of the class. Structured dialogue, whereby students may begin to measure the quality of their knowledge and reflect on the phenomenon of their own thinking processes seems to be an important component of Clarissa's classes. She was trained as an anthropologist, so dance is studied in the context of larger issues of culture making that become inseparable from its existence as a pure art form. To better understand particular dance forms, students are challenged to consider the appropriateness of the words they use and assumptions they hold. Most important, Clarissa's approach to encouraging critical dialogue requires that students become con-

scious of their own cultural boundedness. It is a method she employs to spark self-reflection. Through the questions posed, she helps them begin the process of identifying and unpacking stereotypical and discriminatory thinking:

> [W]hat does it mean to have different values from somebody else, and how can you reconcile those? Can you still try to understand them and what those people believe and then stop and say they have a right to believe what they believe, just like I have a right to continue believing what I believe? Is there still space and respectful energy given out? . . . [H]ow are we going to live on the planet? How are we going to live in this dance classroom? How are we going to live in the world where there's going to be difference?

Clearly, Clarissa views knowledge in very subjective terms, where students are accountable not simply for what they learn but for the value they place on their learning and the power they assign to it. She also feels responsible for helping students make these major ideological shifts. Many of the other teachers have similar positions, using differing methods of attaining this goal. Patti, Sadik, Paige, Mariah, and Clarissa described how they solicit the expertise of colleagues in the arts to enrich their teaching and their students' experiences. This is yet another manifestation of the interaction principal. Here, we find teachers freely drawing from their colleagues for support. Guest artists and teachers provide students with a valuable dimension to their learning. Some teachers say that it helps students measure what they know in the presence of other professionals. Then, there are those teachers who are motivated by the personal satisfaction and dynamic range attainable in the classroom through collaborative teaching.

Clarissa brings guests to her classes so that students have an opportunity to work directly with dancers from those cultural traditions they are studying in class. Although she conducts the majority of the lectures and studio classes on her own, one semester she invited Alaskan, Zairian, and Cuban dancers to demonstrate and lecture periodically throughout the course. Disappointed with some of her students' responses, Clarissa felt that they had not learned what she intended to teach:

> [It was] a unique opportunity. . . . I thought the students would have . . . appreciated the fact that they were being taught by specialists from other cultures. They were being taught in dif-

ferent teaching styles and different modes. That's what the class was about, about difference and about learning about dances throughout the world and opening yourself up to difference. And what came out was a group of students that were apparently very, very alarmed and very, very concerned about their grades and very, very concerned that they didn't know how to add up all this and make sense of it in the end in order to write a project. . . .

I also found in the end when I read the papers that they had not learned. They had not learned. . . . [In] the beginning classes, [I would ask], "What is dance? What is called ethnic dance? Why do we try to eliminate the word *ethnic* in this point in time? What is Western society? West of what? Why is that such an irrelevant kind of term? How can we rid ourselves of ethnocentrism?"

That was the whole part of the first quarter of the course. And yet in the ending project they were using the term *ethnic*. Two of the class projects in the written text were obviously very, very biased and very, very Eurocentric and almost bordering on racist.

Specifically, Clarissa finds that many of her students have obscured the relationship between ballet and dance from non-European cultures. Continuing, she says:

[T]hese students . . . were offended because I put on a ballet film. . . . They're so romanticized about "ethnic" dance that they wanted me only to teach the Australian Aborigine, the Africans, the Caribbean folk, and the Eskimo. They don't want to hear that ballet is ethnic dance too.

I said, "This is your own culture. This is *our* own culture. I share a part of this, your all-American culture. I came up in ballet schools. Why can't you look at a ballet movie and talk about the good that you see there, the values that are demonstrated there as a result of the seventeenth, eighteenth, and nineteenth centuries primarily? Why do you have to judge it in terms of twentieth and twenty-first-century values when in fact that's not even the point?"

In the same way, I ask them to look at Cuban material or Aboriginal material that is busy doing phallic representations and so-called "sexual gestures," and they giggle and snicker, and yet they don't, at this point in time anyway, people don't

put it down. They see that as "exotic" and that's *good* ethnic dance. But they're not willing to examine . . . ballet and the values that are there. They're ready to push that ballet off because it's more politically correct to like the exotic now.

Paige, who says he has only relatively recently begun consciously and in a formal way augmenting his knowledge about the contributions of Black artists, feels that it is important for cultures to be studied and explored on their own terms, according to their respective merits rather than drawing specific attention to racial issues:

I've done that pretty silently. [N]ot mak[ing] it a racial thing. It's not a racial issue. . . . [I]t's like introducing someone to fried alligator, which I had, and I thought it was good. Introduce it as another exciting dish to taste, not as some poor folks' [food], [not like] the only thing they had to eat was alligator tail, and they cooked it up and ate the tail but as another exciting thing that could stimulate your palette. I think that if you introduce the works of the artists that I tell you talked about in that manner, it becomes less of a racial thing. . . .

But, I mean, you can polish a rock, and you can beat a rock, and you chip off some of it. You make it into something. But unless you destroy it and recompose it again with some kind of substance to hold it together it's still going to be the same thing it was. And sometimes these [students] are like rocks. They learn very hard one way, and the only thing you can do is bring some paint to the surface so that they can see a little bit of it. Sometimes it's not transposable. . . . [E]veryone is not a substance that will receive like a sponge and use it. Sometimes people are pretty much set in the way they receive information.

With the exception of Winston, whose classes are usually comprised of an equal mixture of African American, White, and Latino students, the other artists teach primarily White students. This has affected not only the content of their curricula, but their motivation for teaching certain information. For example, Patti, whose choreography reflected her occupation with African American themes, insisted that what she taught be understood in terms of its historical accuracy. Moreover, she was emphatic about her students being conscious of how they represent these ideas in performance and that the work maintain a sense of "self-worth and dignity." Former members of her class performed a dance to Duke Ellington's "Sophisticated

Lady" under the direction of another teacher who was White and who had provided her students with no historical background about the life and work of Ellington. Patti found the choreography to be sexually suggestive and full of many of the negative, stereotypical images traditionally associated with African American culture. Disturbed by this, she spoke about her own desire to bring together the physical study of dance while establishing within her students a deeper respect for the cultural contexts to which the dances refer. She seemed to suggest that the intention on the part of the choreographer and dancer to establish the most honest cultural portrayal possible would in itself dignify the work. The images Patti saw on stage were distasteful to her largely because they were created from a politically uninformed and hence, dishonest place:

> It turned my stomach. [Y]ou had the girls with the bumps and the grinds and the men on their knees actually choreographed with their tongues hanging out of their mouths. . . . And it broke my heart to see them do this every night. I couldn't believe it. But what was I going to say then after the fact? What I did do though was I had all my students write about this piece, and what information they came away with having seen this production, not knowing anything about Duke Ellington. Sure enough, they all came away with something that had nothing to do with what Duke Ellington's work was about. . . . I don't think necessarily that you can just go choreograph a dance piece for people and that's it. They've got to understand what it is that they're doing. Why are they doing it? What's the history and the background of what it is that you're dealing with. That director of choreography didn't do any of that. He didn't know who Duke Ellington was. "Where is Harlem, U.S.A.?" I asked them. They didn't know.

Alois grows through the continual building of her informational base. Because much of her work draws on early-twentieth-century African American dance styles, she often hires the master dancers of that period to present educational demonstrations at schools where she conducts workshops. As Alois concedes, learning from these older dancers has been one of the great joys of her life and has greatly enriched and enhanced her career. Although most of these dancers are poor and have not benefited from their own historical contributions to the dance field, in the recent past, many White dance students and scholars have studied with and interviewed

them due to an increased interest in African American dance history. Alois became aware that the information shared with her by the older dancers is considerably different from what they share with White students. Feeling an allegiance to these elders, she also is disturbed by the potential repercussions of the discrepancy in information:

> I realized in studying and in being a student of SN that they made that differentiation. They let the Whites interpret what the material was. When he and I worked it was, "No. Uh-uh." And I would take both classes. We would practice this dance with White kids, and he would say, "Yeah baby, that's good, that's good." Then I'd get there, and in private he'd say, "No, that ain't it." [I'd say], "But we did it—" [He'd say], "That ain't it!" And that used to frustrate [me]—And then I started understanding. Even his terminology that he used with us—When he talked about "planting." What is planting? Planting is getting your weight centered. . . . With the Whites, [he had] no expectations with them. And that's how they felt they were protecting their stuff. [They'd say], "Oh they can't take our stuff. They can't take our stuff because they don't have it." But what I used to argue with them is that they don't have it, but they're taking these interpretations and marketing it and putting y'all's names to it because y'all would say, "Yeah baby, that's okay," and giving it back to us. It's serious. . . . That's how they saw themselves protecting or not having fear that these White people are taking their culture.
>
> I see it a little differently because they don't really understand that it's not about truth. Truth doesn't always prevail. It's marketing and exposure. It's the same thing [when] SN teaches the White kids Lindy Hop. It's slow. It's a little off tempo. And I said, "They're going to take this, and they're going to take our jobs." "No, no, because they're just doing it for a hobby. They'll never get it." Well, what they're doing [is] that they are super organized. They are now going into the schools teaching this stuff that's a little off tempo, really don't swing, getting grants, because they could say they've learned this stuff from SN, and this is the real thing.

Like Patti and Alois, who are adamant about historical accuracy as it pertains to teaching White students, Clarissa comments on this theme of how African American aesthetics get translated to those

outside the culture. Before arriving at Engleside College, she taught for twenty years in urban areas where most of her classes were from 50 to 90 percent people of color, but predominantly African Americans. Much of how they move their bodies is close to Caribbean dance gestures. The distance between who Clarissa's students are and what she was teaching them being relatively short, she found that she did not have to spend as much time teaching style. She finds that one of her present challenges lies in decoding the subtleties of African-derived dances for White students and teaching at a more basic level: "As a result of trying to reach students and get them to be able to do those things with (a) the right intensity, (b) the right feeling that goes along with it—I finally had to start with breathing."

Nduma, who teaches much less now that his administrative duties have increased over the years, focuses mainly on courses that are geared toward the general student body rather than solely for music majors. His decision to stop teaching performance-oriented courses was in part influenced by frustration with students' inability to grasp the subtler nuances and stylistic elements of African American music:

> I'm not doing ensembles [now]. And one of the reasons that I stopped conducting ensembles is because I felt that I was at a point where what I wanted in terms of concepts of the music was becoming increasingly difficult to get. My experience was at historically Black colleges. And I found them capable of infusing . . . music with the kind of energy and rhythmic emphasis that I wanted because a lot of it was natural.
>
> And here, I found some of the students, and this is an altogether different environment, whose reasoning skills were beyond their playing skills. It was hard for them to understand that. Because they could read those notes, but they did not infuse them with the life blood that belongs with the music. Well, how could they get it then? I had to pull it out of them, which pulled a lot out of me to keep forcing the issue. Particularly, when I found sometimes that they were not playing as well as they thought they were playing. Because they had the notes, very fast, yes, and very technically oriented.
>
> I don't want to say that that's characteristic of all White students. But it's the difference between the cultures again. By the way, there are some Black students who can read just as fast as anybody else. But the majority of them didn't read as fast as

the students here at [the] university or any other place where they have been taught, particularly in the tradition of reading music and that kind of technical standard. Nevertheless, in major research institutions they are predominantly White, and they frequently don't have the naturalness in terms of rhythmic emphasis in jazz in particular.

What Patti, Alois, Clarissa, and Nduma bring to fore is the issue of meaning. They reject the notion of teaching culture in irresponsible ways. Patty wants to see Duke Ellington's work treated honorably. Alois and Clarissa want important historical dances to be taught with the correct feeling, and Nduma wants his students to access the subtle nuances of jazz. They each struggle with the problem of how to communicate or teach meaning. These arts are derived from culturally specific contexts that need to be retained in order to minimize their misrepresentation. Given that these concerns run contrary to traditional formal arts education priorities, these teachers have an enormous task on their hands as they attempt to communicate the importance of this value.

Overall, the principle of interaction is stressed by the teachers through their common concern that the arts not be studied and practiced in a vacuum but in the context of other ideas. The focus on making connections among artistic expressions as well as between art and other areas of human expression, and from the vantage point of a broader, more encompassing view of culture is a driving force behind their teaching.

Definition

Definition involves making sense of personal positions and forging individualized expressions through the arts. It is a critical approach in that it encourages and enables the contemplative, dialogical, and representational refining and defining of subjectivities. To promote this, the teachers encourage their students to explore their identities through their respective art forms.

This principle requires that students recognize their own unique qualities, assess them in the context of the world around them, and present their perspectives with confidence. In some ways, it tends to be the path of most resistance, where students meet the demons of aesthetic expectations and conformity, as well as their own well-drilled message to "play it safe." Sadik describes his approach to teaching drawing as one that pushes students to evaluate strengths and

weaknesses within themselves, as well as to rethink some of the
unproductive ways they may formerly have related to their own
creativity. Instead of referring to the process as "drawing," he tells
students that they are engaged in "superconscious visual art" and that
putting ideas together in color and form is a type of visual thinking.
This is his inroad to helping them uncover their individuality:

> For example, one of the assignments that I continually give is
> an assignment to do a self-ortrait on a square, and the square
> can be any size. And what a lot of people do is to start on a
> square and fill in that area with the portrait. What another level
> of people do is to start on a surface larger and reduce it to a
> square. And what some people do every now and then is stand
> the square on its end so it becomes a diamond. It's still a square
> if you turn it. . . .but most people think of the square as always
> having to be on the bottom side.
>
> The purpose is that most people will not have thought of it,
> and they'll eliminate it as a possibility. . . . They love it because
> it finally dawns on them that it's not what it [appears to be].

Similarly, Winston uses puzzlelike exercises to unblock rigid think-
ing patterns among his dance students:

> Most of us are used to walking forward. Everything is geared
> to the forward plane, the sagittal plane, everything in front of
> us. We never tend to think about what is behind us. And if you
> give them a walk across the floor going forward, and then you
> say, "Okay, turn around and do the same walk backwards, but
> it has to have the same amount of energy as your forward walk
> did," that stops them dead in their tracks.
>
> First of all, they are not used to traveling this way. They
> cannot see what's behind them. And because they can't see
> what's behind there, everything tends to get tentative and
> smaller. So you have to make them see backwards, and you
> have to make them aware of sidewards too.

The ability for students to express this discovery of their evolv-
ing intelligence is something Cindy uses to determine what they've
learned in her music classes:

> [T]hey go from being very fearful or unwilling to do things
> together as a group at first, to more open to different sugges-

tions, or not fearful. Of course, the class meets and often most of them haven't played together before. You have a group of strangers that you're suddenly put in that you're going to improvise with. There's no chart given there that you're going to improvise. I give some different kinds of models that they've never heard before. They actually have to listen to each other, and that's the most important point I stress in most of the exercises when they're working together in ensemble is listening and working back and forth off of each other. It's very strange at first, and it's very uncomfortable. But later on, by the middle of the semester, they're working together, and they're open to trying new things. That kind of acceptance of trying things that they haven't done before is something I measure their growth by.

Jerry teaches privately. It gives him an opportunity to work closely with his students and chart their progress. Encouraging them to fully internalize information they are acquiring and make it their own, he believes that this course of development triggers inner changes that then have far-reaching effects:

[F]inding your own voice in music, and I suppose the other arts, is without a doubt the most important thing in the world. We just don't need another Barbra Streisand. . . . And it takes you forever to find your own voice because you find yourself saying, "Hum, I like what she just did. I ought to do it like that."
. . . I think the process of finding your own voice is in original compositions. I think for a couple of years people ought to play and sing only stuff that has not been done by anybody else, and you are forced to make it come to life. If you sing "Body and Soul," you have much more of an opportunity to think of what Sarah [Vaughan] did with it, think of what Lady Day (Billy Holiday) did with it, think of what Ella [Fitzgerald] did with it, think what Carmen [McCrae] did with it, think of what Sheila [Jordon] did with it and incorporate a little bit of [them] than you would have if you did an original song and you don't have them.
. . . Now it's a funny thing because many people just naturally trust their instincts, and they find themselves very quickly. They believe in what they do, and they believe that others will like it. There are those who have absolutely no faith in themselves so that they must always be doing someone else. I have a guy who sings in my group. . . . It's only been in the last three

years that I have gotten him to try to find himself in his own singing. He's very proficient at imitating other people so that he would sing always with pyrotechnics. You know, scooting up and down, loud here, low here. But there was no *singing*. It was just one extraordinary vocal device after the other. I never got the chance to hear him go in himself and perhaps hold the note until it made him think of something or made him be a better person or made him stop and speak to somebody.

The fact that this internal journey has the potential to be life-changing is shared by each of these teachers. Paige, like Jerry, tries to help his students understand how important inner exploration is to their work:

[A]s a teacher, I don't want to create hundreds of clones of Paige Morrisons. . . . I teach people, and when they get so en-thralled about what I am and how I do things and everything else . . . I go back and break it apart and say, "It's the experience that I want you to have to build on. But I don't want you to lay paint on the canvas the way that I lay paint on the canvas." . . . I don't want them to please me or go out into the world and try to create the same things that I've created. Because then I have not scratched the surface. I have not opened that person to his own or her own possibilities.

So, what I try to do, getting them their wings and pushing them off on their own, is to find out what's inside of them and where they can go. What is it about their thoughts and their emotions and their spirit that can make them an artist? Do they need to do political art? Are they angry enough? Are they dis-satisfied enough to do social and political art? Is that what they're about? I don't want to tell them they should. I don't want everybody to go march for women's rights, but if that's what they want to do maybe somehow in their art they can do it. Or is their art about beauty and nature? If that's what's in-side of them then I want to unlock *that*.

Nduma had an exchange with a trumpet student who was "an extremely hard worker who wanted to improvise in the jazz tradi-tion" but who had difficulty translating her studies a personal ex-pression of herself. He explains: "One of the beauties of . . . how one develops as a jazz musician is the combination of learning a

melody or learning the essence of harmonic sounds and gestures and then playing their own thing, using their own voice in this context. It's not absolutely abstract. It starts from a point of reference."

For many of the teachers, the "point of reference" is that place within the students' own make-up that enables them to propose their own definitions of the world, as Petra explains:

> [T]he phase that [I] lead them through is one that is very reflective and one that is very expressive, and is experiential, and leads them into their own creative experiences. And the by-product of that is that they end up feeling a lot more confidence and a lot more able to take certain risks. . . . You have to be willing to be in that place where you take a risk—where you don't know. Or to learn you have to be comfortable not knowing. I think they're just general stances and understandings that I think are really central to art and what art teaches, no matter what the art is.

Petra's approach, which encourages students to "reflect, express, and experience," results in subtle but powerful changes:

> Their sense of authority changes, which is a big thing that art teaches. Their sense of authority changes so that they become their own authority. They start to use "I" phrasing more: "*I* think this, *I* believe this," instead of . . . the previous way that they talked, which just deletes any reference to themselves [laughs]. It's amazing how you can talk around things without ever saying "I." But, you know, we *learn* how to do that.

This "sense of authority" so important to Petra was shared by Patti, who explained what its development meant both for students and in her own life:

> To be independent thinkers. . . . To trust themselves. To trust their inner capacity for creativity because you do come into situations where in certain kind of schooling they try to deter you and tell you you don't have it. To just know in your heart that this is something that you want to do and that you know that you can do that well. So, what is that? It's a self-confidence. Self-confidence not to be deterred in terms of what you want to do.

She viewed this ability for self-confidence and independent think-
ing as "the difference between life and death": "When I say that, . . . I
mean spiritually, because once you allow people to beat you down
or to make you feel you're inadequate, which has happened to
many of us in society, many people of color in this society, then as
far as I'm concerned, you're gone totally."

In essence, the path of defining invites students to recognize
that they have something meaningful to say through their art and
to risk owning those visions in the presence of a public.

Transcendence

Transcendence entails viewing the mechanics of art-making as ser-
vicing the much broader agenda of expressing human values. Trans-
formational in nature, it encourages students to exceed the limits of
the material quality of the arts, that is, the rules of language mas-
tery pertaining to movement, sound, and visual images, for the
more significant purpose of manifesting their artistry on a spiritual
level. This is realized in the general consensus that technical skills
acquisition has its limitations. One of the many powers that the arts
posses is their ability to access feelings and realizations. These can
potentially transform both artists and audience members to higher
levels of understanding and, henceforth, action.

Making an artistic statement that is moving and meaningful is
what constitutes this principle. It requires that students break through
certain restrictions imposed by the inflexible advocacy of technique,
rules, or theories, which can often stifle the beauty and impact of
the creation. As Nduma confirms, "When somebody says, 'I was
really moved by somebody's playing,' that is not something that is
a technical thing." Though all of the teachers directly or indirectly
spoke about the importance of acquiring proficiency in their respec-
tive art forms, in various ways they warned about the dangers of
overemphasizing cognitive, technical approaches. Rufus affirmed
this: "I think it's important to be analytical. I think it's important to
be thorough. I think it's important to be meticulous. I think it's
important to be detail-conscious. But at the same time you have to
be able to find a balance between the detail and really overanalyz-
ing to the point of destroying the essence of the music, or destroy-
ing the purpose of the music the spontaneity, and the creativity."

The impact that art makes is greatly dependent on the artist's
ability to transcend the physicality of materials and to access their
deeper inner drives. This mystery is what Petra finds most compelling:

I've always been interested in *why* people create. . . . I'm interested in why people create art, why people create dances, or why someone gives birth to a whole musical composition or a whole symphony, why someone creates a picture, a painting, or why someone creates a suite of paintings that evolve over fifty years that at one point in time completes itself so you can look back and say, "This is the Blue period." I'm very interested in not just *why* people create, but most recently in my life, the relationship that people have with their own creativity, the fact that there really is this ongoingness. We live to complete ourselves. . . . It's not just because the mountain's there. My sense is that [long pause] we don't create paintings, we don't build houses, we don't write a book just to say it all. But it's part of our function to do these things. It's a step towards our completion, but it's not our completion in itself.

Patti teaches her students that for dance to be a moving experience its creation must be guided by a personal philosophy and passionate purpose: "I want them to find some basis or some reasoning as to why they do what it is that they do. I don't care what it is that they do, but I think that they should have a reason for their doing it. . . . It seems to me that if you don't do that you're just like in a boat, and you're just sailing nowhere."

The "completion" to which Petra refers and the "reasoning" Patti encourages are subjectively determined and defined by the artist. It is a journey that involves much more than the mechanistic, single-focused output of a product. Getting hold of a vision and then willfully breaking the barriers of sound, space, and time both requires and results in an openness and vulnerability that are necessary for making potent art. Some teachers say that one of the obstacles to attaining this state, or even pursuing it, is the overwhelming influence the media has on their students. Through the media, popular trends are imposed as artistic truths and formulas for success. Rufus talks about the dangers of "mind control," while Petra reflects on the "carnal" way that dance is viewed by general audiences, both challenging commercial motivations. Each teacher addressed the importance of transcending the limits of the outer, visible, natural world of art materials to the inner, invisible, supernatural realm of value, meaning, and purpose. Patti, in speaking about traditional approaches to dance training noted: "[E]ndurance, strength, and flexibility—you notice that's all physical things. They're not taught anything about philosophy. We don't talk anything about

any spiritual [things]. . . . Getting your leg up to your ear is one-millionth of what dance is all about. But the schools train us to think that *that* is the end of all dance."

For Winston, dancing is merely a vehicle for the much greater purpose of helping students become more healthy human beings. He beautifully delivers clear, confident thoughts about a dancer's personal responsibility to become more fully realized. In particular, a disposition for self-discovery is one of the most basic tools dancers can acquire in learning to center themselves and function at their highest capacity. He compares this holistic process to the pistons of a car, with all the parts operating in agreement, and to swordfighting, where the right grip and tension are required for maximum precision. Through these choice metaphors, Winston displays an acute desire to teach much more than movement for its own sake. Through dance, he hopes to offer his students his acquired wisdom:

> You are using your mind, you are using your body, and you are using your spirit. The *mind*, intellect; the *body*, physical; the *spirit*, expression. When you put all three aspects of those things together, and they work in harmony, then the human body is functioning in one of its rare instances as it was made to be, fully: mentally, physically, and spiritually all together. . . .
>
> Learning that balancing, learning that stability. Learning that inner confidence. Learning that humility. . . . Learning how to work with gravity and against gravity. There's always a giving and receiving in nature, a giving and receiving in dance, a giving and receiving [in] most art forms. . . . In dance you are always in a state of becoming. As human beings, that is our process, too, although a lot of us don't recognize it or think about it too often. So, things can't be rigid. There need to be rules, and there are principles, but nothing is ever rigid. It's those kinds of things you try to teach in dance about life and about situations that they will come to in life. I try to teach that it is a discipline that can generate self-knowledge. It is a discipline where you are continually learning about your body, because the body never stays still, like anything else. It's a part of nature. It's evolving. It is growing. It is getting older. It is evolving and diminishing at the same time.

When artists take risks, venture out into unknown or perhaps fearful terrain and imagine more than they may have previously

given themselves permission to imagine, their art becomes their teacher. They can look and see where they've been, where they are, and even where they may be headed. Very often, the next stage is the process of art making as a visionary pursuit, where the artist reevaluates the kinesthetic nature of the work and strives to use it for the greater purpose of communicating truths.

Clarissa finds that most of her dance students are used to aiming for their self-improvement. They push themselves to be stronger and more agile than they were in their previous dance classes, and they compare themselves with other students to measure their progress. She discourages this self-centered orientation by focusing more on collective interactions and awareness, placing students in physically tight groupings where they work shoulder to shoulder. In that setting, it is impossible to move without a strong consciousness of the group since all movements that are strictly self-involved become a dissonant element. The dancers smell, touch, see, and hear each other, bombarded by "multiple and simultaneous" modes of sensing. Clarissa subtly attempts to shift the focus from herself and the from the notion that "the [teacher] is the only one who knows" to a more lateral orientation, where dancers are learning kinesthetically from each other. This promotes a feeling of belonging, self-acceptance, and self-worth. By feeling secure about their value to the successful functioning of the group and their ability to connect with a variety of people, students learn to give and take in a way that is respectful of the group yet true to themselves. Her approach is a vehicle to teach important social lessons:

> It teaches you how to learn differently in a different mode. Then, that experience, that knowledge, I hope can be transferred to [the] larger environment and eventually people can look forward to larger change in society [pause]. So many people want that because we are alienated, we are disconnected. The sociologists have pretty much defined our society as having some inherent kinds of difficulties, weaknesses. And so people are yearning. People want to feel connected. They want to be involved in those kinds of events or situations where people seem to be at least enjoying themselves and having a good time. . . . I think people need to belong. People need to share. People say you need food, clothing, and shelter. But you need spontaneity. You need sex, you need love and affection. You need touching. . . . I think people seek out those things where they can begin to feel more connected than they normally would

be. . . . If you're teaching dance, you can teach a lot more at the same time. You can teach about values.

Recognizing these as opportunities for life-changing experiences, the teachers identified what they hoped their students might learn through the process of making music, dances, and visual art. Some of these included dedication and commitment to their ideas as well as the confidence and motivation to see those ideas through; gaining a level of satisfaction and opportunities for self-acceptance; engaging in inquiry and self-reflection; practicing the humility needed to assess honestly personal strengths and weaknesses; developing the ability to sacrifice old ways that prove to be unproductive in order to promote personal change; becoming more comfortable in unpredictable situations; and strengthening connections with others. The sum of these values balances that often looming divide between certainty and uncertainty. As Winston states, "You have to learn to be as sure as you can while leaving the possibility for any eventualities." Out on a limb, artists come face-to-face with themselves and are challenged to perform some of the most fundamental, transcendental functions—to grow, change, and become better human beings.

Facilitating Learning

What role do these teachers play in helping students realize the importance of these principles? Petra, for one, understands that her own development is directly related to that of her students:

In order to be a good teacher one needs to feel good about one's self. One needs to feel not just able and smart and competent. One needs to feel creative and pushed and passionate about that. . . . I think that creativity is a necessity of my life. . . . It brings out my intelligence. It brings out my sense of ownership and involvement in what I'm doing. It's more than how I survive, but it brings quality to my life, focus and purpose. If I didn't encase what I do in my creativity, there would be little to no meaning for me. It's very, very important for me, and I think that's the way I model it when I teach. . . . I'd like to see people have success with creativity and have the kind of fulfillment that comes from the kind of value I'm talking about.

Those teachers that Alois respects most and who have had the greatest influence on her are ones who maintained active perform-

ing careers while they taught. In turn, Alois' professional activities now communicate this same value to her own students. She spoke passionately about these teachers and why she feels it is so important to maintain their identities as performing artists:

> [They] have all been people who have lived very full lives. And that's what you bring into your teaching, all that reference. . . . They take chances. They've been hurt, they've been loved, they've succeeded, and they've failed. They don't just take the safe way out in terms of doing what is socially or politically acceptable. They weren't afraid to be different. They weren't afraid to pay the consequences for being different, and yet they had the spiritual strength to persevere to the point where that became a unique and valid voice unto itself that had to be reckoned with and respected. It didn't necessarily make them a lot of money, but it made their voice very clear in terms of their intent. So that if somebody walks into their class, they're walking in ready to accept what they have to give, hands down.

Nduma wants his students to find him accessible and approachable. Recently nominated for a distinguished teacher award, he explained what he believes were some of the reasons for the nomination:

> I think it has to do with style, more or less—empathy, understanding. I mean if it's a question of knowledge of subject matter, that's never a problem. I know much more than I could possibly tell them. The question is to tell them in a way they don't feel like I'm talking down to them or over them. I want to open them up to ask me anything. Even things that they may think are "off the wall" I can usually answer because I can bring it around. . . .
>
> Even as a very, very young teacher, I wanted to be sensitive and not kick a person who's already down further into the ground. I think it probably has to do with being raised in a completely segregated environment where you know what it means to be the underdog. I think that's become a strength. . . . When you're in a depressed environment you know what it is to have somebody with undue control over your life: what you can do, where you can go, where you can eat, where you can't eat, where you have to stay.
>
> I think it permeates my whole life. It's a strength now, particularly when you get into historically White institutions where

people have never imagined what it means to be really an underdog. They are very abusive to students frequently. I think students should be nurtured. . . . I mean, . . . sometimes they can say some very, very farfetched things, [and] I find a very diplomatic way to sort of turn them in thinking about it. [Otherwise], they'll freeze up, and they won't learn.

He feels that having a very clear sense of what is right and wrong is absolutely crucial for teachers. Nduma continues this line of thought with a wonderful story about one of his colleagues who spoke to a group of teachers on the subject of teaching and leadership:

He said, "You know, there's good and there's evil in this world." And it brought a snicker from all these intellectuals because "evil" is not a word that's a part of the convention and canon of most of these intellectuals. They think intellectually "evil" is an archaic expression.

I understood why the giggles and so forth, but I agree with him: There are some things that are wrong that cannot be right. Now, we pray or we hope that there are ways to change them, but they're there. It's always been like that. And he laughed, and he went on to talk about it, but I think that got some attention from some people. There are some professors that I think should be in that category. Anybody that can consistently thrive on giving grief to others, to me that's a source of evil. Or to destroy things—I think nature itself will destroy things. I mean, there's a life cycle for trees, for animals, and everything else. I think it's possible human beings have to be in the flow of that cycle.

I choose to be not a destroyer of things or people but something that can help. That's what teaching is supposed to be about. Teachers who violate that, I think, need some kind of way of reconciling what the real fundamental philosophy of teaching is. I don't know whether ministers consider themselves as people who work on our spiritual development. Maybe so. My way of dealing with it is to try to create spiritual things through the arts. That's where I live.

Patti used an illustration of a woman putting a seed in the ground and knowing when to water it, talking to it every day to ensure that the seedling is coming along: "a conductor, catalyst, guide," is how she sees herself. Mariah wants her students to feel

free to ask her anything, believing that this is one of the keys to "opening doors" and aiding them in overcoming the limits of their own racial stereotypes. Most of her White students have never had an African American teacher and usually don't know what to expect when she walks into the classroom:

> The other thing was there is no forum to really talk about race. . . . [I]n teaching my course, I found that the students wanted to be able to talk about race. They wanted to be able to talk about their experiences. . . . What I found was the students saw me as someone, particularly the White students who had no contacts with Blacks—it seemed to me they were interested in bringing up things that were race-related. And it seems that there was no forum for them to talk about it. So the class became a place to talk about it. . . .
>
> Well, here's what goes through my mind: How am I going to get through? What's the best way I can get through to this person? Should I say something that might diminish them, put them down, make them feel like they're sorry they asked? Can I say something that might get them to think for themselves? [or] can I say something that might provoke them to challenge their belief but also to lead them to think for themselves?
>
> I find that you can do that in a number of ways. You can teach people by enforcing and policing and demanding. I mean, I *guess* you can teach people that way. Or you can try to open doors. Instead of figuring it out for them and telling them what they should already know or do, just try to expand that window a little bit more and get them to tell me what it is that they saw or what did they think was happening. What did they think it felt like? What would they do in this situation?

Because of her inviting manner, one of Mariah's students from Indonesia confided in her in an unexpected way. At the beginning of the semester, she asked each student to introduce him- or herself to the rest of the class, encouraging them to share some information about their backgrounds and interests. A few weeks went by before this particular student, who Mariah noticed had been very quiet in class, approached her saying that she had not called his name during that introductory period:

> I remember that day. I had just looked at the roster. And his last name was Ho Ho. And I felt like [pause] I was stopped a little

bit by the name. And I didn't call on him because I was trying to figure out, now let's see—this is his name. . . . [A]s time went on it was fine. I had to do the attendance, and I said, "Ho Ho." I did it, but I was really sort of sensitive. I thought, "This must be difficult to have a name like that." Now where he came from it was all right. And here probably he gets a lot of flack.

As Mariah recalled her own discomfort addressing this young man, Ho Ho went on to say that he enjoyed the class but that something had been troubling him, which he wanted to share with her. Earlier that day in class, while exploring the issue of homelessness as it related to the work of a particular artist, Mariah had posed the questions: "What would it take for you to beg?" and "Who knows what being homeless is like?" The urgency of the questions stimulated a discussion led by a Vietnamese and an African American student who had experienced one or both of these situations: Spurred on by the potency of this dialogue and its relevance to his own life, Ho Ho decided to share his feelings with Mariah:

> He said, "You know, Black people are very hard on my people." And it was hard for him to talk. I knew how important it was that he would take the time to come up, because he could have just kept going. . . . This guy had a hard life. . . . [H]e had traveled and had to go from place to place and boat to boat. And he found his way here, and he was here trying to make it. . . . He said, . . . "They have this thing that they do. A lot of Black people they will rob us on the street or they have come up and they have a bag. And they'll bump into you and drop the bag and say, 'You broke my bottle. You have to buy me another bottle.'" He said he has seen that happen to other Asians and that then that person has to give that person money because they said that their liquor or their bottle was destroyed because that person bumped into them. And he said that he was never going to do that, give them the money. But it happened to him, and he gave the money anyway. He was saying that people do it because they're afraid and how hard it is for him. So, it was good for him to be in a class because I guess he was able first of all to tell that story, and also he was able to talk to a Black person.

To the extent that Mariah views her presence in the classroom as an African American and her emotional availability as catalysts for students' personal growth, Petra spoke about her own role in

raising the level of students' creative consciousness. In that much of her work is directed toward teacher training, she has given considerable thought to what she calls "the culture of teaching." Petra finds that there are commonalities in the behaviors and identities of the public school teachers with whom she works, and what she observes has triggered her role as an educator. She speaks about many of these teachers as being largely defined by their professions. Generally, they work very hard. There is relatively little encouragement available to them, and therefore, often a lack of motivation to draw from other professional models and continue growing. Undersupported, these teachers carry the burden of a public notion that their work is automatic and task driven rather than "a reflection of a mastery." Although it is the artistry of teaching and the overall development of creative thinking and behaving that interests Petra, the fact that the subject area in which she teaches is the arts renders the task doubly challenging:

> I think that when you teach art, your teaching has to happen on an even more masterful level. . . . What I'm referring to is art with a capital "A" and art with a little "a." I think as a popular culture and as a society we don't have an experience with art with a small "a," which means we don't have an experience by and large with our creativity. We think creativity and art are synonymous with each other, and they're not. Creativity can develop into art, but they're not the same thing. And we don't have this kind of . . . grounded relationship with art. We don't have the creativity within ourselves that makes us appreciative of art when we see it. We don't know how to nurture, foster, and teach it because there's no place for creativity in our schools.
>
> I don't think people should be frightened by art. There are . . . reasons why we have those fears, those insecurities. That's when my role as an educator, specifically as a multicultural educator, gets triggered [and] gets called into play. Because I'd rather look at cultural frames that have us frightened of our own creativity and talk about that as a preset for doing an art activity. I find that when I do that, it really helps people to understand their creativity. Because it's not that some people have creativity and others don't. It's that we don't have access to our creativity because we put it down. We close it off. We shut it out. . . .
>
> How do we guide our own creativity? Would we know it if we saw it? How do we recognize our own creativity when it's

expressing itself, and how do we guide and how do we struc-
ture it? What kind of structure does it need? What kind of
feedback does it need? Well, I think it's necessary that it mean
different things for different people. For me, it begins with ful-
fillment. But it's got [pause] a spiritual base to it too. It's really
where I get my energy to meet the calls I receive on a very
deep, personal, spiritual level. It really motivates me to do the
work that I have to do. If I didn't have that qualitative sensibil-
ity, I might not work as hard, or work as long, or work to
achieve the kind of excellence or quality that I push for. So it
gives me a sense of purpose. I don't really know of anything
else or anything in my general schooling that taught me that.
Only my experiences as an artist taught me that. And I would
like to teach people how to have access to that intelligence in
any context.

Sweeping the Temple
Patti's Story

Passionate and strong-willed, Patti delved into a range of difficult and complex topics. Hired as a visiting lecturer at a school attempting to increase its numbers of African American faculty, she spoke quickly and unabashedly, constantly placing her work and the meaning of her personal and artistic involvement in the context of much larger social issues. Patti's recent death from breast cancer throws a particularly piercing light on some of her visions for the future.

I grew up in Queens, New York, as an only child, in a household that loved the arts. We played a lot of jazz music at home and my parents took me to a lot of plays and ballets and concerts. I think it was because they loved the arts but also realizing I was the only child, that I needed to be involved in some kind of activities. My mother was an artist in her youth and had a scholarship to the Sorbonne in Paris for visual arts. My grandmother, who was very old fashioned, from the islands, refused to let my mother go because she was going to be going with a female chaperone, and she was feeling not secure about my mother being in another place with another woman she didn't know. So, my mother was not able to take advantage of that, and that was really unfortunate. Also, at a different point in time in my mother's life, she sang with Count Basie's band very, very briefly. My father was in two or three of Oscar Micheaux's films. One of them was called The Colored Underworld. We have pictures in our album of that movie, and I've seen clips of my father in that film on public TV.

133

My grandmother is from Jamaica, and my grandfather on my mother's side is from Panama. My father's family is very interesting because they're from Philadelphia and they're one of the first Black families to move to Harlem. My grandfather, Solomon Boyce Johnson worked for immigration. Ellis Island. He made a lot of connections with people and was very close with some of the people that were connected with the Harlem Renaissance. They came to my grandfather's house and had dinner and that kind of stuff—Langston Hughes, and the painter Romare Bearden, and some other people. Also, they were involved in what they called the "normal schools" in Washington, D.C. and the Underground Railroad. And I can even say, I mean, I don't know if it's anything to be proud of, but my great, great grandfather was the barber of Abraham Lincoln. There's a letter floating around in the family where when he left Abraham to have his own barber business. Abraham writes, "Yes, he was a good boy when he was in my service." I don't know who has that letter. Somebody has his hair, too, somewhere.

I'd say we were middle class. My clothes were made for me when I was little. We had things, and we didn't have to struggle because my father made money. He graduated from the Massachusetts Institute of Technology in 1916. He went to law school but never practiced, never did his bar. Don't ask me why. I don't know. My parents were invested in education. If you had an education then that meant that you were a decent person, I guess. And if you didn't have an education, I'm not quite sure what that meant. We didn't have that conversation about hair texture and color and skin and all that stuff. I don't remember saying, "I'm colored." I don't remember saying, "I'm Negro." I don't remember saying, "I'm Black." See, I was always around Black people. That's the other thing. I never was around White people. I didn't get around White people in numbers until I was a grown woman. The community was very insulated and very self-contained.

I went to Catholic school from the first to the eighth grade. When I was about seventeen, I went to the High School of Performing Arts. Now that was a very interesting school, but I have a bitter taste from that experience. In fact, I've been thinking about even writing a little something on that. A lot of the people that I went to school with had a bad taste in their mouth, too. That again was predominantly students of color, but we had no people of color at that time on faculty. Again, I felt and other people felt there was an underlying feeling of racism going on there. You couldn't put your finger on it.

They were very brutal and very—I mean, structured though, because they were getting you ready to go into the performing world.

And everybody that I graduated with did go to reputable companies. So maybe I was not mature enough to deal with what was demanded of me. When I went to Performing Arts High School I was 126 pounds. Part of the process is they treat you like cattle. They treat you like cattle. The audition process—they have you turn all different sides. They're looking at you from both right side and left side, front side, back side. All this, just visual. It has nothing to do with you moving. They just said simply to me, not "Hello, how are you." They said, "Either you lose fourteen pounds in two weeks or you get out."

At that age I knew that I didn't feel that that was what teaching was about. It was not about dehumanizing and humiliating a student. And to me, that was the atmosphere there. And what they said to me was, "You were good when you came in here, and you're good now, but we don't see that you have improved. You didn't go from good to great, or good to a little better. You stayed at the level that you were at, and therefore we feel that this school is not for you. You will never be a dancer." It's like the athlete who's in the high school that's used for what they can do and then discarded at the end of the use. You know that people don't really have a real concern for you as a student and your education. They just want to use you. I mean, there were some fabulous people in the school that made the school look good, and that was good for them. They liked that. But I don't think they ever really wanted to give us the respect or the credit for that. While you were at the school, you had these different concerts and these different presentations in which the community was invited and parents were invited, and board of director people were invited to see what kind of curriculum the school was presenting or producing. It was for show to a certain extent. Even though that school has turned out some fabulous dance people and theater people and musicians, you paid a price for that.

I went to the next school, which was the Springfield High School, which was in Queens and was a newly opened school. And they had a beautiful dance program, very low key and not competitive. We were never censored. We were encouraged to choreograph our own work, and that was really nice.

I had a daughter in 1969. I got pregnant in the end of my junior year. I was eighteen. And you could not go to school at that time with other students. I couldn't go to school during the day because I was pregnant. Heaven forbid by osmosis they should get pregnant by looking at me or being in class with me. That was the kind of mentality they had then. So I had to go to school at night. Forget about doing dance classes or any of that stuff. I had a daughter to support. First,

I wrapped meat in a meat market. Then I worked at the telephone company for two years, and then I worked at Bellevue Hospital for three years. And I was still going to night school. My mother helped me. I would have been in the street if my mother had not helped me in terms of raising my daughter and providing a roof over my head.

At Belleview Hospital I was a clerical person. I did diagnostic coding of charts. I read everybody's case history. I went on the wards. But I realized that I didn't want to do that for twenty years. I knew that whatever you chose to be your career should be your purpose and that it should be something that you love because you're going to have to do it the rest of your life. And a girlfriend of mine and her two children had moved to Massachusetts. And during vacation time from Bellevue Hospital I went to visit her with my daughter, and she said, "Listen, I'm at the University of Massachusetts. You'll be able to get some grants, some funds. If you have to, you could get public assistance, and it will make it a lot easier." So I went.

What was fortunate for me when I got there was I had seen Diana Ramos on television on Channel 3 when she was with Eleo Pomare performing Hex. And I said to myself this is a very exciting, different kind of dancing. First of all, she didn't look pretty. She looked very ugly. Her face was painted. The movement was very strong and very direct. I've always liked very harsh or strong movement. Miss Ramos is a fine technician. When it came to looking at the facility, what the body could physically do, her facility was fabulous. And the music was avant garde Black classical or jazz music that didn't have any melody. It was just very different from anything that I had seen. I said, "I love this. This is exciting. Real different." And it turns out that Diana Ramos was teaching at the university. But I had been turned off from dancing. I was going into social work. I had no intention of going into dance. I had had it. I was going to work with people. And so what happened was I didn't want to go to Diana Ramos' dance class. I'd see her on the street. My girlfriend had told Diana Ramos about me, and she'd say, "When are you coming to my dance class?" And I'd say, "I'm never coming to your dance class because I don't deal with dance anymore. I don't like dance. I don't like people that are connected with dance. I don't like anything about it. I'm not going to be a part of that." And one day I don't know what happened. I went to that dance class, and I never left. I was with her for three and a half years.

Diana's class was a safe place. I knew that she believed in education and the freedom to pursue your creative voice and that even though she was very much a disciplinarian and very much a task

master, it was with love. And there was a wide space that you could move in, in terms of creativity. We did our concerts with her. She ended up having an ensemble: The Third World Ensemble. In rehearsals, she would set up a skeleton, but then she would ask us to improvise. And there were many times where that improvisation remained in that piece because it worked out. It was really beautiful, and she allowed us to do that. She was not a dictator. All of the whole three years, those interactions were great. With Diana it was very clear that dance was a vehicle to address political issues, whether it be around race, class, gender. And this was the first time that I saw it in a formalized form. There was always a theater component attached to her classroom teaching and definitely her performance teaching. And she talked a lot about philosophy, and we talked as a group. It was a very unusual and special group because we were all very open and flexible and sweet.

I was a principal dancer in that ensemble. And then after that, I was an independent dancer. In the seventies, it was a time where the community that I lived in was very receptive to what I was doing. That can make a difference. And I saw, as I stayed there, how the audience changed from a majority people of color audience to a sea of white faces. That felt strange to me, and I didn't like it. I'm geared for work that is for, by, and about Black people or people of color. If anybody else can come in and get something from it, fine. But that is not my agenda, to educate White people. Even though when I am put in that position, and I have been, those students, I love them all equally. It isn't that I feel I cheat them on any kind of level because I have this feeling. But let me say this. Education is different. I think in a classroom it's different from performing. I think in the classroom anybody should be able to go in and learn anything. But I am a stickler on certain things in terms of performance. I just feel there are so many talented people of color that can do everything. There's no need for me to ever ask a White person to do anything if I have access to these other people in the performance arena.

I was happy to go teach at [the] college. It was a good experience. And my feeling is that every experience that you get involved in is a learning experience. I'm saying that it was a good experience because I had a lot of time to delve into what teaching entails. I was not censored by the university on any kind of level. Well, nobody has ever tried to censor me anyway. You hear stories in academia, that people might not always approve of what you want to do and maybe try to

deter you from doing whatever it is you want to do. And I didn't find that a problem, which was great. I had freedom in what I wanted to say and how I wanted to express myself.

Choreographing for White students was so hard. The difficulty was I never worked with White people. I never choreographed on White people that I can remember as long as I'd been choreographing. If I could get around it, I did. What was difficult was that all the pieces that I wanted to do that had to do specifically with the African American experience then I couldn't do that. Because I was not going to put White people in those kind of roles. It just is not logical to me. So it meant there's certain things I couldn't do. However, there were some other feelings and experiences that people have that go beyond color. In other words, depending on the community, everyone is starving. It isn't just Black people that are poor. There are White people that are poor. There's other people that aren't of color that are suffering certain conditions. So what I would do is try to find a subject that I felt would be able to encompass these White students without feeling that I was compromising myself in terms of who I was as an artist and who I am as an African American person because I don't separate it. It's all connected. So, it was very difficult.

I taught modern dance, three courses each semester. The staples were always Introduction to Modern Dance. I taught Intermediate/ Advanced Modern Dance. Then every semester I would deal with my specialty, and it rotated. The first semester I was there I taught Dance and the Spoken Word. Second semester I taught Dance as a Vehicle for Social Commentary. And the third was The History of Black Concert Dance from the 1930s to Present.

I loved that Modern Dance class. These are the students who have never danced before, and they think they're going to use this dance class to get over. You know how some students are in terms of fulfilling the physical education requirement. So they feel, Okay, let me take a dance class. They were very frightened and self-conscious. I loved that class because when they first came in they were scared to death. By the end of the ten weeks, they're going to be a solo dance artist [laugh]. I loved it. What I would do is I'd trick them. I wouldn't put it in the syllabus because I knew it would scare them. I always have a slot for my students to improvise. And what I would do is I wouldn't put it in the syllabus, but I would whip it on them on the sly. What would happen is by the time of the end of the quarter they had choreographed a dance piece and didn't realize it, or they did realize it, but it was too late [laugh] because they already did it. It was nothing to be afraid of.

Now, the Intermediate/Advanced class ran the same way with improvisation, and you're not supposed to do that. You're supposed to run a technique class for the whole duration of time. That's how people do it. They don't give you the time to improvise, but I didn't want to do that. So a half an hour before the class was over, they would work on their improvisation. And then they'd work with one another. And then I'd have them make sounds and accompany themselves to movement. And then I had musicians come in from the music department and play for them. And then they'd do some interacting with the musicians, improvisation. Oh, it was a lot of fun.

Usually, in a technique class you don't have that opportunity. You are in there to do what the teacher tells you to do. It's as simple as that, like being in the army. None of the dance schools I trained in, ever. Never. It's just not done. For whatever reason, I don't know. Sometimes you'll take a choreography course in graduate school that might involve improvisation. Maybe. Depending on the professor. But generally, no. It's a technique class for you to develop your physical facility, period. There are courses that involve improvisation, but those courses are not within the modern dance technique. They would have a course called "Improvisation." They'd have a course that would be separate. You don't mix that with technique. When you look at dance forms here in the U.S., it's like medicine in the sense that the body is not treated as a holistic entity that has a mind, spirit, and a physicality. It doesn't happen in medicine. If you notice, they just treat the body, not the spirit or anything else. And with dance it's the same thing. It's just about the body. There are, of course, great artists or great teachers who know better and make sure that they give that to their students. But I bet there's as many dance people or educators who don't and believe in that regimentation.

Dance and the Spoken Word is a course to delve into how to interweave movement with any kind of spoken text. Whether it is in poetry form, prose form, narration, story telling. . . . How to work with it but without making it cliché. How to work with it in trying to make it innovative. But what was unique about the class is the midterm and the final. The midterm required that the student[s] choreograph a dance piece no less than three minutes that dealt with any kind of spoken word that they wanted to use. Now this is the difficult part. They had to choreograph a group piece. And the reason why I wanted them to deal with a group piece is because a lot of time artists are put into a solo mode. They know how to work with themselves, but they don't know how to work with anybody else. And I think that that's important. Also, I wanted them to really understand the idea of

what collective meant: taking in other people's ideas and trying to figure out how to encompass everybody's ideas and not cheat anybody.

The other thing is they wanted to be graded individually, and they were graded collectively. That's something else that they had a hard time with. It has nothing to do with dance, but I did it because it has to do with daily living skills and transactions and relationships. And I felt that it was important for people to know how to work collectively because I think that that's going to erase some of the problems that you deal with now in today's society. We're in a very individualistic society: me for me, I for I. It was my way really to get them to start dealing with that kind of concept. And they didn't like it. But I said to them, "You are only as strong as your weakest link. So that means that everybody's got to try to rise to the occasion so that there is consistency, there's evenness and strength all across the board." I think that they learned a lot about themselves by going through that process.

I left the school because there were too many battles. The Black community was thirty years behind the times, at least. The faculty of color were about fifteen years behind the times. The administration was maybe fifty years behind the times. There were too many battles, too many fights. In other words, if the faculty on campus was strong, I feel, and committed to this idea of multiculturalism or ethnic studies and women's studies, and the community was an innovative community, maybe I would have stayed. But there's no way I was going to fight the community, fight administration, and fight faculty members too. It was too much.

I think that the university's intent was good, but I don't think [it] had a clue about how to approach this. It didn't have enough intelligence to go ahead and pay somebody to come in and give equity workshops, or whatever, to give them some guidance and direction in terms of how to approach this. They've been in all this Whitedom for so long. How are you going to make a transition like this overnight? You can't. So I think in a way this Minority Lectureship Program, even though they got six people this year, which is more than what they ever had, I think that they did it wrong. They didn't really have a clue as to how to really do it. And they didn't have other things in place to make this thing work.

I think that I have known my direction for at least twenty years. I feel that I do know what I want to do in the future. I know that I want to make dance films. I know that we're not documented. I know

that dance is not documented enough, and that's scary to me because of the loss of elders. Because of the AIDS generation, we're losing a lot of dance people, and if you don't document it, you're going to lose everything. I do know that I want to do that. I want to get away from the performance. I'm not interested in doing that anymore. I love choreography, but it's not necessary for me to be on the stage anymore. But that's how they train dance people, unfortunately. They train you so that the only important aspect of dance is the performance end. Forget therapy, forget administration, forget anthropology, forget choreography. That's second fiddle to performing. And my feeling is that that's just one way of expressing yourself. It's not the only way. I want to swing more now into education in the sense of writing about it, putting slide presentations together about dancers and the art of Black concert dance.

I do want to be in a university setting because I think you need all kinds of people in those kinds of institutions. I don't think that they can manipulate me, and I don't think I can be held hostage by a job. And I think you need that type of person because you have a lot of lobotomized people in university settings. They're pretty much dead. They have stopped fighting for themselves, and they have stopped fighting for anything that is of any kind of importance. You tell them to go jump in the lake, and they'll go jump in the lake. They're robots. They're afraid for their jobs, so they have gotten into a mold now that they can't get out of. This is White people, too. This is across the board. I don't care who it is. And that is a regimented kind of "Yessir, boss! I'll do whatever you say. How long should I shuffle, boss?" The bottom line to me is the students, their education. The best education they can get is what all students deserve. If you're going to have people to tell you, "Don't inquire, don't ask questions, don't analyze," then what kind of education is that? And a lot of professors do do that. They don't want you to think. It's so sad. And I guess they think that they're doing the right thing, or they're just tired. They're tired of fighting the fight. Because academia is an enormous overpowering, overwhelming kind of setting. So you have to go with what you feel is right. And if you've made enemies, or there's some conflicts, confrontations, then so be it.

You don't look for nurturing in that kind of setting. Hopefully, you're in a community that gives you some kind of sustenance. You're in a family situation that gives you some kind of sustenance. You don't depend on that kind of corporation to give it to you. I think that's where we make our mistake. For Black people to look for any kind of recognition, or any kind of support in these White institutions, forget

it. It's not going to happen, period. You have to know what you're dealing with and be honest about it and say, "Can I deal with it or not?"

I'd like to write a couple of books, too. I think that in the last ten years or so, Black dance artists and philosophers and educators and choreographers have really written, but we haven't up until that point. I think it's very important so we can leave something to those people who might be coming after us. It's important for people within the culture and within the art form to document. I don't know if we can trust that people outside the art form or outside the culture are going to tell the whole story. In fact, it's proven that we can't trust that they're going to tell the whole story. I have two ways of thinking that are opposite. One tells me, no, I don't trust that because they don't know anything about it. But at the other end, maybe somehow or another these dance critics and dance philosophers who do write about it, maybe they have been able, in some kind of way, to glean information and are capable of doing so even though they're not dancers themselves. I don't know.

We as Black people are in such a mess. I'm really concerned about us. I think that from the beginning of their nurturing—I'm talking about White people—they've had certain kinds of opportunities about self-worth and self-esteem that we have not had. So, I guess I'm saying that I have to be who I am in that I am an African American woman. I am that, and I am concerned about those issues. So I have to be who I am in the classroom. The other thing is, and I talk about this in dance even though it's not dance. I want them to change things, too. See, I expect everybody to make changes. I really do. But my focus is people of color. And I don't treat my students any differently. I care for all of them, there's no doubt about it. But I know that we, as people of color, need other kinds of assistance or input. Of course, I would prefer to be in an all-Black classroom. That's my ideal. But it doesn't mean that I can't still give and teach in whatever situation I'm in.

Are we schizophrenic? In general we have to be, I would assume. And I think we have to say that we're pathological. Black people are pathological. We have a pathos. We are ill on a certain level. I think we have to acknowledge that because of what our history was. But it did damage to White people, too. They're pathological also. They're sick. They're crazy, too. We all have suffered because of this notion, this idea, this perpetuation of racism. That they feel so threatened by Black people—that they feel so threatened by us says to me there's something wrong. In other words, in order for me to celebrate who I

am doesn't take away from who you are at all if you're a secure person. Now, if you're an insecure person, then for me to assert and celebrate who I am is going to make you scared and uptight. And they're scared because I believe they know all these years that they've not been just with certain groups of people. And instead of trying to fix that, which it can be fixed, they have gone along with it. And I think it has made them ill too. You can't buy and sell people and think you're going to be all right. I don't believe that. I'm talking about the slave trade and all that. There's this idea about knowing things unconsciously as a group, a collective unconsciousness. There's some body knowing that nobody can put their fingers on, body knowing. They're suffering too. When you see Caucasian people trying to hold on to African culture, or African American culture and try to eat it, sleep it, drink it—and they think they can get it by reading and taking these dance classes, taking these music classes, it's not going to happen.

But yeah, we're definitely all sick. Black people wouldn't do things to one another that we do to one another if we weren't ill around color, around hair texture, around financial status, around education. I mean we do awful things to one another around those really insignificant qualities. It's not important. None of that is really important. Since when do you make a judgment about somebody according to how much they make a year or what they do for a living, how long their hair is and how much it curls, what shade you are? You don't. It's crazy. It's just a shell. The body is just a shell, or a house, or a temple of the spirit. That's all it is. It gets you around for you to be able to do and communicate. That's all it is. It's not the end of all ends. The body is not the end of all ends. It's the spirit that is forever.

Who Built the Ark?
Conditions at Schools

To the degree that these twelve teachers bring a wealth of knowledge regarding the value of creative development to their classrooms, there are events and circumstances that affect their performance at their schools. The ability for teachers to function well and accomplish their goals is influenced by factors ranging from their physical environments to the emotional impact of daily interactions. These teachers spoke candidly. They discussed conditions that affect them academically, socially, politically, and economically and that directly support and impede their teaching and their professional well-being as artists. The issues raised pertain to policies, resources, structures, and relationships within their academic departments, schools, and communities. They address concerns about the ways in which schools demonstrate their commitment to cultural diversity, the need for African American scholarship to be more highly regarded, and how plans for multicultural programs have been implemented by high-level administrators. Most of the teachers bemoan the fact that there are so few African American students in their classes. Some of them explore the nature of their relationships with colleagues as well as academic and social support systems. They also reflect on the advantages and difficulties of being artists affiliated with academic institutions.

Commitments to Diversity

Rufus, Clarissa, Jerry, Nduma, Paige, Alois, and Patti spoke at length about the need for schools to prove their allegiance to the notion of

building a more equitable education system. For many, a major pitfall is the monocultural, European-centered canon traditionally regarded as the measure for scholastic achievement. Teachers are acutely aware of the discrepancy between what their schools deem important for learning and the perspectives and expertise they believe they have to offer, which are often culturally broad by virtue of their own personal and academic experiences, training, and interests. Added to the obvious rift between what these teachers bring to their schools and what schools value is the fact that schools often regard themselves as neutral sites of knowledge. This "objectivity" is advocated in Sadik's department and grossly undermines his teaching. He resents the expectation of many of his White colleagues that he position what he teaches in relation to European art or "the big picture," arguing that many of them have still not revised their courses to portray more inclusive and accurate representations of art history.

Not only has the African American presence generally been omitted from most academic curricula, but an overwhelming number of music departments exhibit what Nduma describes as "an inferiority complex." That is, they measure the musical achievements and standards of American music against that of Europe. By ignoring America as a source of cultural wealth, they perpetuate subordinate identities within a constructed notion of cultural legitimacy. Jerry observes this same attitude:

> I'm in an American school, but it's not very American. What I sing is American, but it's not very much respected. See, the old method, up until twenty-five years ago, was when you graduated from Julliard then you went to Europe, and you studied. Now it is turned around so that people from Europe come to Julliard no matter what they studied there. They haven't quite *done* it until they get over here. I don't know that it will ever happen that American music will be as respected as European music because Americans must . . . [m]ake American music as respected as European music. We don't even play American music in our symphony orchestras. We don't do American operas in our opera companies. And we're the ones who are going to have to do that [pause]. . . . Duke Ellington ought to be taught in every music [program]!

Cindy, who has taught for seven years at her school, became a faculty member soon after receiving a Ph.D. Her assumptions that

the academy was where experimentation and "cutting-edge" ideas were welcomed were based on experiences as a student at a progressive secondary school, college, and graduate school. She remembers the music department where she earned her Ph.D. as an exciting place where controversy, criticism, and debate were regarded as essential to learning. Her school is relatively young and was founded on some of these dynamic philosophical principles, yet she feels that some of their "progressive" goals have become static:

> [I]t seems like there's an idea of liberalism that is kind of rhetoric at this point. There's some rhetoric that has been kind of frozen in time and unchanging. "Racism" and "gender," those words are thrown around. Race and gender and class. Courses always deal with these words. Students come through, and they learn about these issues, but I'm not sure. I mean, I don't . . . deal with courses that relate solely to those issues in music. Not enough I guess. I try to bring that in when I can, but . . . it's kind of a situation where those issues, those terms almost have been trodden deep down until I'm not sure what they mean anymore at Rangeview [College]. Ideas have been kind of frozen, and there's a resistance to change.

Many of the teachers concede that their schools express concerns about diversity and have made efforts to recruit more African American faculty. However, most of them feel that these efforts are symbolic and superficial and that schools do not take the necessary steps to ensure the retention of these teachers. As Paige, who is both an administrator and teacher says, "When we had a few affirmative action inquiries, they always wanted to find me to put on my suit and stand up front so they knew that we had one of us."

Patti talked about some of the reasons for declining an offer for a tenure-track position at her by her school. The main one was that she recognized the trend in diversifying the campus as a system that was destined to fail. It was not mandated by the president, and it was dependent upon the dean to carry it through. The dean, however, was not invested in these efforts, nor was a sufficient number of faculty, as she explained:

> [The president said], "I want multiculturalism, I want ethnic studies, I want women's studies, and I want it . . . immersed in the curriculum." But there was no way to implement it because

it wasn't really demanded. And people are not going to change ... by you asking them to please do it.

In fact, I went to the president about five times when I was there, ... and I said to him one day, "Now when you took America from the Native[s] you didn't ask for them to give it to you, right? You took it. So, it seems to me that in this case, for you to expect that you're going to stroke people into making these changes or cajole them into making these changes, it's not going to happen. Is this just as important as the other things that you thought were important?"

He said, "Yeah, that's true. But you know Patti, you can't make people do things." I said, "Why can't you? You're the president. Yes you can if you care to. And if you don't care to then you should stay White and all male and forget about this multiculturalism and just be who you are, White and male." He said, "That's true. But it's a slow race, and you can't move too fast." I said, "Yeah, and if we were to be dealing with that I guess Black people would still be picking cotton off plantations."

So, I just in essence said, "Look, I'll meet you half way, but you're not meeting me half way. Don't waste my time. I'm willing to dig in and roll up my sleeves and go ahead and fight along with you for this, but you've got to be serious. I can tell the way that things are not in place and the way that you're approaching this that you're not serious. I don't ... think I can stay."

All the teachers view the expansion and reform of the academic canon as necessary for the support of their teaching. Cindy, Patti, and Nduma spoke about the role that African American teachers play in presenting more inclusive approaches to the study of music. Cindy states: "There's a responsibility to cover music by women, music by Black American composers, as much music as you can or else it just won't be covered." Nduma goes on to explain how he feels about this responsibility from both the standpoint of a teacher and administrator whose dedication to diversifying the academy affects all aspects of his work:

I'm pleased and proud to have had the opportunity to do this. It has meant opportunities for people of color. But it has also meant opportunities for people who are not of color. Because they can't know about us the way we know about us. We have

to be their teachers. Some of them study and do pretty well. . . . Some of our strongest allies have been Jewish people. At the same time you see the media using the two forces to work against each other, battering and beating each other. History will show and documents will show that they have been some of our stronger allies. . . . So, I don't mean that nobody else can help us. I never meant that. But we have to really help ourselves too.

One of our present conflict[s] in the second generation, probably on to the third, is that somehow or other somebody thought that we could be taken care of by the government. I think that's a dangerous mistake. Governments look out for themselves. They always have. They're not going to take care of Black people or any other people of color. They're not going to take care of poor White people. They're going to take care of power centers because that's what they've always done throughout their history. . . . It's individual. So, I transfer that to people of color. We know more about our culture than they do. They can't possibly have some of the insights that [we] do with [our] background.

For some, finding relevant books, films, videos, and sound recordings in their school libraries is difficult, particularly for those who teach at smaller colleges. Not only is there a dearth of resources pertaining to African Americans, but for those teachers whose curricula have a more multicultural focus, suitable information about non-European arts is difficult to locate, a sign that their school's commitment to diversity is weak. Inviting artists from outside the academy to lecture is one way that teachers have sought to supplement faulty resources. Nonetheless, Clarissa is displeased with the position her department has taken on its use of resource funds:

Faculty-wise, I find the dance department really exciting, challenging, interesting individuals. They seem to be on not only the politically correct mode, but I think they genuinely are concerned with diversity and interested in me being here. I think that [my] position came up as part of their programming before it became a kind of affirmative action issue. They were ready to augment their dance program. So, I came here with a real clear vision of what I was going to do and how I was going to fit in. And now, the honeymoon is over. They're happy. They enjoy

my classes. They see that everything is working out fairly com-
fortably. Now they're not willing to work anymore. They say,
"You teach your class. We gave you those funds your first year
to augment the library. Well, you've gotten two drummers and
we only get one pianist. You get double the budget for your
classes. Why do you keep wanting to invite [artists], use up all
the rest of our money for ethnic dance? We have a right to have
ballet and modern dance people here too." And I'm saying,
"Well, there are eight of you."

Clarissa's description of how her colleagues have reacted to
her use of department funds suggests that in hiring her, they
were unaware of what long-term strategies required and there-
fore unprepared to support her requests. Patti also addressed the
issue of her schools' accountability in its efforts to diversify the
dance department:

It's one thing to have me come in and teach a modern dance
class. You can get anybody to do that in brown face. It's some-
thing else to say, "We want the history of Black concert dance
from the 1930s to present in the curriculum." Two different
things all together. So, the idea was to not only bring me there
because I'm a brown face but to bring me there because I am
also going to be able to offer some kind of expansion to their
curriculum.

The subject of hiring was also raised by Paige, who as an ad-
ministrator is often involved in his school's faculty recruitment.
Cognizant of the criteria and motives of his colleagues, he is con-
cerned about the lack of commitment to building a diverse faculty
body and the general inability of the administration to grasp its
implications for its students:

We have three of me. We think that we're doing well. I think
that they don't understand that sometimes you have to elimi-
nate the competitive advantage. They think that anyone that
comes across the horizon, whatever color they are, if they qualify
we'll give them a job. . . .
 I think that if you have a person that teaches on a regular
basis and that person subconsciously is not "Black" to the stu-
dents, that person is just a good teacher, . . . [it] subconsciously
does something [to] the student. It makes them very comfort-

able in their mind knowing that Black professors and Black teachers publish and write and do all of those things. And they get a better experience out of it. They're taught better. It doesn't crop up as a problem to them at another time down the road. I think that we're deficient there in what we owe to our students.

.... I'm saying we need to eliminate the competitive edge. I think that next time we decide to hire people we should say openly, "Why don't we look at hiring an American Indian, a Black, a Hispanic, and . . . women." It would be a better experience for students and would make the college a little more well rounded. I don't think we have done that.

When Rufus participates on review committees to hire new faculty, an important consideration for him is the candidate's ideological thrust. He shared his thoughts about interviewing a woman who was an eighteenth-century American and European historian from a school in the South:

My whole question is, "Let me hear your analysis of the relationship of slavery to the development of the . . . American economic, geopolitical, cultural development of the last four hundred years." I couldn't get into this conversation with her because it wasn't appropriate. But that gives a bearing on how someone is going to look at things. If they're going to teach European or American history in relationship to "Thomas Jefferson was a great man and George Washington was a great man, cut down a cherry tree and told his mom and dad," you're living in a fairyland of an ideology that was created early on in order to make you look the other way. And in that same document that you all are saying is so important, it said that my people were two-thirds human beings. I'm very vocal about that.

African American Students and Communities

The lack of African American students in the teachers' classes was a common source of discontent as well as confusion among them. Though no one spoke at any length on this topic, tending to focus more on the students they presently teach, when the subject arose, there was almost always a pause in our conversations. They reflected and speculated about some of the reasons. Most feel that

Black students are usually not attracted to their classes because they are more inclined to study subjects that will be more financially rewarding as careers. Clarissa stated:

> Sometimes I think that Black students are so busy becoming the new occupations that are there and specializing in international relations and computer sciences and calculus, and social work, and humanities that they don't come to the art department. Or, that they don't take the next step. If it's filled up, they don't come to the first class and ask permission to come. . . .
>
> [W]hat I came to realize was that Black parents are no different than any other kind of parent. That they felt that by coming to [this college] and having their daughters be here and get a degree for $24,000 or whatever it costs to go here was not worth having a degree in dance.

Rufus' thoughts are similar: "[Y]ou get a little discouraged because to get the African American students interested sometimes requires you have to go to great lengths to get them because the whole mind control thing that they've been conditioned to. Music of their cultural tradition is the last thing they're interested in, because they want to go where the money is. [They say], 'I want to make the bucks. I want to get paid.' "

Actually, there are a number of reasons for the low number of African American students. Clarissa and Rufus have observed that these students view their education as a means of socio-economic advancement, which is antithetical to the traditional status of the arts. Some of the other factors contributing to the scarcity of these students are identified as leaks in the "pipeline," which many agree begin as early as the elementary school level. Affecting leakage are conditions such as crisis-level high school drop-out rates, crime, family disruption, drug abuse, lack of preparation at the precollege level, high drop-out rates at the undergraduate level, and the fact that commitments to the recruitment and retention of African American students at TWIs has remained a low priority.

For Nduma, the scarcity of African American music students has been very disappointing. He identifies it as a "literacy" problem, in that due to the way music is taught in conservatories and universities, if Black students have not begun their studies early they will not succeed at the undergraduate level: "It doesn't matter how much you can play by ear, how talented you are. What you do here is learn to become a professional. And being professional means

maybe you're trying to make your living doing it, If you're trying to make your living doing it you've got to do what most professionals do in the convention, and that's read and write music. So automatically, a lot of the talented ones are wiped out."

Although there are very few African American students in their classes, some of the teachers strongly believe that their own value as role models and mentors to those few students as well as to those in other disciplines should not be underestimated. Alois talks about young women in her class who not only benefit from her mentoring but who remind her of her responsibility as a role model even for those who may not make dance the focal point of their academic studies: "I've had girls come in and take my class, not because they're interested in dance. They just want to see who a person like me is, because they've never seen a Black woman who does what I do. So, they go through the course just to be around me, to see me on a day-to-day basis. And one girl said at the end [of the course], . . . 'You helped me understand more the woman I want to be.' "

Added to the issue of African American students, there were some teachers who also commented on both the real and symbolic value of neighborhoods and communities as they relate to their professional circumstances. Some teachers are more involved in the activities of African American communities, where they feel they can make meaningful contributions. Rufus, for example, presents concerts for afterschool programs and public schools. One particular concert reinforced the fact that there is a real need for more of these experiences, both for his sake and for that of the African American community:

> Last year I played at . . . the Mahalia Jackson school, which is one hundred and four years old. Twenty percent of the kids at that school live in shelters, and 10 percent of the kids come from families with drug situations in the family. So I said okay, this will show me whether this thing about them saying jazz is too esoteric or incomprehensible or cut off from the masses is true. Don't you know, these kids applauded after every solo, and we did three standing ovations. This is six hundred first through sixth grade . . . central Harlem children. From that point, I realized that it's all a myth about this music is not comprehensible. . . . [A]nd it's not just that I'm a good performer. It's because of the power of the music. When these children get it, then they can relate to it. But when they *don't get it*, they can't relate to it.

My whole thing since then has been if anyone wants to give me a bunch of money or if I come across a bunch of money, what I would do is I'd just set it aside and I'd book one hundred, two hundred, five hundred elementary schools. I'd play every inner-city elementary and junior high school and high school in the northeast that I could. . . . Instead of depending on the media or something else to bring it to them—they're not going to do it. The only way they're going to get it is if we take it to them.

For Patti, being part of a community that is politically progressive and active is important. Although she felt that the relationship she had established with a small community of African Americans near the college where she taught was needed in order for her to balance her school environmental experience, her dissatisfaction with what she regarded as their political conservatism made it difficult for her to fully invest herself emotionally.

Nduma, who will retire in the next few years, hopes to make a contribution to Black colleges similar to the one where he did his undergraduate work. His words reflect a deep care for the future of these communities as he considers some possibilities:

What I want to do upon retirement is to go back and lecture at historically Black colleges. I could take my . . . saxophone and take my books of poetry, and I can tell them about being in distant lands. Because . . . being in a university like this is quite different from being in the kind of institutions I came from. Those students have no idea. It can be very dangerous if you're not prepared to deal with it. . . . So I've got something to look forward to.

It would be my preference to do it in historically Black colleges, not that I couldn't do it at the others. I mean, I could do it anywhere. But it seems to me . . . they don't have the kind of inspiration I had when I was there, often. And they wonder about this. Public schools don't have the strength now because integration has had a toll on some of them. And it was supposed to not be like that. We were all happy, right? "Ah, integration and we're going to have equality." That has not turned out to be a reality, has it? . . .

I think I heard out in Oakland, California, or something, some brothers and some sisters talking about going back and segregating. Now liberals, particularly White liberals, and I

imagine some Black people, abhor the thought. I think we need to try, somebody said this, "by all means possible" to try to get a hold of ourselves and raise ourselves up to some self-esteem.

Colleagues

The nature of the teachers' relationships with their colleagues and the degree to which these interactions affect their work seemed to vary greatly among them. Also, those whom they regarded as colleagues differed among them. Some stressed the fact that the scarcity of African American faculty at their schools is problematic. Clarissa, who has spent most of her career in culturally diverse communities, has been teaching at her school for five years. She spoke intensely, emotionally, and at length about some of the factors contributing to her feelings of alienation:

[T]his is my life's work, teaching. But it's not my life. I'm a human being, and I need to have other human contact. I need to have a sense of belonging and the well-being and excitation from time to time. And I don't get that readily here as a Black professor, as a Black person in this [community]. . . .

I pass the same people. They walk the same path, and they don't speak. They don't say hello. It's like [I'm a] truly invisible woman. . . . It's not a friendly place according to my values of friendly. . . .

I don't have the energy or the inclination to . . . do the things that you have to do to accommodate certain kinds of settings. . . . I just feel like if you don't accept me as I am, I'm not going to worry about it. But, when you're in an environment where you continue that strategy that I just described, you're not going to be successful in your life's work. You're not going to get tenure if you're going to ignore the fact that you are not making friends and not networking and not being congenial—[pause] Look at it. I just reversed it. I'm saying that I feel excluded, but then the way the institution interprets that is that I'm not fitting in. But I feel that they aren't making me welcome. They aren't as open and warm and friendly and welcoming as they might be. . . .

So that slowly but surely you begin to feel, if not marginalized, isolated, from time to time you just feel pretty different. You just begin to feel so different, even though at another level people are really *trying* to make you feel welcome. Well, you

can't make somebody feel something. And sometimes when you try to make them feel something, you can feel the effort of trying, but it's not real genuine, or it's not [pause] shared by the whole group. It's not a majority feeling. You find that everybody is trying because it's *not* a majority consensus feeling, that really only a few people are in agreement with you, or a few people really want you there. So . . . you feel alien. You begin to be aware of your feelings of alienation and anxiety about that. And you begin to question should you be here. . . . I am nourished a great deal in my classroom. I know I'm serving a purpose, . . . but is that going to be enough for me in five years from now, ten years? Do I want to spend the rest of my life like this? . . .

I came here also to Engleside in particular because I thought Engleside impacts a huge span of the occupations that women are going to be in charge of in the next generation—the leaders, the women leaders, a fair share of them are going to be Engleside alumni. And I'm saying I'm going to make a contribution to those mainly White minds about diversity, and to those mainly White minds about the importance of dance and this field of dance anthropology. So, I came here with that kind of challenge to my teaching. But am I . . . going to become a raisin human being? I need nourishment and juices and excitation and other stuff [but] Engleside by itself can't supply it. It has to be the whole environment, the whole community. The demand, it sucks you dry. It just takes so much energy to constantly be talking about this. To constantly be aware and be sensitive to the differences. I guess we always have to do that. That's the biggest question: Can I survive in a teaching environment, in a professional environment, in a career environment that's challenging and exciting and interesting, and a social environment that's almost deadening?

She will take a sabbatical leave next semester, during which time she will seriously consider a recent offer to teach at a college in Florida. Though Clarissa would earn less money, she would have contact with a more diverse population and welcoming community.

Jerry reflected on relations among African American and other faculty of color, which he said is "a bit of an enigma":

[T]hey really don't work together the way that some people think that they might. And you have to look at it two ways.

There are some people, regardless of their race, who are not identifiers. They just don't identify with that culture. They either would rather be by themselves, or they would rather be with another culture for whatever [reason]. Then there are others who want to identify but who [pause] just don't want to get involved anymore. And there are those who support each other.

Some fundamental difference among a fairly diverse group of teachers of color became evident to Patti. She explained about the difficulty of agreeing on a course of action to mobilize an organization that was established to address the needs of "minority" faculty:

We had a faculty meeting on campus [with people] of color. We're talking about East Indians. We're talking about Africans. We're talking about African Americans. We're talking about Latin American faculty. We get into a debate about whether we are going to let White people into this particular commission, in which we would try to watch-dog the university is what we were going to try to do.

I said, "Now, this is very sad to me, because what you're telling me is that we are . . . not justified in what it is we want to do unless we let White people in. That is so sad. I'll tell you one thing. You want a White person in here? I'm out of here." Because . . . there was no organization on any kind of level that just dealt with faculty of color or students of color. And we needed that.

Paige said his collegial support comes from professional artists outside the academy. After years of exhibiting his work abroad, he has developed a number of strong international alliances. He reflected on his relationships with artists from Holland and Ireland as sources of tremendous satisfaction. In both instances, he recalled very traumatic events in these artists' lives that called on them to support each other. Traveling long distances in intrepid weather and due to family emergencies, the types of connections Paige spoke about went far beyond what might be expected of peers. It was clear that these colleagues had made concerted efforts to establish themselves on a deep, personal level, relying on each other emotionally, economically, and professionally. Bonds of this quality have been more difficult for him to establish with local artists in his community. Paige speculates about this: "That group of colleagues [is] not afraid to be gentle. We exchange information. . . . Now I

don't know why that is. Maybe I found that with [those] artists, . . . I'm not invading their space. I'm not a challenge to them."

Roles as Artists

There are many reasons why it is advantageous for artists to be affiliated with schools. Most of these teachers feel that their positions benefit them in a number of ways, speaking about the "perks" in physical and emotional terms. There were advantages for Patti as a dancer in that it provided her with rehearsal space, which she otherwise would have had difficulty affording. Nduma says that his Ph.D. was his "union card," providing him with benefits such as a regular income and the ability to choose his performance engagements without economic pressure. Rufus's feelings are similar:

> [I]t works in the bigger schedule because it allows me not to take some of the nickel and dime gigs that I just don't really have any interest in doing anymore. I want to perform things that I *want* to do. I don't want to be when I'm fifty, sixty, seventy years old working in places that I don't want to work in because I need the money.
>
> Academia has allowed me to really focus on [certain] aspects of the music and not be as worried about the lowest common denominator. Because when you're in academia, . . . as we work along, this music is hopefully being perceived in the stature that we want it to be looked at. And in the commercial realm of media and big business, you're dealing with something that could care less about aesthetics. All they're concerned about is: What are the numbers? How many people came in [to the club] tonight? That's the part that really makes me sick, that part of the jazz business, where you go in and work some place, and the only thing that's of interest is how many people come in. Well, I'm not interested in that part anymore.

Many agree that being able to engage in meaningful personal arts projects fuels their teaching and inspires their students. They are bringing in fresh ideas from the dynamic world of the arts to their classrooms. In turn, students have access not only to ideas that have made their way to the classroom via textbooks, but to the primary sources of those ideas, which are the artists themselves. Rufus continues:

I feel like I'm blessed in the sense [that] what I do for my day job is basically what I do for my creativity job. I'm teaching. And I teach it in a manner that's really the exact same flow as how I go about my work. . . . I feel very comfortable and actually blessed in my situation because I have the flexibility. I can still do my creative work and travel, and do whatever I need to do. And what I teach is very much [in] the direction of what I'm also interested in studying and performing. So, in that sense the flow is right there. . . . [W]hen you have to explain something you have to know it better. [C]ertain things as an artist you can know and you work through. And once you have to explain it, you really have to be able to break it down and still be able to present it in a way that doesn't rob it of its life.

Cindy agrees with this:

If you're excited that you're writing this piece, and the Chicago Symphony is going to play it next weekend, that kind of excitement is going to just infuse you. And you're going to go into the classroom, and you're going to tell them about the experience of going to a rehearsal with the Chicago Symphony and have them look at your piece. That kind of thing I think is just directly going to be related right back to them.

As Alois explained, the key to her survival is to remain active as a professional dancer and only teach part-time because it relieves her of many of the administrative responsibilities that full-time faculty have and allows her the necessary time to concentrate on performing. However, like Rufus and Cindy, she finds that teaching provides an important balance to performing: "What's very good about teaching for me is that it keeps me honest. It makes me question and be very aware of what I'm saying. . . . Because people ask questions. People confront you. If they don't believe what you're saying, or they don't understand, then you've got to know what you're saying well enough to break it down."

By having his summers free, Sadik can pursue projects that otherwise would have been impossible had he chosen to supplement his salary through employment in a profession other than university teaching:

It allows me to renew myself. It allows me to plan, to research, to do my art. . . . If I had a regular nine to five with one week

off or two weeks off in the summer, I wouldn't be able to. And I've had those kind of jobs. . . . So, I'm happy. I think it's about the kind of life that I have, and the kinds of things that I've chosen to do. And I think *that's* the key word, *choose* to do. Because a lot of people don't have an opportunity to choose. I come from a whole line of people that had no choice. I'm the first one in my family to choose.

Because there are so few opportunities for composers to secure a living solely writing music, Cindy realizes that teaching is necessary in order for her to stay within her field:

Most composers around are affiliated with an academic institution because [composing] is not an area that's highly valued in our society outside the academy. And for that reason, we do have to usually have the academic job to pay the rent. . . . It's helpful to be within the field that you're in, even though it's not what you really want to be doing. You have to think, What can I do which will be closely within my field, and I'll be dealing with the materials of the field that I love, and maybe somehow, some aspect of it will be inspiring to my own work?

Though hypothetically, she should be able to compose while teaching, Cindy has found that as one of two full-time music faculty members, her heavy teaching load has not allowed her to do so. In spite of the fact that school facilities are available to these artists and that the academic calendar promises time to engage in their personal projects, Clarissa, Cindy, Nduma, Jerry, and Paige, who are five of the six full-time teachers, explained that it is extremely difficult to find the time to develop their art. The emotional and academic demands of teaching, as well as academic counseling, and in Paige's and Nduma's cases, administrative responsibilities, can be overwhelming. As Cindy points out, artists who teach need "time to replenish themselves and do their work." Mariah realizes the same thing and is presently considering making some major changes in order to accommodate that need. Exhibiting in galleries regularly, and receiving commissions from public and private sources, Mariah, who has been teaching part-time, relies on her art as her major source of income. She decided not to teach this year. Unsure as to whether or not she will return, she struggled as she spoke, searching for answers:

I just could not continue to do it because the way I do it takes a lot of time, a lot of time in preparation. It's a three-hour course, but it took many more than three hours to get ready for it. . . . And I needed a break, really. My exhibiting and also illustrating meant that I needed to not have to know that I had all these papers to read and all these grades to get in and those deadlines. So I really had to stop teaching. . . . [A]nyway, it just wasn't enough money. That, and then my work started demanding more of my time, and if I could have been paid better—I'm not sure if I would have stayed actually. If I could have been— I guess there would be some kind of way I could have stayed if it had been significantly more money. . . . I think it's really the money issue.

Juggling the factors of time, money, and priorities, Mariah has had to make some difficult choices. Winston also talked about the financial strain on him and some of the related pressures:

[T]hey pay me twelve hundred dollars to teach a course for the semester, out of which they take taxes, out of which I have to pay my own transportation, which for two days it's forty dollars a week. [laughs] And that's not even chicken feed. . . . But I do it. When I came, I was confronted with doing this. It was the difference between not having a job . . . and continuing to teach, continuing to make two cents even though you were going to take it in your left hand and give it to your right hand. . . .

I basically have time to get out of my house, get there, do what I have to do, and get out of there to get back [home]. Aside from one or two people I may meet in my department and a chairperson and the secretary, I really don't get to know other faculty people. I don't have the time because next morning I'm teaching someplace else. . . . I don't have time to go take a bus and go up to [the school] for a meeting that I'm having to pay for. I'm not earning enough as it is. Because they do have their staff get-togethers, and you'll get a memo inviting you, but I don't have the time nor the money. . . .

At the same time, all this time I've been there they were always after me to put on a performance, to put on a dance concert. I said, "How am I going to put on a dance concert when I come here and teach classes two days a week. It is too far for me to hold rehearsals starting at four, five o'clock in the

evening. When do I get home? At midnight?" But still I would
contribute a work or two on a program that they had. [They]
brought up the fact of wanting to do something to make the
department more visible to keep the enrollment up. But I can't
even deal with that. . . . I don't have time for that. That's a whole
other job description. I'm a teacher. I'm not a recruiter.

There isn't any money in teaching dance for dance educa-
tors. We are at the bottom of the totem pole. Teachers are at the
bottom of the totem pole in this society to begin with anyway.
You know, you pay somebody who hits a ball or kicks a ball or
who runs with some piece of pig skin more money than some
of them can ever use in a lifetime. And the people who you are
depending upon or who you look to to nurture and help the
growth and development of your kids, you pay them next to
nothing.

Alois and Rufus both know that their academic appointments
were secured largely on their status as professional artists. Although
Alois's school hired her because of her reputation, she feels that
they are not flexible enough when it comes to accommodating her
larger, more time-consuming projects that take her away from school
for extended periods of time. Rufus says that the expectations and
standards by which African American artists are measured for part-
time appointments are not the same as they are for other part-time
faculty:

[W]e're kind of like highly achieved "superniggers" that come
[and] teach them in a manner that they can digest. [They say],
"We like you, but don't bring your cousins" [laughs]. That's all
up in there. That's definitely in there. Not even, "Don't bring
your cousins," but, "We're not interested in your cousins. We
want what you have." . . . It's like, "You're beyond the cream.
You're the top of the cream. We want *you*. Come on up here,
and we'll give you this and then you'll be like us." That's an-
other thing. Diversity doesn't mean a bunch of people who
look different who think the same. That's not diversity. That's
a bunch of people who look different. Diversity means people
who look different and think different.

Nduma brings yet another variation to this theme of teachers'
identities as artists and their relationship to institutional life. Added
to the pragmatic issues of money, time, and physical space raised

by the other teachers, Nduma emphasizes that being an artist informs other aspects of his life. This bears not only on how he acts, but also on how he thinks and feels. After a fifteen-year period in his career where he focused almost exclusively on composing, teaching, and administration, then finally deciding to return to playing the saxophone, he describes those earlier years as one of the "driest" periods in his life. Now, he allocates time for both his own music projects and teaching, practicing music in the evenings when he goes home and reserving a portion of his summers for both composing and performing. He makes sure to attend carefully to his creative needs because the demands of administration would otherwise consume him. Doing his best to integrate the various components of his life and seek the necessary balance, he has made an important discovery: "The arts give me the insight on how to do absolutely everything I do." Nduma talks about the artistic temperament and its translation into his daily routine in this way:

> I think the best administrators are *imaginative*. I think the best scientists go beyond what you read in textbooks. They go beyond that, probing and looking and searching for something else and discovering something that somebody else may put in textbooks. I have seen administrators who relied on technical and scientific data, and [their] batting average is no better than people who don't. It's something else that helps you make the right decisions where people are involved.

A View from the Hilltop
Nduma's Story

For Nduma, the many facets of his work are shared from the perspective of a seasoned teacher and high-level administrator. Fair, broad-minded, distinguished, and highly respected by his co-workers, he has successfully implemented and developed a unique and extensive multi-arts program at his school. His long-standing commitment to both the integrative functioning of the arts and cultural diversity as institutional missions make him a pioneer in the field. Close to retirement, his insights into academe are thoughtfully and critically delivered as he reflects on the meaning of a range of experiences and issues.

My mother said the way she kept me quiet was to sing to me while changing diapers. She got the best results by singing. In other words, I think I responded to music at a very early age. As I see now, I've never, ever been happier than when I am involved in music or some kind of art. I think it goes back a long, long way.

I was born in Galveston, Texas, in 1930. So, what we're dealing with is a completely segregated system by law and by custom. I was put in at three years old in the kindergarten. I learned my ABCs. I learned all sorts of things. By the time I got to elementary school I was already ready for the second grade. You could do that in those days because people invested in you. All of these teachers are African Americans. I mean that's a given because it was illegal for it to be otherwise. It was a real blessing, too. When you have all Black teachers, the advantage

165

is that they care, at least they did then. I had all the love you would need. My teachers would tell me if I was acting up. I was a prankster, I'm sure, and had a certain amount of capriciousness and mischief, I'm sure. I also remember some corporal chastisement. The things that I can remember are of a supportive nature. That's the big impression I have of elementary school. Now, I can't say that this would not be possible if they were not African American, but it hadn't been my experience. I think it was a period in the history of our development as a people, African American, where everybody aspired to go up. Teachers really had a mission, and they taught with a kind of passion because they thought by leading us we would be better than the experiences that they had.

I joined the drum and bugle corps in the fifth grade. So I went and took lessons. Then, in three months I was in the band because I was fanatical about practicing, absolutely fanatical. No day could go by—even when I traveled and went to the country I said I had to have my horn. My mother was right on target. When neighbors complained about my playing, she said they could move. In other words, I was locked into that. I was locked into it.

I didn't grow up in neighborhoods that were prudish. I grew up in some tough environments, really. But my church and my family kept me on the right course. The thing that really saved me was music because by the time I got to high school all sorts of things were going on. So, once I got involved in music, most of my energies went there because I cared more about being a very good musician. I was inspired. My teacher, he'd assign two or three lessons. I'd come back with six. And I went through books so fast because it was a challenge.

I was playing professionally at twelve. What happened is that it was World War II and the musicians that had the level of skill that I had that were young were drafted. So I was playing with musicians forty-five years and older. I remember one old fellow, Russell, Russell Louis. A great, great nurturing situation because here I am playing seven nights a week from eight to twelve, a junior high school kid, with a guy who had transcribed Coleman Hawkins' "Body and Soul," and that was probably what we were playing on the stand way back then. Great, great, great experience. And I also used to go to jam sessions all the time. Oh boy, that was great fun because you'd really be challenged by the musicians. That's how you prove whether or not you can do what you're supposed to do. So, I was proficient.

I went to the city auditorium, which was the largest public facility where the big bands came. This is a part of my education incidentally, too. I saw Louis Armstrong in person. Inspirational, everything

that was going on. Louis Jordan, Mary Lou Williams, Jimmie Lunceford, all of the great jazz bands came and played our city auditorium. At these dances I was allowed to go in because I was a musician. I was under age. You're not supposed to be at those places at twelve and thirteen because those are for adults, but I was there because I think one of the church members knew one of the Black policemen. Incidentally, this town was more advanced than a lot of places in Texas. It was politically savvy. One of the highest officials was a Black policeman who said, "Let him in."

All through high school I was developing my jazz chops. I also played in a band that my band director established. We would play for dances. So I would go, and there was a little area reserved in the right corner of the facility for Whites. It was a little area. It was the reverse because in the movies everything was segregated. So the Whites were allowed in too because they wanted to come, and they accepted being segregated. It was the opposite. They didn't dominate this one. Blacks were the ones on the dance floor and up in the balconies and all around doing things. The Whites were in this corner. But they loved the music so much, and they would dance in that little space. I thought that was one of the ironies of segregation. Every place else it was illegal but there.

People say, "How could you keep up with your course work and do this?" Well, playing the music was a pleasure and a joy and a learning process. I just did my course work earlier before I went to work. It worked out all right. In fact, I even went to audition on the stage for Benny Carter when I was thirteen. But my mother put her foot down and said, "You're not going on the road." I think she was right. Thirteen is a little early for what was going on. Bless her soul. Without that woman I don't know what I would have been. I remember back in those days I was a loner a lot of times too. Because if you practice, practicing is a lonely art. Nobody's interested in your repeating these things, or whatever it takes to get your technique going. I think there may be a lonely kind of path that most artists take at one time because it's a way you can get in touch with yourself. What happens is that nothing else is there besides you and your instrument. You discover things about what you can and cannot do.

I was in college at age sixteen. I went to Wendell College. That's a Methodist college, a Black college. I went there on a scholarship. It was a small college, very small, six hundred people then, three music teachers. Within the first semester, my teacher allowed me to be music director of the swing band. He was inspirational, very encouraging. I think he was delighted to have somebody that could do that. I had

the authority simply because of my musical ability. In those days all of the historically Black colleges had jazz ensembles. That was just a given. This was before the music was even allowed in White institutions. We played dances for fraternities and sororities.

In 1949 I finished. Then I accepted a teaching position at the college. Isn't that something? Unheard of. But what had happened is interesting. The music teacher was a very talented man, a musical man that I respected. He had unfortunately gotten too amorous with some of the co-eds, and he had to be terminated. So I just went right into the position. So here I am teaching at the college level. And so, in 1949 and 1950 I taught. But in 1951 I went to graduate school. I got my master's degree.

All of my graduate degree work, the master's and Ph.D. is in composition. And, in fact, I didn't even do much playing the first time I went up there. I had to catch up. I had to be able to work and produce as well as my counterparts, and that's all that they had been doing. They'd probably graduated from schools where they had been majors. I'm from this school with only three music faculty members, and there was no such thing as a concentration in composition at the college. But I got into it because I was interested in it. I got into classical music actually in reverse chronological order. I started off with Stravinsky and worked back to the early masters because Stravinsky was closer to jazz because of his harmonic vocabulary and his rhythm. When I mentioned that to my professor, he dismissed it immediately. Because he couldn't hear that. He didn't know jazz well enough to know what Stravinsky was doing. And I think he probably would have dismissed Picasso's leaning on the African visual images in the same way. There's a certain arrogance that goes with thinking you invented something, and you don't know.

I stopped playing for about ten years when I went back and got my Ph.D. in 1960. What happened was, by the time I started working on my Ph.D., a major influence on me, compositionally, was Arnold Schoenberg who was a German expressionist using the Dodecaphonic system of composition. And I was writing in that style. I learned the techniques and so forth. It was ten years or so later that I discovered, Hey, why am I doing this? Well, I know why I was doing it. Because it impressed my peers, White peers, composers. It was intellectually oriented and most people couldn't understand it. We all thought, Hey, we're pretty hot stuff. We can do these things and the people will catch up with us. But, if you want to say something and to be a part of humanity, I think that you ought to talk with people. You ought to communicate your feelings and ideas so that they can understand

them. So my work is no longer overintellectualized. It's more coming from a spiritual reference.

I got back to playing again actually as a result of Billy Taylor. He said, "You know, Nduma, we know and the kids know you're a good administrator, but you ought to play because that's another aspect that would be useful." And now it's unthinkable not to. I must play now. There's actually something physically that happens to the body at times when I'm playing. So, I have to do it. It's a great marriage between the two now. By playing more I write faster. The creative juices just come faster. I denied it for a bit. It was a mistake, but I recovered. Now, though, I'm looking at finally using what I want to about all the variety of experiences, and then letting that be my identity. There was a time when I rejected what was me. Part of going through these institutions, which, again, you go there to learn what they have to offer, but when I received my inspiration by Schoenberg, in a way I had absorbed his Germanic or Austrian culture, placed it in a higher priority than my own. I found a way then to remain creative, in a sense, but not reflect my culture the way that I'm willing to do it now.

I came to this school in 1970. There were no Blacks in the music department when I came here. I was the first one. I was, of course, somewhat of a novelty in the department and in a field where standards of excellence are set by European conventions and traditions. Most of them had no idea that I came into music by way of jazz, not by way of the European classical tradition. Nevertheless, the first thing that happened was that the department chair had complained to me that a group of students had come to the office and inquired about playing jazz. And since it had been a policy of the department not to allow jazz performance, pressure from the students had been put on them. He mentioned to me that he would try to find somebody in the department who didn't mind serving as a faculty guide or counselor for a group of students who wanted to play jazz. So I told him, and he probably was surprised, that I thought the music was more important than that and that it was a part of my background. He had enough respect for me as a musician in his tradition to listen. And I said, "I think it's important enough to be given credit like any other courses that you teach here." So, it started that way. I carved out a niche for myself in our tradition.

I don't teach necessarily in the traditional canon. I teach according to trying to see where the students are individually and collectively.

Then I try to get them interested in what we're doing and let them rise to the occasion, rather than superimpose a rather rigid curriculum. It seems to me that in many, many instances some teachers' approach to teaching is more vertical or hierarchical than horizontal in terms of concept. I'll put it this way: You start off with theory to become a musician. If you cannot read, that is, A-B-C-D-E-F-G and then back to A, if you don't know those seven letters and then know what they mean on five lines and spaces, then you're not going to be a musician. That in the center, although we know on the side that some people don't read music—musical illiterates, but they can play music because they've learned it by ear. You do not move in the academic world that way. You must read music because that's the canon of the tradition. So, when I said my approach to teaching is to try to find out what is the level of talent in the individual student and then see if we can introduce concepts in music, ideas, usually by way of music itself to stimulate them so that they want to be able to move themselves from where they are, it's not that I don't recognize that growth is necessary, but it's a question of how you get it. And I never enjoyed rigidity in terms of trying to develop the canon of methods for learning.

When composition students come to me, it doesn't take me long to see what kind of style or tendency they have, what their harmonic vocabulary is. And often it's not expansive, but I listen. And usually they're talented, and I compliment them. Then, I suggest, "Have you ever listened to this? Have you heard this?" Trying to get something that will get into their heads and minds about other concepts, different things. That's what I mean by teaching with flexibility, or horizontally, or with recognition of either the musical talent or the intelligence of the individual studying. As a barometer, I use the relationship which usually develops between me and the students, even if there's a lot of them. What you want to be able to do is to allow them to feel that they have a capacity to comprehend what you're talking about. You don't want to intimidate them.

I think in some instances my flexibility as a teacher is rather difficult. And probably I could get criticism from people whose system is much more rigid in terms of tests. I don't give tests. I want to know what they've learned, not what they remembered that I'm trying to teach them. So, I ask them to do papers where they have time to reflect. Now, I make it pretty clear. I say, "You have two papers to write. But write them well. I know the class doesn't seem particularly difficult." I want to see what they're learning, not what they have learned by rote. I want to see how they think and apply themselves. So that a

person who doesn't read music can get an A out of the course. Then the intelligent students realize there's a certain amount of rigor there. It's not a lack of standards, but it's a question of how you apply them. It gives them the freedom to express themselves. For those who don't write well, there's not much I can do about it. They don't get a good grade. But I don't flunk people. I tell them, "The only way you can flunk this course is don't come. And if that's where you are, why did you take it in the first place?" I never get the criticism of being unfair.

I think to be a successful teacher you don't intimidate students. I mean it's just my style. I have at least two composition students now, graduate students, who have natural lyrical qualities. One has a strong harmonic sense. And I said, "That's good." But I find that in his second semester study with me it is too predictable. It's like being caught in a groove, and it works. But who wants to wear the same suit all the time? I mean, how do you get out of something like that? The only way you can do it is to get variety in your wardrobe. I told him, "Your vocabulary, try to expand it some way." But I want him to expand it in a way natural to him. The only way I think you can do that is to tell him to do certain things, to listen to a certain kind of music, and then give him guidance.

I must say, all that I've been describing has to do with my mature teaching. When I first started teaching right out of college, I think I was a monster, an absolute monster [laughs] because I had been such a perfectionist. I mean, I had practiced every day come hell or high water. I was fanatical. I had to do this. I did it. It didn't matter. Seven days a week for many hours. As a result, I made progress, and I was rewarded by winning the approval of peers. That's the only way you really know if you can do it. You don't have to ask somebody, "Am I good?" You get out there and play enough with people who are good. You develop self-confidence. Being a young fellow like that and directing ensembles in college when I was about seventeen or eighteen years old, I was not tolerant. I think it was unfortunate now with hindsight. I got good performances. But some of the people that I leaned on very heavily did not have talents large enough. I got results, too, by beating them to death. Well, not to death, but [laughs] I just don't want to do that anymore. In fact I don't think I can do it anymore. Then, I was quite young, and as I said, very, very much a perfectionist.

I think the competitive streak in me is not very visible. I usually am quite calm, poised, and so forth. The competition comes with a kind of self-satisfaction. Why did I practice so hard earlier? When I first started playing the trumpet it was because I wanted to be in either Count Basie's band, Duke Ellington's band, or Jimmie

Lunceford's band. Those were the best bands, and there were a lot of other Black bands. I never thought of being in a White band because I recognized that in that period, in the forties, they had not yet learned the language sufficiently. I understood the awkwardness about them. Just like when you see people who try to dance and can't really, their bodies don't do it. I heard that in their music. So I wanted to be in the best bands. I don't know whether that's competition, or it may be a form of it, but it also is the way that you critique yourself. I knew when I wasn't playing as well as people that I admired played. Whichever way you want to look at it, it helped me. It gave me drive.

I think competition can lead to ruthlessness, but I've never been like that. I've always felt that I knew how well I was playing or writing, and if I didn't get some of the breaks that somebody else got, I wasn't willing to undermine them in order to get it. It's not necessary. I've never found it necessary to be ruthless to get over. I've never found it necessary to degrade somebody else in order to upgrade myself. Not that kind of competition because I don't think it's necessary. I don't think it's wholesome. In fact, you can either call it ethical standards or go back to something as simple as the golden rule. Whatever it is that allows you to be happy without undermining other people. I think people who are inherently evil, which means they like to do things to other people, are either mentally disturbed or are wanting in something, that is, in self-esteem. Because it's not normal. It's poison in a way. And who wants to live with poison? I think it can do you in. I think it's physically unhealthy. At least that's the psyche that I use, so why get that into my system? So, competition yes, but in the service of art. The spirit of wholesome competition.

I find since I've been teaching music at all of these institutions that the level of talent of the students that were in my class when I was in college, which was between 1946 and 1949, is no higher now than it was then. People have been exposed to more things. But I graduated from an institution that had about three members of the music department and faculty. This department in music and dance has about forty, and the net results of the students that graduate is no better than the historically Black colleges where we had three teachers. What that tells me is that the whole concept of trends in higher education is inflated in terms of what's needed. The National Association of Schools of Music and a good number of other accrediting associations in different disciplines in higher education behave more like other institutions in American culture based on growing and getting larger, and largely on the theory that that means better and better. And, of course, that really isn't true.

My prior experiences as both a teacher and an administrator at institutions historically Black and smaller have been instructive. It means a great deal in this sense: How could I survive in an environment like this, coming from such a "poor" background? When in fact, I survived very well. Which means the whole notion of those historically Black colleges being places where people were deprived of opportunities to compete [pause]—In the sixties, they were talking about phasing them out. Since integration had come about in the fifties and sixties, they said, "There's no need for those colleges because of the predominantly White colleges, which are much better equipped with facilities and have people with higher degrees and so forth. We don't need those colleges." Well, I didn't think that was a good idea then. I knew that was a wrong notion. Now I'm happy to learn that many middle- and upper-middle class Black professionals are sending their children to historically Black colleges. And the reason for that is the nurturing quality. So I've learned a great deal. The basic thing for people to be successful with their lives is to have deep convictions about whatever they want to do and love what they want to do and then go about doing it. You can do that in historically Black colleges and you can do it in White colleges. It's hard in both of them in one sense because you may not have the resources in historically Black colleges, but you'll have the nurturing qualities, which for some people is what they need. In other words, you have strength in teaching. That's what those Black colleges have.

What satisfies me? The growth that I've had as a musician and the fact that I'm able to do things. I'm very satisfied about what I think is a kind of documentation of our culture because the music that I'm writing now is not something that somebody else would write. It speaks to our culture, and I'm talking about African American culture, in a way that's personal to me. It does not sound like what somebody else would do. So I like that. What's dissatisfying about what I do? I don't have enough time to concentrate on the things that really interest me the most in terms of the arts. That is, I could write more, play more as a performer if I were not involved with administrative matters. But I can't say that I really dislike administration because I'm successful at it. Administration is something that I have accepted. I didn't seek out these administrative positions that I have, but I accepted them with an eye on service.

What's the next move for me? Decelerate. Shed some of the things that I'm doing so I can concentrate on art. So I will shed

some administrative responsibilities. Probably shed some of the teaching responsibilities because I have some concepts about playing, and the only way I'm going to be able to implement them is to have enough time to be able to do that. The main emphasis is that I think I want to go back to where I started, actually, playing. I have come to the conclusion that improvisation is a very, very important part of music that has been neglected in the twentieth century with our technology. I mean, now the composers are considered, at least in the European tradition, important people, and everybody else is in their service. But earlier there was no separation between the two. Bach was a great improviser. He played every Sunday and probably throughout the week for church services. He was both an improvising musician and he wrote his music. I think that that is the way music probably ought to be. I choose to live where there's sort of a balance there.

I don't think I've ever had natural tendencies that led me to very commercially acceptable ventures. I just think it's not my destiny to make a hit record. My wife said, "You write all this music. Why don't you write something we could make some money off of?" [laughs] It's just not been my destiny. And it's okay with me. I think about music more than I do money. I look upon my being able to be satisfied in life and not worried about money. I make a decent salary. You only need so much money to be happy, as far as I'm concerned. And acquisition of things just for their own sake has never been an interesting thing. I've always enjoyed music. I don't worry about money. I imagine if I were not sufficiently competitive to function in an institution that gave me a decent salary [pause] I'm not willing to starve to death for my art. I don't have to. I can still do things that I think are worthwhile and then do my service in these institutions.

I have the dream that this program does not come unglued. I'd like to try to strengthen it a little bit because I don't have a lot of time. And what it takes, of course, is resources, that is, money to do it. Oh, I don't worry about the mainstream culture. That's going to be here, and they can afford greater waste than we can because there are more of them. Layers on top of layers of incompetence in many instances. It's a hell of a thing. It looks like I do have critical views about some parts of our society, don't I?

You are very much appreciated in this kind of environment if you are "smart." That means if you understand what you need to learn according to those conventions. But there's not a lot of room for the unusual and the people that even look at life differently. And this school is always going to be predominantly White and European.

That's understandable. That reflects the country. But I think it's unthinkable not to have some diversity in there. I'm convinced that real cultural diversity and an appreciation means an acceptance of difference, not just an accommodation. I would even go so far as to say embracing of another culture. And you can do that so nicely with the arts. This is why I'm saying I'm happy that I've chosen something that is very important to life. I think it's as important as anything that there ever was, just as important as science.

The Chinese, you know, look upon the human body as a garden. [They believe] that things develop and grow at different times at different seasons at different innuendoes. I think I heard an interview where someone said he thought that the American philosophy was that the body is a machine and that when it breaks down you just fix it. You've got different parts. It's a technological orientation about how the body functions. And the Chinese have a different notion— that it's something that grows like trees or anything else and that it's going to have a limited amount of time, and you just nurture it, plant it, fertilize. I like the Chinese attitude. I don't have to throw away the American notion that it can function like a machine. It needs oil. But I'll embrace the idea of it being a garden because I think there are aspects that mechanics will never know about the body. That's what diversity to me should be. Embraced, not just accommodated, not just talked about.

I came here in 1970 and started something. And now I've seen it. I think our core idea here is about the importance of the language, of the culture, of the soul, of the hearts, of the imagination of other people. So I will still have made a contribution towards what I believe in. In other words, I think that the spirit is very powerful, too, not just the material. What means a lot to me are things of the spirit. That's where art lives. But also, it's been my experience that the most creative scientists live there too. It's the world of imagination. It's the world of abstraction. But I think if you're creative enough, you use that kind of imagination to solve problems. I think that at one time in the history of the human race music, or the arts, had a much more integral part. They were thought to be more necessary than now. We don't value that now. I mean, the first thing that drops off in our public schools are art and music and dance, if it was ever there. Well, that's unfortunate because I think that if this place wants to be great it's got to pay a decent homage to the arts. Even medicine. I've talked with doctors who said it's not all science. It's an art.

This is a great universe, and I'm an optimist. But I'll tell you, we may have to go down a little bit more before we turn this country

around because of the history of it. Depressions in this country are cyclical. They just keep going on and on and on. This is one of the longest ones for Black people. The biggest one was the first one for Black people brought over here to be slaves. A double whammy: depression and oppression. But for poor people, it's been that way. We're going down now. It's going to be hard for people. Poor people, period. We can say people of color if you want to, but all poor people are having a hard time. What's interesting about it though is that we have gone beyond the threshold, I think, where people used to feel sympathetic about that. Enough of them are doing well so they're just writing off. I think the Reagan years was a classic example of the write-off of the so-called "people." When Reagan on one occasion got up in front of the camera with the newspaper, talking about all these people talking about they need jobs, and all he sees when he opens the Washington Post is all those positions. As far as he was concerned, there are jobs because they're here in the Washington Post. Well, there are more people than that newspaper will allow. And they don't have the skills necessary. But I think what he was saying was, "Get them, because that's the way we did it. You come up on your bootstraps." It isn't really like that, you know? So we've passed the threshold. Racism is more rampant because there's not enough. And, historically, you'll find in periods of depression the victims are being blamed for the problem. They're saying, "We would have some except for these people who are a drag on the economy, so let's get rid of them."

The universities are interesting entities and institutions in our culture. They are some of the most privileged institutions in America. It used to be in Europe that the church was privileged like that. Now universities are the privileged. The universities house the upward mobile, the upper echelon of the intellectual income. So it is not nearly as painful here as it is out in the real world. It's not as bad. I mean in spite of the University's retrenching, we've made progress in multiculturalism. But you do it incrementally, and, in fact, you get people to realize that it's an integral and important part of the fabric of the university. If they thought it was a drag on it like they think all the welfare systems are, then we could have those kinds of severe backlashes. But the way we're doing it, I think we're showing them that it is important, particularly in the arts. There are faculty members or intellectuals and staff members who probably say, "Well, wait a minute. We could use that money to solve some of our problems." But I think they won't do it. Universities are a little bit more civilized than the brutality that goes on out there. At the University, it's not as severe. Let's put it that way.

I think there's something to the notion of wedding age with wisdom. I really do. Some things you can't learn without experience. There are certain truths. What I thought was true when I was nineteen about how smart I was, I know now I wasn't nearly that smart. I was smart in some kind of sense. I had book sense. I was learning, and I was acquiring. But there were other whole levels of life that I didn't touch. I think it takes time to come to this place.

Faith and Vision

Mariah

I don't see how any of this is going to get any better if we don't start telling all the stories, examining everything and just bring it all out.

Alois

But you have to understand. We as Black people are not an easy people.

Mariah

We spend a lot of time talking about what we can't do and don't do or won't do. We have all this that we don't acknowledge or we don't see as important. A part of us is untapped. And then there are few avenues that we have to release or let it out or share—or a place where you can give this up.

Petra

As culture makers, Black people know how to make. We know how to create. We know how to gather, and we know how to project. In our cultural experience, we have not been taught access. We're still just beginning to learn it. I think in this society it comes through privilege, and since we don't have that [laughs], and we probably won't have that for some time, it has to come by another way. We have to learn how to build that through means other than privilege, wealth, and that power base. I think I've seen in the past twenty years that we're teach-

ing ourselves about it. We're learning how to build that access creatively, politically, technically. We're learning the skills and the values and the attitudes to build access that's relevant for Black people. It isn't that we don't know how to do it. It's that the other messages really work on us so that we *don't* do it.

Sadik

There's a lot of sickness around. And you try and remain healthy, and you try and wade through it, and you try and make a difference, and you concentrate on that.

Mariah

I think that talking to people is a good way to start opening up some of this. Because some of it we don't even talk about, and we don't get to run those things across each other and really deal with it in a way that makes it really useful.

Interviewer

What are some of the ways that we can continue with some sense of forward motion?

Petra

I have some thoughts coming out of where I am now. But where I am now is very much a fielding out of future possibilities. It's not really [pause] the future is not really separate or highlighted from the present.

Rufus

You know, I'm a, a sinner who is full of [pause] of short comings and, and in many ways I do have many shortcomings. I'd like to be more patient and more loving and more kind and, and less, less, [sighs] less angry. Sometimes I get very angry at a lot of things. You know, the full range from the kids to the history of the last five hundred years. Sometimes they intersect and overlap in ways that it's hard to separate.

Clarissa

My mother in her protectiveness tried to say, "You are as good as anybody else. There was this kind of encouragement, but within that encouragement, you know, there's also this hope. My mother didn't know if I was going to succeed, but there was this encouragement to kind of try and do.

Mariah

I do believe that there's hope. I really do. If I didn't believe in hope, then I wouldn't—I'd just stay in bed. [laughs] Why bother? There has to be. There's excitement. There's possibilities. There's room for change. We are not powerless.

Petra

What we color ourselves to believe we can do—How we color ourselves to believe we have power or don't have power—It's interesting. It's an interesting thing. It has to do with the same issues of access, behavior all around creativity, how we handle our creativity.

Mariah

We are capable of doing and changing and making and inventing and all of those things, definitely.

Petra

And I think it probably goes full circle, and it brings you back to fundamentals. Instead of, [pause] instead of living with the multitude I think it inevitably forces us to come back to what we basically believe in, what we basically want.

Mariah

For me, I move under the assumption that basically people are good. Now I know that sounds sort of ridiculous or something when we know all the stuff that's going on in the world, but there is a lot of goodness, and we don't focus on that. We don't focus on the positive, the possibilities of things being better because we're too busy trying to deal with some of the horrible things that are happening right now.

Nduma

We've lost too much. I mean this country almost doesn't have— The church is still there, but there are so many people who don't believe in anything. They don't believe in the church. They don't believe in religion. We spend a lot of time demystifying ourselves, that is. I think myth and some mystery and some symbolism are useful. I mean, [pause] so we got prayer out of public schools, and everybody thought that was a heroic thing. I think the premise of doing it was false, and I think that it's harmful.

We have now probably gone into a second generation of young-sters who don't have even a slight hint of what it might mean to think of life in that way and what religion might mean. These are spiritual things. We're very materialistic. And I don't know that in the long run that is where happiness lies. I really don't think so. People think that psychiatrists are the new people who can minister [to] their ills. Well, half the psychiatrists need to go to psychiatrists. There's something else beyond what they think of objectified in these books and so forth. I think it's spiritual things.

Interviewer

That's a good point. What part *does* spirituality play in this equation?

Alois

There's a divine plan for everybody, and our challenge on this planet is to discover what it is. I guess when I chant, or if I pray, it is to be able to hear clearly what it is that my purpose is while I'm here. Having tried to commit suicide and being unsuccessful, [I say to myself] "You're going to be here, so you've *got* to do something. So, let's find out what it is you have to do that you're here to do."

Clarissa

There's always a time to make a contribution. It may not be in the way in which you would expect or you would want, even.

Winston

Because in life we're all trying to find out—You know, it's al-ways been the big question: Why are we here? I still can't answer that as to why we're here. But I know a part of what has to happen while I am here is to give God praise. And if I do, that all things will start falling into place. He told us that He would take care of us. And I go back, and I look at my life, and I say, "What more convincing do you want?"

Paige

I'm sixty. I come from a time when for me, the most I could aspire to be was an undertaker because you had to have Black ones. A Black barber or maybe a Black doctor because White doctors wouldn't take care of you. Or contributing member of

a society as the other people told us and go out and get a job and work on picking cotton to working in a factory. And in spite of all of that, I carved out something I think is very successful to me, that I'm very comfortable with.

Winston

You have come up the hard way. You started out with nothing, and you have been taken care of.

Mariah

When I was a child, my aunt Rose said, "You are so gullible. You believe anything. You better get over that. You better stop that." And that hurt my feelings because I didn't know what she wanted me to do. I couldn't understand what she wanted me to do if I didn't believe. And she said one day, "You come home from school, and you say, 'My friend this, my friend that.' Everybody's not your friend." Well, of course I knew that, but that cut, too. She said, "That's just somebody you met. It's just somebody you know." Well, certainly I've learned that lesson. I mean, I don't see myself as a person with my head in the sand. I see myself as a fighter really.

Patti

I might be a dancer, but I'm also a boxer. And I'm going to get in the ring, and you just have to make that decision. Is it worth it to you? Is it important to you? It's as simple as that. Yes, it is, and I'll continue to box. It's a drag, you know what I mean? And I think it does take a certain kind of toll on people. But what I think people are hoping is eventually if you box enough, and if there's enough of you boxing in the same place, that things are going to change.

Sadik

I'm one of them soldiers struggling to change things. And knowing other people who are doing that and forming alliances to do that—And education is part of that. Not only my education, *their* education, but it allows you to have these minds and to allow them to explore changing their minds about things.

Mariah

My vision is that things will get better. Sometimes I feel, "Really? How?" Particularly, when I think about drugs, and I think

about our children, and I think about our communities. And so I don't have the answers. But I don't think that we are incapable of finding some answers.

Petra

Now we understand what's really happening—What's a myth, what's a distraction.

Mariah

I think that it's going to take everything we have if we want to—If we really wanted to focus on some of this, then we could find some ways to make it a whole lot better right now. [pause] And every time I see somebody who makes a move in that direction, I have a lot of admiration for them, in any kind of direction that's aimed at making the quality of life, particularly where our children are concerned, better.

Rufus

I don't have any answers. I'm thinking about calling my record *Love Is the Answer*. I don't have any singular answers, but I do know that spiritually, love is the highest form that we as human beings can tap into the universal power of God. And when we say "love," we're always so confused in terms of love being romantic or physical love, which is love on a lower level than spiritual love. Romantic love is something that we need. We as humans have a need for it. But we also have other kinds of love. We have family love and emotional love and supportive love. But the greatest is spiritual love, which is the transcendent power of the universe.

By me saying that, I'm not trying to push any—You know, I'm a musician. I'm not a minister. I have a calling through the music, but I'm not a minister, and I'm not trying to develop a denomination or movement or anything. I'm just trying to put the music out there and put it from the source that [pause] absolutely my whole life is built around, which is the highest level of our existence.

Clarissa

I'm not a psychologist, but I'm a human being. I'm a mother, and I know intuitively as well as academically, we need to feel connected to other people.

Rufus

By saying "love is the answer," I'm not necessarily coming up with an original answer. I'm just putting something in that zone. I'm throwing my little two cents in that bucket as opposed to the bucket of "confusion is the answer" or "money is the answer" or "power is the answer" or "sex is the answer," whatever other different messages you get through television and the media. If you listen to the messages in the music that's out there in mass consumption right now, it's about some confusion.

Interviewer

What you're saying about struggling, proposing solutions, and keeping our visions intact is really important if we're going to make any significant changes.

Clarissa

My real choice now in my life is this issue: Where am I going to put the remainder of my energy? We don't know how much time we have left. I may have five years. I may have ten. I may have another fifty. But in case I don't, I've got to make some really serious choices. And when I have choices, I'd better think them through carefully in terms of time and in terms of my energy and in terms of my life. What am I going to be doing?

Alois

Well, I realize I've been in enough fights, and I've been close enough to death that I'm not afraid of dying, and that's the worst thing that can happen to you. And it will happen at some point anyway.

Paige

Even at the end, I'm not ready to die [laughs]. I've got to go on forever. Maybe I'm just prepared to live forever. Maybe I'm prepared to live forever through my art and to be here physically as long as I can. And after that, to leave something of mine, and I don't just mean leave these images that I create. I mean, leave something else, the part of me that's alive in somebody else that'll just keep on going. And I don't mean my sons and daughters and all of that. It's through the other people I touch.

CHAPTER 7

Sailing Lessons

Two are better than one, because they have a good return for their work. If one falls down, his friend can help him up. But pity the man who falls and has no one to help him up! Also, if two lie down together, they will keep warm. But how can one keep warm alone? Though one may be overpowered, two can defend themselves. A cord of three strands is not quickly broken.

—*Ecclesiastes 4:9–12; N.I.V. Bible*

Throughout this book, the twelve teachers have spoken in past, present, and future tenses. They have addressed the reader and conferred amongst themselves. Some have offered a more extensive rendering of their lives through profiles. All of them have been presented in contexts where their words were woven in with my own. Functioning in complex capacities, they have spoken from many angles and to many issues. Having heard the depth and range of their accounts in this way, what can we learn from African American artists that might both fortify us and be useful to TWIs?

This picture of a united front depicted in the above quotation from Ecclesiastes or "The Teacher" offers guidance in framing the answer. We know that in our efforts to be responsive to the educational needs of a rapidly growing and changing society, we often find ourselves overwhelmed. Sometimes, the workload is exhausting—like a maze, each door unlocked seems to lead to yet another one. In spite of this, our labor is often handsomely rewarded in remembering that allies may be found in unexpected places, we

stand on the shoulders of those with similar visions, and what we do may serve as a catalyst for the subsequent efforts of others. Remembering that attempts to broaden and deepen education are not new courses of action, but continuous, is humbling. Realizing that such work is inspirational to others is invigorating.

That "a cord of three strands is not easily broken" suggests strength in numbers. It is wisdom that needs to be embraced by schools in preparing learners to live meaningfully and responsibly in a culturally diverse society. African American artists contribute a great deal toward these efforts. Their presence at TWIs signifies an important opportunity for shaping the identities of schools and should be a priority for those committed to fostering more equitable education. These teachers bring knowledge with them to their classrooms that many of their students may otherwise never have an opportunity to experience. By engaging in activities, dialogues, and relationships with these artists, student learning is enhanced by the experience of teachers who attest to the full scope of sociopolitical, cultural, and artistic creativity in their own lives. Figuratively speaking, African American artists represent a significant part of this third strand in Ecclesiastes that may help enrich education at TWIs. Following is a summary of some lessons they offer us pertaining to the overall climate at their schools, ways they view the meaning of their experience, and their contributions to student learning.

School Climate May Support or Hinder Teaching

The teachers identified conditions at their schools that affect their teaching. Institutional commitment to cultural diversity, the lack of African American student and community presence, the nature of collegiality, academic standards, and their identities as artists in the academy are areas that pose difficulties for them. Where most of the teachers felt supported was in their schools' ability to provide a financial base that supplements income from their professional artistry, physical work spaces to develop their own artistic projects, and classroom opportunities for their ideas about artistic development to be explored.

Some feel that their presence is not appreciated, merely tolerated, and that specific signs indicate this lack of commitment. Many of the those whose teaching focus on African American arts or arts of other cultures not traditionally represented in academe draw from resources outside their library facilities to supplement lesson

plans. Although each teacher wants students to have contact with practitioners, the main reason for inviting guest artists, when they do, is to compensate for the lack of available resources. Some say that what materials are at hand focus more on traditional art by people of color rather than more contemporary, innovative artists. They also make concerted efforts to acquire funding and to supplement scarce resources, which often entails either paying professional lecturers, photocopying large amounts of literature, or documenting the lives and work of contemporary artists. Of those teachers who do this, each is provided with financial support by his or her respective academic department, although the availability of these funds is politically driven and directly related to schools' public policies regarding cultural diversity initiatives.

There was expressed concern about the scarcity of African American students in their classes. One reason is that many teachers view themselves as role models for these students. Another is that most of their White students possess little if any knowledge about African American arts, which is sometimes problematic when there are culturally specific projects teachers would like to tackle that would be enriched by the participation of African American students. Although some teachers insisted that African American students are no better informed about their own cultural histories, they felt that as "insiders," they tend to access the nuances of the art forms with greater ease and that spending so much time developing the cultural vocabulary of their respective art forms makes it difficult to progress with students to more advanced levels.

In terms of support systems for faculty, most sources of collegiality, inspiration, and motivation come from outside school environments, primarily from families and other practicing artists. As one of few African Americans in their schools, at some point during their appointments, most of the teachers have actively sought out African American colleagues for social and scholastic support. Added to the fact that the lack of African American faculty to a greater or lesser extent induces feelings of social and academic isolation is the pervasive perception that the arts are frills, and for some, certain structural aspects of their faculty appointments further aggravate this issue of alienation.

Full-time teachers who participate in meetings, academic counseling, and other administrative duties felt better informed about their departments' and schools' policies and activities. Part-time faculty members, because of the nature of their contracts, are primarily limited to teaching and do not engage in administrative

and service-oriented activities to the same extent as their full-time colleagues.

All of the teachers are fully aware of how their presence at their schools reflects current directions in education to diversify as a result of public pressure placed on them. However, most of them clearly articulated the desire for schools to recognize their contributions above and beyond educational and sociopolitical trends.

Teachers Translate Their Own Social Experiences into the Development of More Equitable and Creative Learning

Another lesson is that African American artists who teach may be integral and vital components to their students' overall development. Similar to the way they have been influenced by relationships with teachers, friends, community members, role models, and arts groups, in turn, the teachers help form their students' knowledge and identities. They steer their students' art making in directions shaped by those principles embodied in their own cultural knowledge, namely interaction, definition, and transcendence. These principles come from somewhere. They have a history in that they are rooted in the many ways African American people have responded to sociopolitical and personal circumstances, be they restrictions or opportunities. These teachers then communicate this aesthetic knowledge, which is a result of their own experience, to their students.

The value of interaction, which advocates the development of more expansive views of the arts and an emphasis on culturally diverse education, where connections between ideas and bodies of knowledge are readily made, appears to be shaped by the teachers' experiences in a few ways. The importance of acquiring interactive modes of learning may be rooted in a response to the pervasive popular conceptualization of African American culture in isolated, disconnected, and hence erroneous terms. All of the teachers referred to how they learned the importance of developing solid identities, as well as the effects of negative social myths, stereotyping, and discrimination. Lessons about self-worth, self-knowledge, perseverance, and the need to accrue knowledge, wisdom, and discernment have been forged through both supportive and challenging relationships with families, teachers, role models, arts groups, peers, religious affiliations, and political ideologies. Each teacher sought to rectify deficient aspects of their own education through their teaching. Overall, their experiences appear to have resulted in their

guiding students in the direction of more inclusive, relational ways of perceiving their respective art forms.

The second value, definition, pertains to the development of individuality, a quality unanimously regarded as essential to artistic growth. The importance of risk-taking and the forwarding of personal perspectives seems to have been constructed through relationships and events in the teachers' lives that taught them the necessity of developing solid, positive self-images. Each one learned this in a different way. For some of them, it would have been detrimental to their emotional well-being and professional development to let other people, social values, and institutions define their standards and expectations. Experiences influencing their high regard for self-determined identities were both empowering and disabling ones. Some included the limitations of gender roles, class membership, racial bigotry, and social casting based on skin tone. They also included growth that occurred through affiliations with political and religious organizations. One of the ways they learned to forge definitive, personal standpoints was through family relationships, where these teachers were either encouraged to take responsibility for pursuing their goals or challenged to redefine themselves due to lack of family support. Also, role models served as advocates of new and unusual ways of perceiving reality, exemplifying the attributes of originality. Some communities supported the artistic directions of teachers, while others did not, at which point they faced the strength of their convictions to become artists. Some of their early teachers recognized their gifts, while others laid the burden of their own prejudice on them. In the case of the latter, they had to decide whose images were most accurate and how their identities might serve to protect them from the emotional pain of bigotry in the future. Overall, these experiences taught them the importance of giving expression to what Jerry calls the "rhythm of the soul."

The third value, transcendence, concerns the central place of heart-centered knowledge in promoting personal growth through the arts. Each of the teachers advocates this by means of affective exploration at various stages of learning, with students often challenged to engage in emotionally tough issues. Social experiences that have shaped this value for them are deeply rooted in their identities. Given that there may be few outlets to express the emotionally intense and complicated designs of their "minority" status, and the often overwhelming conflicts inherent in reconciling public images with personal ones, these teachers may enthusiastically seek

out opportunities to fully express themselves. The arts hold tremendous promise in this regard. They allow for the personal and social bypassing of the face value of things to their deeper, underlying realities, thereby making room for a range of intense emotions. The importance of creativity is directly related to the teachers' identities, since the desire to express and create is inseparable from the social factors that deem it necessary. However, they seem to recognize that for their students, who are primarily White, the impetus for *their* creativity has to be explored and guided by their own places in the world.

Overall, the combined effect of the teachers' social experiences, interpreted differently for each of them, has resulted in the goals they promote and standards they uphold for the making and appreciating of the arts. These values constitute means by which the teachers have handled their responsibility for organizing the constant influx of a range of social, economic, political, and aesthetic variables into cohesive, meaningful experiences for student learning.

Teachers View the Meaning of Their Experience in Artistic, Sociopolitical, and Emotional Terms

There are three ways in which the teachers defined the meaning of their experience, expressed in artistic, sociopolitical, and emotional terms. In regard to the first, teaching in the academy allows them to remain close to their art forms. They can earn a livelihood in the arts while maintaining artistic standards and integrity by avoiding arts projects they find undesirable. In the classroom, exchanges with students become valuable means of sharpening their ideas. That is, unless artists are somehow connected formally to arts organizations or informally to a network or community of other artists, there are few opportunities to talk about projects in ways that allow them to explore either details of the art-making process, their motives for the development of particular avenues of exploration, or the value that they place on their work. Teaching gives artists a chance to sort out concepts and techniques while fine-tuning ideas, which in turn effects the quality and evolution of their art.

Second, the dynamics of the classroom help artists verbalize their social and political ideas. As a result of their own experiences, each of the teachers, to varying degrees, holds strong views about the need for social equity. They encourage the learning of materials, styles, and methods that were unavailable to them through their

own formal education. In the classroom, they may express these viewpoints in discussions and through an emphasis on fostering learning that is responsive to issues of cultural diversity. Many of them readily embrace this opportunity to influence the next generation, crediting their teaching as an important way of participating in social change.

Third, teaching in White institutions at this particular period in history when integration has been legally enacted, but to a large extent, socially impeded, places emotional demands on many of the teachers. In discussing the meaning of their experience, they reflected on the marginality of their faculty status. Coming to terms with the fact that their colleagues, environments, or school policies are not sufficiently supportive places them in stressful positions, which often causes them to assume confrontational or defensive postures. This happens either overtly, in their exchanges with other members of the academic community, or personally, as they face teaching in indifferent or hostile environments. Some strategize for survival at their schools, while others seriously question whether they can continue to teach in socially and academically alienating surroundings. Some have fully immersed themselves in their teaching, resolved about the inevitable nature of the struggle. Others keep one foot outside the school door and maintain active artistic professions, viewing this as a means of assuring their flexibility and independence. Needless to say, it takes tremendous energy to prioritize such a range of variables as they decide whether and how to continue teaching and living in those environments.

Artists/Teachers Negotiate the Complexities of Personal and Political Views

Each teacher, without exception, attempted to manage the emotional demands of two divergent standpoints: the acknowledgment of African American sociopolitical oppression, both historical and present, and the expression of genuine concern for their students, who are primarily White. "Planting seeds," "breaking down barriers," "opening doors," and "bridging gaps" described their roles in the classroom. Many of them talked about personal experiences with racial discrimination and offered their views on the difficulties of teaching at institutions that have traditionally been segregated. However, they also thoughtfully communicated regard for the development of their students and provided insight into their own

roles as agents for student learning. The empathy and responsibility expressed toward students, in spite of the clarity and poignancy with which they perceive their own complex conditions as "minorities," is impressive and provocative. However, rectifying extremes between sociopolitical awareness and accountability for sound, effective teaching is by no means simple. Patti, for example, unhesitantly said that ideally she would prefer to be teaching African American students. Still, she became very emotional in recalling the dedication of four White, male student dancers at her school and their unwavering commitment to her during a particularly stressful dance project she coordinated, based on the theme of racial oppression. Paige also struggled to make meaning of yet another irrational experience: racial discrimination in his hometown and, years later, professional acceptance and honor from that community. His account is profound in that it suggests the interplay of conflicting forces on him. Nevertheless, his passion for teaching and care for his students is evident.

The ability to define parameters of control seems to affect how teachers resolve this potential schism. To varying degrees, they perceive themselves as having some control in shaping the minds, emotions, values, morals, and, henceforth, social actions of their students and may therefore attempt to fill in that often large, gaping rift between their own social experiences and their roles as teachers. Though this rationale is purely speculative, what is clear is that they have strategized and wrestled with extremes and inconsistencies in their environments for the purpose of ensuring their social, psychological, political, and professional survival.

In summary, there are four important lessons that we can learn from these teachers. The first one is that they regard the climate and conditions at their schools as directly influencing their teaching. The most commonly cited environmental factors affecting them include (1) schools' commitments to diversity; (2) their abilities to engage socially with African American faculty, students, and communities; (3) the quality of collegiality and; (4) how they are supported as artists in the academy. The second lesson is that by virtue of these teachers' social experiences, which directly affect their teaching practices, they may provide powerful opportunities for learning among their students. Third, the teachers view the significance of their experience in threefold terms: as artists in the academy, as advocates of social change, and as it pertains to their emotional well-being. Finally, each teacher exhibits the ability to discern between constructive and crippling aspects of their social experiences

in order to assume the responsibility of teaching predominantly White students.

Given the dimensions of the twelve teachers' stories, probably one of the most striking features may be found by momentarily taking a step back, away from the specifics of them, a mosaic of issues ranging from work to play, and from politics to spirituality. Often, when we focus on details, much of what we need in order to give us a more complete sense of the picture remains in our peripheral vision. I began this book with the vague but persistent notion that African American artists who teach at TWIs lead lives requiring immense negotiations between the various facets of their worlds. Through my relationships with them, the accounts shared, and findings disclosed, all of which verify the largely unexplored value of these artists, I have learned a great deal. To summarize my learning, I refer again to the model of African American music that has been applied at various stages of this book, and specifically now to the phenomenon of polyrhythms, which may be one of the keys to more fully appreciating their experience.

Polyrhythms, one of the most distinctive qualities of African-derived music, are created through the repetition and interlocking of rhythmic patterns, their beauty and power found in the generation of extraordinary movement and force. Yet each pattern, as interesting as it may be, when heard apart from the entire composition, may be unimpressive and may even sound simplistic or appear incompatible with the other rhythms. It is the multiple stacking of layers of rhythms in perfect synchrony that makes the music "swing."

To borrow this analogy, I believe that the teachers from whom we have heard possess tremendous skills that enable them to function polyrhythmically. Each of their experiences is unique to them as African Americans; artists; men or women; members of various economic classes and family structures; mixtures of cultural heritages, educational backgrounds, organizational affiliations, and numerous other conditions. Each of them is molded by distinct circumstances, and articulate highly specific concerns. However, it is their collective voice that bellows and sways so splendidly.

Similar to how an improviser might build a coherent, moving musical idea from a limited set of resources, these teachers function under conditions that put this ability to the test. They teach, learn, and live within personal coordinates that result from the balance

and organization of extraordinary emotional and ideological dichoto-
mies. They attempt to integrate multiple levels of experience into
whole perceptions. The variables with which they work, both inter-
nal and external, push them forward as they face obstacles and turn
often less than promising circumstances into highly meaningful
teaching and learning ventures.

From them, we have heard that their roles and life circum-
stances require constant and difficult emotional adjustments. Some
of the more apparent sites of struggle, or dichotomies, include:
various degrees of expressed opposition to Eurocentricity, but tre-
mendous care for students, most of whom are White; experiences
with legal and social discrimination, which have continually threat-
ened their psyche, in contrast to the creation of a highly developed
aesthetic system that has endowed American culture with an
abounding cultural legacy; advocacy for greater expression of indi-
viduality, while acknowledging group membership and social re-
sponsibility as crucial for survival; and mindful attention to the
often arduous details of economic, social, and political conditions,
juxtaposed by an expansive, enlightened insight into the need for
spirituality and greater affective functioning.

Separately, these values may seem irreconcilable. However, in
considering them in their entirety, we see that these teachers have
sought to resolve, integrate, and make meaning of these incongru-
ities. It is their skill at making the pieces fit or managing experien-
tial polyrhythms that is distinctive and inspiring.

Charting new and arduous courses of exploration, willing to
dig in fearlessly, practicing the merits of trial and error, turning
failure into promise, facing personal limitations, proposing unpopu-
lar suggestions, and feeling the joy and pain of those around them,
through their teaching at TWIs, African American artists are those
navigators, leading us into the twenty-first century.

CODA

Creation Pedagogy: A Proposal for More Imaginative and Culturally Responsive Education

In paying tribute to the ingenuity of African American artists, we have acknowledged the stature of jazz improvisation in a few ways throughout this book. First, we entered into the minds of musicians, following their train of thought as it occurs in group performance and subsequently as this thinking is translated to engagements across the arts. We then observed parallel values in the teaching practices of artists in the academy, listening to the ways they talk about developing the artistry of their students. Yet clearly, the arts are only one manifestation of creativity. Creativity is that spacious place where dreams come to life. Residing there, as these teachers have proven, requires faith in a promise for new and abundant opportunities, rage with the obstacles that threaten it, and passion for the venture at large. Collectively, these twelve artists have commissioned us to increase our vision, strengthen our voices, and propose alternatives for more productive, meaningful living.

Being open to new and often unexpected knowledge, notions, and experiences as we courageously explore and expand our own views and those of our students requires, in short, an unwavering commitment to our creative potential. In closing, this chapter invites consideration of creation pedagogy through these very principles, namely interaction, definition, and transcendence for use by

educators concerned with promoting learning that is vital, imaginative, and responsive to the learning needs of a plural society.

The arts offer tremendous possibilities in this direction. However, they are not only useful in the literal sense of making music, dances, or visual art. The place inside ourselves to which we travel in order to make art is that same place we need to go in order to successfully envision and actualize more equitable social conditions and relationships and the means by which we might create them. Moreover, as we develop a critical engagement with and consciousness of diversity and learn to value and support the many ways that people live and make meaning, we need to empower our imaginations. This is key to being responsive to the needs of individuals and communities and not becoming fixed in our assumptions or expectations of others or ourselves.

Creation pedagogy is useful for this purpose. Like its jazz improvisation prototype, it encourages learning through the advocacy of a simultaneously specific and open-ended path. Certainly, the practices advocated through this paradigm are not novel. Most aspects of it are far more articulately and comprehensively expounded upon by proponents of critical pedagogy, multicultural education, liberation theology, racial identity theory, and such educational reform practices seeking the eradication of prejudice, discrimination, and oppression at all levels of society.[1] Some connections also may be found in the way Michele Foster and Gloria Ladson-Billings have highlighted the pedagogy of African American teachers and in the writings of Maxine Greene and Trinh T. Minh-ha through their use of artistic language and metaphors to embody and actualize the notion of "polyphonous voice,"[2] or how we affirm depth and range of experience to testify about reality.

What may be insightful about creation pedagogy, however, is the suggestion that we relinquish authority in learning to the arts-making process, and specifically, to the jazz improvisation canon. It is precisely the fact that there seems to be a strong match between the approach to learning required to successfully engage in improvisation and many of the areas of knowledge, concepts, and skills advocated by these educators and researchers that makes this a timely proposal. Towards this end, creation pedagogy is an accessible, tangible model that sanctions the expeditions of jazz musicians, prompting us to look to them for leadership as we work with their tested and proven principles.

These musicians do many things: interpret and try on others' ideas; analyze methodically while expressing passionately; measure

the amounts and meanings of things; strive for excellence and perfection while fully embracing the inevitability of incompletion and shortcomings; appreciate the relationship between practice and performance or trying and achieving; grapple with the mechanics and ambiguities found in the learning of new "languages"; communicate with others in unprecedented ways; and momentarily create distance and safety from the dense, exhausting restrictions of the physical world in order to share a piece of eternity—that part of us not confined to time and space. To teach and learn according to these values requires that our practices be rooted in ideals that acknowledge our spiritual heritage. Most notably, these ideas include our need to hope, to have faith, to engage in tireless action inspired by expectations, to have encounters with others that exist beyond the limits of words, to experience the power and responsibility of both self- and mutual forgiveness, to be accepted into the fold of another human being's reality.

Endorsing experiences such as these necessitates a complete shift in the measuring and marketing of "intelligence." For this, intelligence must become synonymous with meaningful living in the world. Validating the wealth of knowledge embodied in the consciousness of all learners, use of the artistic model requires that we nurture and employ the expansive, complex nature of subjectivity, and henceforth, intelligence in very specific ways. Through creation pedagogy, we can begin to assist each other as learners in identifying those experiences and concerns that shape our perspectives. As we confirm and share areas of our lives that we deem important, such as our fears, desires, frustrations, limitations, and expectations, we can then begin to participate with each other on the most honest and fundamental level.

Following are some remarks about creation pedagogy that punctuate the twelve teachers' suggestions about the development of artistry, found in chapter 5. It is important to note that although use of the arts in education provides direct and expedient opportunities for working with these principles, it is not the only avenue through which they may be explored. The principles of interaction, definition, and transcendence will now be acknowledged in the context of promoting more imaginative and culturally responsive teaching and learning in general areas of education. These comments are not intended to suggest practical, hands-on applications. Instead, in further immersing ourselves in the inner circle and nuances of jazz, the reader is invited to consider some of the ways these principles might be adopted and fashioned by educators in

order to provide learning opportunities that parallel the profound experience of improvisers. In particular, it is essential in grasping the full impact of each principle that we walk in these musicians' shoes, imagining our classrooms, meeting rooms, auditoriums, and other places of public educational assembly not unlike the charged rehersal studio or performance stage occupied by these master improvisers.

Interaction

Interaction is a principle represented by broad, swift, gestures that both draw inward and disperse outward with equal enthusiasm. Highly collaborative, here is where all ideas derived from individuals become available for the shared use and benefit of the group. This is not to suggest that their source is insignificant or to be overlooked. On the contrary, they are *so* significant that all opportunities to acknowledge the value of those ideas are expediently welcomed. The mark of mutual recognition is that all ideas become potential agents of change.

This is the level where acute listening skills are developed, and memory, which provides for continuity and connection making is rewarded, its benefits found in the unearthing of innovative paths. Musicians' ears are fully attuned to the sounds around them as they enter into highly responsible engagements with others. As the ensemble interacts, there is no such thing as accidents, only precious opportunities to experience success. In the absence of written notation, they learn to read themselves, their colleagues, and the charged musical atmosphere; they sift through a barrage of sounds, drawing from what exists outside themselves and mixing with what is generated inside themselves; they cautiously examine the seemingly predictable as well as what may be regarded as outrageous; always planning, hunting, gathering, sorting, they destroy unproductive boundaries and merge incompatible territories. Seeking to avoid static dynamics at all cost, improvisers reassign roles within the group in order to keep each moment fresh. Understanding the importance of being fully present at this stage, perhaps more so than at any other, they need to be able to hear whole moments, not simply the parts that constitute them. Successful interactions require that each ensemble member suspends the need for immediate results, knowing that the power of influence lies not in the strength of the musical idea as a phenomenon on its own, but in its appropriate placement and its eventual and organic integration into the whole composition.

The following description illustrates the value of interaction in one ensemble. Saxophonist, composer, Ornette Coleman's musical system, which he calls "harmolodics," has influenced and infused contemporary thinking in regard to ensemble performance since the early sixties. The listening experience suggests that harmony be created through the interaction of melodic and rhythmic ideas rather than superimposed from an external harmonic source. This is intended to free each instrument from its fixed, conventional role in the ensemble, resulting in broader viewpoints and choices from which each member may draw.[3]

For example, traditionally, the bass provides the harmonic and melodic foundation to which the rest of the ensemble refers. It serves as the bridge between the drums, which maintain the rhythm or "keep time" and harmonic information provided by a chordal instrument such as the piano or guitar. Sometimes, the bass will deviate from that role for designated solos, when it then usually makes melodic statements related to the underlying harmony. However, in Coleman's ensemble, the musicians may all appear to be playing melodies, when in fact, their interactions are also creating the harmonic direction of the music. In addition to this melody/harmony relationship, each member's subjective voice defines the rhythmic identity of a composition. Although the rhythmic ideas may originate and exert themselves from within the mind of the musicians rather than superimposed by an external instruction, this simultaneous interaction of individual rhythms does not contradict the feeling of unity or synchrony in the group.

The principle of interaction has implications for learners, one of the emphases being on an openness and availability to new experiences and alternate ways of viewing the world. According to this principle, we would attempt and view all experiences as useful for learning,[4] making connections in knowledge whenever possible. This might include developing more interdisciplinary experiences; having learning draw and evolve from pertinent social issues; and making diverse cultural perspectives integral components to all curricula and encouraging learners to develop greater appreciation, respect, and knowledge of them. It also has implications for the personal and professional sharing among teachers, communities, schools, parents, youths, and overall, the exchange of knowledge and resources across traditional boundaries to enhance learning. These exchanges result in mutual shaping, whereby everyone is influenced by everyone else, the interactions generating responses and often triggering significant and unpredictable changes. It is

through them that learners begin to formulate their roles in relation to others,[5] and which should then enable them to effect changes in their perspectives and henceforth, in their actual conditions both in and out of the classroom.

Also, similar to the way Coleman's harmolodic model allows for the embrace of that subjectively constructed group rhythm derived from the complexity of many individual rhythms, recognizing the diverse, multidimensional quality of rhythms among learners is crucial. As they interact, they affect each other, creating a culture that is unique to that particular combination of learners. Synchrony then results from the close observation of and participation in internal paces and relationships. This approach may challenge what many people traditionally have believed about order and chaos. What we perceive as discipline or an adherence to form and rules may actually be indicative of a passive, relinquishing of personal voice and power, while what appears disorganized and chaotic might possibly reflect the healthy, constructive questioning of or experimentation with new ideas. If we are willing to avail ourselves of this "mess," as improvisers usually are, we can then appreciate this process as intrinsic to growth and relinquish expectations for preconceived and often inflexible results.

This has implications for how we regard differences. We work in the above described way when we believe that all contributors, regardless of how different have intrinsic value to the larger group. Unfortunately, many of our prevailing attitudes toward "difference" contend that the way to appreciate the unique qualities of individuals or groups is by simply measuring and coming to terms with similarities and dissimilarities. This implies that appreciation or "tolerance" is the bridge that mediates problematic relationships occurring between two distinct appearances, when, actually, it always has been the need for one person or group to express, exert, and maintain power over others that has rendered diversity as problematic. The appreciation of differences seems to have become a preoccupation among many well-intended educators seeking to implement education that reflects the needs of a diverse society, and consequently, a diversion from this issue of power.[6]

Jazz improvisation offers us an alternate model. Although it is the qualitative variations among the instruments that give richness to the sonic possibilities of a composition, power is not used for self-grandeur or abusive purposes among musicians, but rather for the mutual uplifting of group members. For example, when a saxophonist takes a solo, part of how the group supports those ideas is

by acknowledging the soloist's innate attributes and limits. The saxophone's capacity for loudness and its ability to sustain a tone for an extended period of time dictates the type of accompaniment needed by the ensemble. Because of these qualities, it is possible for the ensemble to play at a relatively high volume while suggesting possibilities for harmonic, melodic, and rhythmic explorations. However, when the bassist solos, it requires a different type of accompaniment. The bass produces less volume, and played in its usual manner, by hitting the strings with the finger, creates a sonic duration that is relatively muffled and short. By nature, the bass is less able to exert melodic direction through pure force of volume than is the saxophone, and so the ensemble has to establish a complimentary background to help facilitate a successful bass solo. In itself, the difference between the instruments has little bearing on the success of the composition. It is the sensitivity to each instrument's ability to exert control when placed in the position of soloing that prescribes the appropriate behavior and response by the ensemble.

Returning to schooling, to be aware of differences for their own sake, and even to provide formats for the expression of differences does not automatically address the critical issue of individual and group oppression. It is and should only be the means to a greater end. As in the case of the ensemble, power should become an important consideration when determining how some people or groups might support others in enabling them to reach their full potential.

The equitable ensemble represented by Ornette Coleman's group in the above description is a highly desirable achievement for many musicians who are motivated by an interest in the collective owning of a musical moment. But, after inspecting, interrogating, and challenging what appears to be a bombardment of sonic material at this stage of interaction, musicians then retreat at regular intervals to measure themselves.

Definition

Definition represents the acquisition of insight into and full participation with personal meaning making in the process of self-measurement. It entails discovering and expressing who we are. This stage necessitates our moving in closer to the center of ourselves and coming to terms with deep-rooted impulses. Embarking on an introspective path, but ultimately working toward the full,

healthy functioning of the group, we need to evaluate our own strengths and weaknesses on an ongoing basis, using everything we produce as a barometer for growth.

For musicians to define themselves, many things may take place: they locate the source of their responses; they put the pieces together and attempt to make meaning, the core of who they are becoming more clearly observable to the group; they bear down, shut out all distractions, and enter the dark cave of subjectivity, certain that truth is hidden there. This grain of truth always overrides the frail, transient nature of what we have become accustomed to calling "facts" and can be found on only a certain path. This is the path of earnest self-examination. The mature musician seeks to avoid clichés, self-indulgence, and superfluous emotionality because focus and concentration hold the promise of clarity. They define themselves and their experience by choosing, weighing, assessing, speculating, and measuring, striving rigorously to clarify their ideas in order to express that uniquely singular point of view that might truly reflect who they are.

This principle is readily applied to classroom learning. To help learners define themselves requires that we hold individuality in high regard. Within the larger circle of a group culture lies the multiplicity of the individual who is altered and reconfigured, consciously and unconsciously, as a result of exposure to new and often competing bodies of knowledge, social circumstances, and individual relationships.[7] This challenges us to remain open and flexible in our definitions of both individuals and cultures, understanding individual identity as the powerful tonal inflection that gives life and meaning to the group cultural composition. Each individual within any given group, as with each musician in an ensemble, is appreciated as a co-author in creating culture.

We can never know about the group apart from the range of individual variations within it, and within individuals as well. Here is where we experience the freedom to teach ourselves and thus to redefine and properly name ourselves. In fact, learning becomes dogmatic when we fail to account for individual voice, threatening the very imagination that would allow us to even entertain alternatives to oppression.

To imagine solutions for the effects of internalized oppression or superiority, all learners must have concrete and consistent opportunities to express subjectivity in social contexts. Searching for those memories, responses, events, emotions, and realizations that make each of us unique and precious, we may then begin to define

our value in the context of our classrooms and our worlds at large.[8] In this way, we also may begin to view subjectivity as mutable and changeable, as something that we can directly affect, a process upon which any vision of an improved world is directly dependent.

A critical posture is essential to musical improvisers at the stage of definition. They develop the confidence to forward an idea, step back and reflect upon its impact, beauty, accuracy, meaning, and after internally negotiating possible alternatives return with an addendum to the original idea, often within a fraction of a second. Ultimately, each musician must determine the meaning of all moments leading up to the present one. Furthermore, it is that sense of responsibility afforded to individual choices that empowers the collective nature of improvisation.

Through social analysis,[9] or an investigation of some of the tougher, most poignant issues, which traditionally have been submerged with tremendous force below the surface of learning, we learn to choose. For this, issues that need to find their way into the curriculum literally, conceptually, and symbolically might include racism, self-labeling and being named, identity, economic oppression, stereotyping, tokenism, assimilation, alienation, nationalism, migration experience, intercultural dynamics, family and community values, gender roles and discrimination, religious beliefs, genocide, homelessness, human rights, censorship, drug abuse, AIDS, teen pregnancy, the environment, and a host of dreams, aspirations, and areas of tension and mutual coexistence. We may take our cue from improvisers who face all ideas, their own and those of others head on in order to understand, embrace, and provide an honest assessment of that musical moment. Defining ourselves in this way, like these musicians, helps us as learners to speak confidently about what we know and may still need to learn.[10]

Transcendence

For some, this may be the most difficult of the three principles. It uses words and engages frames of reference that are either difficult to measure, may seem obscure, or are at least highly interpretive— words that are largely unorthodox in formal education circles, yet commonplace among so many artists. Yet, without this principle the others remain void of momentum, and even rhetorical. The goal of transcendence is to become more spiritually conscious and therefore more human. It is a stage of catharsis that results in a joy and appreciation for higher levels of knowing. Here, there is a fearless-

ness required, which is a direct reflection of our faith. To enter into this principle, we go further than we might ever have anticipated. We become more assured yet assign less attention to either the interaction between things or the definition of self or the group. It is at this junction that it becomes possible to mature into our full power, mainly because we recognize and face our intellectual mortality and hand ourselves over to the spirit of Creation. Having bloomed from a minuscule seed of possibility, we courageously relinquish all self-involvement and trust to the transcendental stronghold of compassion. Having skillfully sought out and applied knowledge at the stage of interaction, then explored the abounds of personal self-expression at the stage of definition, the stage of transcendence is where our emotions and minds settle down and our spirits take over.

The educational implication is that in order for learning to be fresh, inventive, and fully realized, teachers and students must avoid viewing knowledge as an end in itself. When we recognize the limits of acquiring knowledge for its own sake, we may then begin to experience a greater connection with others and even expect it. We need to be not only aware of but invested in providing opportunities or vehicles to propel and transport ourselves and our students from the mundane arena of mechanistic engagements to the supernatural realm of intuitive knowing, which is the throne of Creativity. Classrooms should be places where dreaming is welcomed, where new and previously untapped and unimagined ways of being are stimulated and more deep, meaningful connections with others are made.

For the improviser, sound is constructed and manipulated against a backdrop of time that continually passes. This passing of time is inevitable and will occur regardless of what sounds are superimposed over it. There is therefore an unspoken expectation and responsibility to utilize time to its maximum capacity—to embrace it. The only power the ensemble has over time is to create an illusion of its distortion. Yet this illusion is more than a magical trick performed for fascination purposes. The illusion of a time warp allows for important emotional involvement. We may experience time in hurried, fast-paced terms or in slow, lagging ones. It is affective, imagined time that holds much greater meaning than real time: our qualitative relationship to time, or *how* we participate in the intervals between moments gives subjective meaning to the quantitative time lapse. Here is where we surrender to the fact that

we are not all-knowing, but that at least some knowing is possible if we will only allow ourselves to be moved above and beyond our selves.

In the same way that time has no meaning on its own, except as we relate to it in the sequencing of events and our emotional investments with those moments, there is nothing sacred about knowledge. The "facts," whether historical, political, or otherwise, have always been subject to interpretation and distortion and remain so, even in our own hands. What *is* sacred and key to our transformation as learners is that we come to treasure wisdom, which is necessary in order to maintain faith. As the master improviser well knows, our transcendence is determined by *how* we choose to react and relate to the things over which we have at least some control and *how* we wait in those less certain moments. Transcendence occurs, and we barely recognize ourselves as we are crowned with our spiritual promotion—a greater capacity for love.

Dropping Anchor

Interviewer

This has been good. Thank you for your thoughtful and candid responses and for agreeing to meet with me.

Paige

You know what? And I'm being very frank. One of the things that made me agree to do this with you is when I found out you were a Black woman. I didn't know you were a Black woman at first. Then I thought, "Well, this is something that's going to be doing something for her, okay? Why not? Why not?" And after figuring out what you were going to do, I thought that it's just something I need to do. And I'm not doing it for you, I'm doing it for me. I'm doing it because I think it's somewhere that I can have some input into what somebody else is doing without being forced to do so, and feel good about it. And besides, I don't have to pay for a psychiatrist [laughs].

Nduma

I'm happy that I did this. What it does is it brings to fore where I want to go. I reflected on what I've done and I think that there's going to be a certain consistency about positiveness. I believe in positive forces more than negative forces. So, I'm happy that I did this. It'll be interesting to see what it all turns out to be. It's been useful. Thank you for inviting me. I hope it turns out to be useful to you.

Notes

Preface: The Author's Story

1. See introductory notes by Roland Wiggins in Yusef Lateef, *Repository of Scales and Melodic Patterns* (Amherst, MA: Fana Music, 1981).

Introduction

1. I used a phenomenological interviewing methodology as developed by Irving E. Seidman. See *Interviewing as Qualitative Research* (New York: Teachers College Press, 1991).

2. Joyce N. Payne, "Hidden Messages in the Pursuit of Equality," *Academe* 75: 5 (September-October, 1989): 19–22.

3. James A. Banks, "Citizenship Education for a Pluralistic Democratic Society," The Social Studies (September/October 1990).

4. Maxine Greene, "The Passions of Pluralism: Multiculturalism and the Expanding Community," in *Freedom's Plow*, edited by Theresa Perry and James W. Fraser, (New York: Routledge Press, 1993), 185–96.

Chapter 1. Understanding the Voices of Artists/Teachers

1. Yusef Lateef, "The Pleasures of Voice in Improvised Music," in *Views on Black American Music*, Selected Proceedings from the Fourteenth, Fifteenth, Sixteenth, and Seventeenth Annual Black Musicians' Conference, pp. 43–46, Amherst: University of Massachusetts, 1985–1988.

2. Julinda Lewis-Ferguson, ed., *Black Choreographers Moving*, papers, panels, and interviews from the 1989 National Dance Festival (Berkeley, CA: Expansion Arts Services, 1991): 53.

3. Judith Malina, "The Work of an Anarchist Theater," in *Reimaging America: The Arts of Social Change*, edited by Mark O'Brian and Craig Little (Philadelphia: New Society Publishers, 1990), p. 42.

4. Ellen Dissanayake, *What Is Art For?* (Seattle: University of Washington Press, 1988).

5. William F. Pinar, "The Abstract and the Concrete in Curriculum Theorizing," in *Curriculum and Instruction*, edited by Henry A. Giroux, Anthony N. Penna, and William F. Pinar (Berkeley: McCutchan Publishing, 1981), 431–54.

6. Francis E. Kearns, *The Black Experience: An Anthology of American Literature for the 1970s* (New York: The Viking Press, 1970), 379.

7. Cornell West, *Race Matters* (Boston, MA: Beacon Press, 1993), 105.

8. Frederick S. Wight, *Arthur G. Dove* (Berkeley: University of California, 1958), 64.

9. Carl Belz, *The Story of Rock* (New York: Osford University Press, 1972), 29–30.

10. Eileen Southern, *The Music of Black Americans* (New York: W. W. Norton & Company, 1983).

11. Ibid., 288.

12. Ibid., 288.

13. Richard J. Powell, "The Blues Aesthetic: Black Culture and Modernism," in *The Blues Aesthetic: Black Culture and Modernism* (DC: Washington Project for the Arts), 27.

14. W. E. B. Du Bois, "Criteria of Negro Art," *Crisis*, 3, no. 3 (1925).

15. Julinda Lewis-Ferguson, ed., *Black Choreographers Moving*, 23–24.

16. Sylvia Moore, ed., *Gumbo Ya Ya: Anthology of Contemporary African-American Women Artists* (New York: Midmarch Arts Press, 1995).

17. E. Ethelbert Miller, "Black and Blue: Toward an African Aesthetic," *High Performance* (Winter, 1990): 22.

18. James Clifford, "On Collecting Art and Culture," *Out There: Marginalization and Contemporary Cultures*, edited by Russel Ferguson, Martha Gever, Trinh T. Minh-ha, and Cornell West (New York: The New Museum of Contemporary Art, 1990), 145.

19. bell hooks, "Talking Art with Carrie Mae Weems," in *Art on My Mind* (New York: The New Press, 1995), 93

20. Kwame Anthony Appiah and Henry Louis Gates, Jr., eds., "Nappy Happy: A Conversation with Ice Cube and Angela Y. Davis," *Transition: An International Review* 58 (New York: Oxford University Press, 1992), 179.

21. Michele Wallace, "Why Are There No Great Black Artists? The Problem of Visuality in African-American Culture," *Black Popular Culture*, edited by Gina Dent (Seattle: Bay Press, 1992), 333–46.

22. Jacquie Jones, "The Accusatory Space," in *Black Popular Culture*, edited by Gina Dent (Seattle: Bay Press, 1992), 97.

23. Robert Farris Thompson, *Flash of the Spirit: African and Afro-American Art and Philosophy* (New York: Random House, 1983), 9.

24. Maureen A. McKenna, Robert V. Rozelle, and Alvia Wardlaw, eds., *Black Art—Ancestral Legacy: The African Impulse in African-American Art* (Dallas: The Dallas Museum of Art, 1989), 270.

25. Julinda Lewis-Ferguson, ed., *Black Choreographers Moving*, 53.

26. Eileen Southern, *The Music of Black Americans* (New York: W. W. Norton & Company, 1983).

27. William Francis Allen, Lucy McKim Garrison, and Charles Pickard Ware, eds., *Slave Songs of the United States* (New York: A. Simpson, 1867), 13–14.

28. C. O. Simpkins, *Coltrane: A Biography* (New York: Herndon House Publishers, 1975), 151.

Coda: Creation Pedagogy

1. See for example, Paulo Freire, *Education for Critical Consciousness*; Sonia Nieto, *Affirming Diversity*; James A. Banks, *An Introduction to Multicultural Education*; William E. Cross Jr., *Shades of Black: Diversity in African-American Identity*.

2. Nicholas Paley, *Finding Art's Place: Experiments in Contemporary Education and Culture* (New York: Routledge, 1995).

3. These are observations I have made by listening to recordings, engaging in conversations with Ornette Coleman, and observing rehearsals and performances of his group Prime Time from 1985–87.

4. Anna Kindler, "Children and the Culture of a Multicultural Society," in *Art Education*, Special Subject Council, July 1994: 54–60.

5. Patricia Phelan, Ann Locke Davidson, and Hanh Cao Yu, "Students' Multiple Worlds: Navigating the Borders of Family, Peer and School Cultures." *Renegotiating Cultural Diversity in American Schools,* edited by Phelan and Davidson (New York: Teachers College Press, 1993), 52–88.

6. Henry A. Giroux, "The Politics of Postmodernism," *Journal of Urban and Cultural Studies* 1, no. 1, (1990): 5–38.

7. Donna M. Gollnick and Philip C. Chin. "Tenets of Multicultural Education: Culture, Pluralism, and Equality," in *Multicultural Education in a Pluralistic Society,* 3rd ed. (New York: Maxwell MacMillan International Publishing Group, 1990).

8. Cynthia Dillard, "Promising Practices from Lessons of Self to Lessons of Others: Exploring the Role of Autobiography in the Process of Multicultural Learning and Teaching," *Multicultural Education* (Winter 1996): 33–37.

9. Christine Sleeter, Foreword in *Contemporary Art and Multicultural Education,* edited by Susan Cahan and Zoya Kocur (New York: The New Museum of Contemporary Art, 1996), vx–vii..

10. Nitza M. Hidalgo, "Multicultural Teacher Introspection," in *Freedom's Plow.*

Bibliography

Allen, William Francis, Lucy McKim Garrison, and Charles Pickard Ware, eds. *Slave Songs of the United States*. New York: A. Simpson, 1867.

Appiah, Kwame Anthony, and Henry Louis Gates, Jr., eds. "Nappy Happy: A Conversation with Ice Cube and Angela Y. Davis." *Transition: An International Review,* no. 58, p. 179. New York: Oxford University Press, 1992.

Apple, Michael W., and Lois Weis, eds. *Ideology and Practice in Schooling.* Philadelphia: Temple University Press, 1983.

Banks, James. "Transforming the Mainstream Curriculum." *Educational Leadership,* pp. 4–8. Association for Supervision and Curriculum Development, 1994.

———. *An Introduction to Multicultural Education.* MA: Allyn and Bacon, 1994.

——— "Citizenship Education for a Pluralistic Democratic Society." *The Social Studies* (September/October, 1990).

Barron, William, Jr. "Improvisation and Related Concepts in Aesthetic Education." Ph.D. dissertation, University of Massachusetts, 1975.

Benjamin, Lois, ed. *Black Women in the Academy, Promises and Perils.* Gainesville: University Press of Florida, 1997.

Berliner, Paul F. *Thinking in Jazz: The Infinite Art of Improvisation.* Chicago: The University of Chicago Press, 1994.

Borden, Victor M. H. "The Meaning of the Numbers." *Black Issues in Higher Education,* (July 10, 1997): 38–48.

Britzman, Deborah P. *Practice Makes Practice: A Critical Study of Learning to Teach.* Albany: State University of New York Press, 1991.

Clifford, James. "On Collecting Art and Culture." In *Out There: Marginalization and Contemporary Cultures.* Edited by Russel Ferguson, Martha Gever, Trinh T. Minh-ha, and Cornell West, p. 145. New York: The New Museum of Contemporary Art, 1990.

Cross, William E. Jr. *Shades of Black: Diversity in African-American Identity.* Philadelphia: Temple University Press, 1991.

Dent, Gina, ed. *Black Popular Culture.* Seattle: Bay Press, 1992.

Dillard, Cynthia. "Promising Practices from Lessons of Self to Lessons of Others: Exploring the Role of Autobiography in the Process of Multicultural Learning and Teaching." *Multicultural Education,* pp. 33–37 Winter, Caddo Gap Press, 1996.

Dissanayake, Ellen. *What Is Art For?* Seattle: University of Washington Press, 1988.

Du Bois, W. E. B. "Criteria of Negro Art." *Crisis,* 3, No. 3 (1925).

Egan, Kieran. *Imagination in Teaching and Learning.* Chicago: The University of Chicago Press, 1992.

Elbow, Peter. *Embracing Contraries: Explorations in Learning and Teaching.* New York: Oxford University Press, 1986.

Epstein, Dena J. *Sinful Tunes and Spirituals.* Chicago: The University of Chicago Press, 1977.

Farris-Dufrene, Phoebe, ed. *Voices of Color: Art, Education, and Cultural Diversity.* New Jersey: Humanities Press International, Inc., 1997.

Freire, Paulo, and Donaldo Macedo. *Literacy: Reading the Word and the World.* Massachusetts: Berin & Garvey Publishers, 1987.

———. *Education for Critical Consciousness.* New York: The Seabury Press, 1973.

Foster, Michele. *Black Teachers on Teaching.* New York: The New Press, 1997.

Gay, Geneva. "Designing Relevant Curriculum for Diverse Learners." *Education and Urban Society,* 20, 4 (August 1988): 327–40.

Giroux, Henry A. "The Politics of Postmodernism." *Journal of Urban and Cultural Studies* 1, 1 (1990): 5–38.

———. *Teachers as Intellectuals: Toward a Pedagogy of Learning.* Massachusetts: Bergin & Garvey Publishers, 1988.

Gollnick, Donna M., and Philip C. Chin. *Multicultural Education in a Pluralistic Society,* 3rd ed. New York: Maxwell MacMillan International Publishing Group, 1990.

Greene, Maxine. "The Passions of Pluralism: Multiculturalism and the Expanding Community." In *Freedom's Plow*. Edited by Theresa Perry and James W. Fraser, 185–96. New York: Routledge Press, 1993.

Gresham, Joi. "A Critique on Models for Approaching Multiculturalism through Dance: Insights Drawn from a Survey of Scholarship." Working paper, Creative Arts in Learning Program, Lesley College Graduate School. Cambridge, MA, 1994.

Hall, Edward T. *The Dance of Life: The Other Dimension of Time*. New York: Doubleday, 1983.

Heckman, Don. "Inside Ornette Coleman." *Down Beat* 32, 19 (September 9, 1965): 13–15.

———. "Inside Ornette Coleman, Part 2." *Down Beat* 32, 26, (December 16, 1965): 20–21.

Hentoff, Nat. *The Jazz Life*. New York: Dial, 1961.

Hidalgo, Nitza M. "Multicultural Teacher Introspection." In *Freedom's Plow*. Edited by Theresa Perry and James W. Fraser, pp. 185–96. New York: Routledge Press, 1993.

Hilliard III, Asa G. "Teachers and Cultural Styles in a Pluralistic Society." *Styles and Expectations*. National Education Association, p. 65–69. January 1989.

Ho, Fred Wei-han. "'Jazz,' Kreolization and Revolutionary Music for the 21st Century." In *Sounding Off! Music as Subversion/Resistance/Revolution*. Edited by Ron Sakolsky and Fred Wei-Han Ho, pp. 133–43. New York: Autonomedia, 1995.

———. "The Real Next Wave: Multicultural Artists and Empowerment as Sources for New American Art." In *Reimaging America: The Arts of Social Change*, Edited by Mark O'Brian and Craig Little pp. 124–27. Philadelphia: New Society Publishers, 1990.

hooks, bell. *Art on My Mind: Visual Politics*. New York: The New Press, 1995.

Johnson-Laird, Philip N. "Freedom and Constraint in Creativity." In *The Nature of Creativity*. Edited by R. J. Sternberg. Cambridge, MA: Cambridge University Press, 1988.

Kearns, Francis E. *The Black Experience: An Anthology of American Literature for the 1970s*, p. 379. New York: The Viking Press, 1970.

Kindler, Anna. "Children and the Culture of a Multicultural Society." In *Art Education*, Special Subject Council, p. 54–60, July 1994.

Ladson-Billings, Gloria. *The Dreamkeepers*. San Francisco, CA: Jossey-Bass, Inc., 1997.

Lateef, Yusef. "The Pleasures of Voice in Improvised Music." In *Views on Black American Music: Selected Proceedings from the Fourteenth, Fifteenth, Sixteenth and Seventeenth Annual Black Musicians' Conference*, pp. 43–6. Amherst: University of Massachusetts, 1985–1988.

————. *Repository of Scales and Melodic Patterns*. Amherst, MA: Fana Music, 1981.

Lewis-Ferguson, Julinda, ed. *Black Choreographers Moving: Papers, Panels, and Interviews from the 1989 National Dance Festival*. Berkeley, CA: Expansion Arts Services, 1991.

Lincoln, Yvonna S., and Egon G. Guba. *Naturalistic Inquiry*. Newbury Park: Sage Publications, Inc., 1985.

McKenna, Maureen A., Robert V. Rozelle, and Alvia Wardlaw, eds. *Black Art-Ancestral Legacy: The African Impulse in African-American Art*. Dallas, TX: The Dallas Museum of Art, 1989.

Mesa-Baines, Amalia. "The Real Multiculturalism: A Struggle for Authority and Power." In *Different Voices*, Edited by Marcia Tucker, pp. 86–100. Association of Art Museum Directors, 1992.

Miller, Ethelbert. "Black and Blue: Toward an African Aesthetic." *High Performance* (Winter, 1990): 22.

Minh-ha, Trinh T. *When the Moon Waxes Red: Representation, Gender and Cultural Politics*. New York: Routledge, 1991.

Moore, Sylvia, ed. *Gumbo Ya Ya: Anthology of Contemporary African-American Women Artists*. New York: Midmarch Arts Press, 1995.

Murray, Albert. *Stomping the Blues*. New York: McGraw-Hill, 1976.

Nettles, Michael T., and Laura Perna. *The African American Education Data Book: Higher and Adult Education* 1 (1997): 427–445.

Nieto, Sonia. (1993) "From Brown Heroes and Holidays to Assimilationist Agendas: Reconsidering Critiques of Multicultural Education." In *Multicultural Education, Critical Pedagogy, and the Politics of Difference*. Edited by Christine E. Sleeter and Peter McLarens. Albany: State University of New York Press (forthcoming).

————. *Affirming Diversity: The Sociopolitical Context of Multicultural Education*. New York: Longman Publishing Group, 1992.

Otuya, Ebo. "African Americans in Higher Education." *American Council on Education*. 5, 3 (1996).

Paley, Nicholas. *Finding Art's Place: Experiments in Contemporary Education and Culture*. New York: Routledge, 1995.

Payne, Joyce N. "Hidden Messages in the Pursuit of Equality." *Academe* 75, 5 (September–October 1989): 19–22.

Phelan, Patricia, Ann Locke Davidson and Hanh Cao Yu. "Students' Multiple Worlds: Navigating the Borders of Family, Peer and School Cultures." In *Renegotiating Cultural Diversity in American Schools*. Edited by Phelan and Davidson, pp. 52–88. New York: Teachers College Press, 1993.

Pinar, William F. "The Abstract and the Concrete in Curriculum Theorizing." In *Curriculum and Instruction*. Edited by Henry A. Giroux, Anthony N. Penna, and William F. Pinar, pp. 431–54. Berkeley, CA: McCutchan Publishing, 1981.

Powell, Richard J. *Black Art and Culture in the 20th Century*. New York: Thames and Hudson, 1997.

———. "The Blues Aesthetic: Black Culture and Modernism." In *The Blues Aesthetic: Black Culture and Modernism*, p. 27. Washington, DC: Washington Project for the Arts.

Rogers, Carl. *On Becoming a Person*. Boston: Houghton-Mifflin, 1961.

Rose, Tricia. *Black Noise: Rap Music and Black Culture in Contemporary America*. New Hampshire: University Press of New England, 1994.

Sahasrabudhe, Prabha. "Multicultural Art Education: A Proposal for Curriculum Content, Structure and Understandings." *Art Education*, 45, 3 (1992), 3 41–47. National Art Education Association.

Seidman, I. E. *Interviewing as Qualitative Research*. New York: Teachers College Press, 1991.

Shallcross, Doris J., Dorothy A. and Sisk. *An Inner Way of Knowing*. Buffalo: Bearly Limited, 1989.

Shaw, Arnold. *Honkers and Shouters: The Golden Years of Rhythm and Blues*. New York: Macmillan Publishing Company, Inc., 1978.

Silver, Joseph H. "African American Faculty at Traditionally White Institutions: The Impact of the Adams Case on Hiring Practices." *The Urban League Review* 14, 1 (1990): 829–37, 1990.

Simpkins, C. O. *Coltrane: A Biography*. New York: Herndon House Publishers, 1975.

Sleeter, Christine. Foreward in *Contemporary Art and Multicultural Education*. Edited by Susan Cahan and Zoya Kocur, pp. vx–vii. New York: The New Museum of Contemporary Art, 1996.

———, ed. *Empowerment through Multicultural Education*. Albany: State University of New York Press, 1991.

Smith, Leo. *Source: A New World; Music: Creative Music*. Self-published, 1973.

Southern, Eileen. *The Music of Black Americans*. New York: W. W. Norton & Company, 1983.

Tatum, Beverly. "Talking about Race, Learning about Racism: The Application of Racial Identity Development Theory in the Classroom." *Harvard Educational Review* 62, 1 (Spring, 1992).

Thompson, Robert Farris, *Flash of the Spirit: African and Afro-American Art and Philosophy*. New York: Random House, 1983.

"Vital Signs: The Current State of African Americans in Higher Education." *Journal of Blacks in Higher Education*. (Winter 1995/1996): 45–50.

West, Cornell. *Race Matters*, p. 105. Boston, MA: Beacon Press, 1993.

Wight, Frederick S. *Arthur G. Dove*, p. 64. Berkeley, CA: University of California, 1958.

Wlodkowski, Raymond J., and Margery B. Ginsberg. "A Framework for Culturally Responsive Teaching." In *Educational Leadership*. Association for Supervision and Curriculum Development, pp. 17–21, September, 1995.

Discography

Carter, John
"Conversations," 1986. *Castles of Ghana*, Gramavision 18–8603–1.

Coleman, Ornette
"The Jungle Is a Skyscraper," 1972. Science Fiction, Columbia 64774.
"Sound Museum," *Sound Museum*, Verve 314 531 914–2.

Lateef, Yusef
"Metamorphosis" and "Biography of a Thought," 1993. *Metamorphosis*, YAL
Records, 100.

Reid, Steve
"Lions of Juda," 1976. *Nova*, Mustevic Sound 193–18.

The Revolutionary Ensemble
"Side One," 1973. *Manhattan Cycles*, India Navigation IN 1023.

Threadgill, Henry
"Crea," 1994. *Song Out of My Trees*, Black Saint, 120154.

Tyler, Charles
"Fall's Mystery," 1977. *Live in Europe*, AK-BA 1010.

Index